# The Conversations

## Interviews with Sixteen Contemporary Artists

WORKING BOOK SERIES

# The Conversations
Interviews with Sixteen Contemporary Artists

## Richard Whittaker

WHALE AND STAR

# CONTENTS

# INTRODUCTION

Yves Michaud:  What inspires you to paint?
Joan Mitchell:  When I was sick, they moved me to a room with a window and suddenly through the window I saw two fir trees in a park, and the gray sky, and the beautiful gray rain, and I was so happy. It had something to do with being alive. —Interview, 1986

In one sense, the interviews in this book owe their existence to my own dissatisfaction with what I was reading in the art press in the early 1980s. Today, twenty-some years later, they rectify something that was missing then. There is some satisfaction in that, but there's more: I believe these interviews cannot be read without being touched in an ontological way and encouraged, perhaps even given hope of a special kind.

In 1980 I was unfamiliar with the ideas of Barthes, Foucault, Lacan, Derrida and others, whose ideas had swept through the literary and artworlds, and to which it seemed so much of the art writing of that time aspired. I had found something else. Art making, I'd discovered, "had something to do with being alive," as Joan Mitchell put it so beautifully. The depth of that simple statement has always been difficult to put into words, but I didn't expect to find it completely overlooked, somehow, in the art writing I was encountering.

It's still a little amazing to me that this collection of interviews exists at all. Call it folk art, if you wish—on my part, at least. I am not a certified art expert. But it's surprising, sometimes, how things evolve—for instance, from a question. Back in the mid 1970s, I'd become intrigued by how the quality of certain late afternoons affected me and, one day, driving across the San Francisco Bay Bridge, in thrall to the ever-changing beauty of that passage, a question came to me. Could a photograph capture something of this atmosphere that so moved me: the late afternoon sun on the railings and struts of the bridge itself, the faces illuminated in passing cars or, out on the bay, the sunlit sides of ships resting at anchor? Could a photograph capture the diamond points of the sun's fire reflected from distant windows in the East Bay Hills, or any of the magic alive in that great sea of marine air?

It could not have occurred to me to ask if my experiences should be analyzed for their hidden political content or any culturally bound assumptions. I simply took to heart the joy of finding myself alive in such astounding circumstances. That one question did arise, however: what could a photograph reveal? And it led into territories utterly unexpected. The next ten years I spent with a camera were rich in too many ways to detail here, but most relevant to eventual appearance of these testimonies, the sixteen interviews here, was the collision between what I experienced in my own search and the preoccupations of the artworld, as I encountered it then. How to understand the incongruity?

Not having been an art student in any of the standard ways, in those days I attended seminars and workshops; I approached galleries with my work, and so on. I began getting something of an art education, and what I learned wasn't what I expected. It seems that I'd been rather naïve.

One day in 1985, more upset than usual with my own, by then, confirmed status as an art outsider, I decided to embark on my own research. It might be interesting to talk to people directly instead of depending on the voices coming from the venues that counted. I bought a tape recorder and began to ask people questions: What is art? Is art important? What does art do? What is art's place? It was the act of a desperate man. I began first with friends, and then started approaching strangers. Some were involved in art, others not. These were my first interviews.

I noticed that everyone was willing to talk. I noticed also that what people said had nothing to do with what I had been reading in the art press. And there was another surprise. It was impossible not to notice that the language that kept coming up was related to the realm of religion and spirituality. At the same time, any mention of the word "religion" was met immediately with resistance. The subject of art, however, remained unmixed with cynicism. This discovery was almost as shocking as when, many years later, I ran across an artist [Ehren Tool] who had been giving away his work for free. But it must be added that the closest I came to speaking with art sophisticates was with docents at the Oakland Museum.

Remembering those early conversations, a quote from Joseph Beuys comes to mind, which I will have to paraphrase: [from an interview, 1979]: "Creativity isn't the monopoly of artists, this is the crucial fact I've come to realize, and this broader concept of creativity is my concept of art." He goes on to say, "We have a restricted idea of culture, which debases everything; and it is the debased concept of art that has forced museums into their present weak and isolated position."

It took another six or seven years before all the threads came together and I began publishing an art magazine, *The Secret Alameda*. [The Jane Rosen interviewed appeared in the last issue, #8.] The decision arrived suddenly in the autumn of 1991. It came with great uncertainty and doubt, but the scale tipped just enough to begin and, slowly, a certain degree of clarity came into focus. The first issue of *works & conversations* was published in March of 1998.

Contrary to the fashionable ideology of the early 1980s, which devalued the voice of the art maker, I found that it was the author, the artist I wanted to talk with. It was there I discovered the common ground that had been missing earlier. I found that those who make the work often have important, and even inspiring, things to tell us. We don't need to add to the cult of celebrity, but perhaps we do need to listen to those who have learned things from their own efforts, from their own search and direct experience.

# RICHARD BERGER

## OAKLAND, CALIFORNIA, AUGUST 1996

*I'd heard about Richard Berger long before I'd met him. "Richard? Oh, he's a genius!"
is one of the comments I'd gotten used to hearing. "He's got a killer sense of humor," is
another one. Berger is a long-time art professor at the San Francisco Art Institute where
he chaired the sculpture department for over twenty years. Long ago, I'd seen one of his
early pieces and its pure elegance had left a strong impression. I finally met the artist at
a restaurant in Alameda, Peggy William's place, where I liked to go for breakfast. Peggy
is a story in her own right, but that's for another time.*

*Over the years now, I've talked with Berger on many occasions and understand the
stories I'd heard. Berger has a rare gift with language. He told me once that he never
prepares for his lectures. He's a devoted student of jazz, and listening to him develop an
idea is like listening to an accomplished jazz soloist. At the same time, he's a very private
person, perhaps to a fault. While the artist is revered by those who know him (in 2005
he received SFAI's Adeline Kent Award) perhaps his staunch reluctance for self
promotion is part of the reason his work has received far less attention than it deserves.*

*One morning I got together with Berger at his studio and home, an old wood-framed
storefront in one of the most ethnically mixed neighborhoods in Oakland. I asked him
how he was approaching his work lately…*

Richard Berger: Now, when I'm making something, the idea of when it's
going to be finished is far more remote to me than it was ten years ago.
When I was making those pieces with the wire, every decision was
diagrammed. There's a map for that face, and measurements. I scaled it up
off a cast of a face. Everything that could be known about what it took to
make that piece was known. All that was left was the making, and it was still
a real eye-opener when it was finished.

Here, I'm starting out to make a puppet. It may be Ezra Pound, or it
may be a woman. With that piece [*Artist at Work*] I made the corner of the
room first. I didn't know where I was going. See these drawings down here?
They are hundreds of overlays that were cross-sections of an image keyed
to one another. I thought I'd try to recycle this work, and it didn't really
cohere, but, on another level, the work still isn't finished. I don't know what
will become of these. I just did them because I was desperate, and I had to
do something.

Richard Whittaker: What do you mean when you say that you were desperate?

RB: Well, inertia is a state of desperation, as far as I'm concerned. Being frozen in the headlights of life is a desperate circumstance—the sense of impending peril if you don't move. That's the way I'm talking about it. If you don't know what to do, and you don't do anything, then nothing has changed. It's always better to do something when you don't know what to do.

RW: I know you have a real interest in architectural space. With *Artist at Work*, you said you started off with "a corner." Was there a metaphor in that?

RB: I'm literally talking about a corner and, maybe, "being cornered" or other states we feel sitting or standing in a corner. And if it encroaches on somebody's mental architecture in the same way—does it cast a shadow in your corner?—then that's great. I feel that if I do that first part of the job to the best of my understanding, this other part will be a possibility.

On another level I think of any art-object as the signpost denoting a crossroads that articulates a psychic location.

But this is so literal; I made this piece to go into a corner. There is something about a corner, a sense of a kind of funnel. You get drawn into it. I think that, to the extent you categorically orchestrate a physical architecture, you've established a psychic space. That's why being in a cathedral is the way it is. That's psychic space, no doubt about it!

RW: With this piece, *The Erratic Mechanism of Human Desire*, could you say something about why you put those two figures on each side?

RB: This comes from an image in a short story I wrote. There are several different aspects, and it has to do somewhat with Duchamp's *The Large Glass* also. There's an interior space, and you see there are people outside of that space: a male figure and a female figure. Each one is looking through a silhouette—kind of like the things you stick your head through at the boardwalk at Santa Cruz and get photographed.

Each one is looking through their opposite. So the male figure is looking through a female figure and vice versa. They look across at each other, but they are really seeing themselves. When you look at others, you are projecting yourself, you know. And the way they are automated, the way I've designed their movement, is that when one extends their head through the opening toward the other, the other one withdraws. They go back and forth that way. And what they can see in this room, if they look, is they see this little motor. They see this mechanism that moves them, and it's very simple. There's a gender duality and a pattern of habitual behavior in terms of

identity projection. Another visual source for this was from a cave on an island in Bombay Harbor, a very famous temple to Shiva carved into a mountaintop. There the central iconic representation of Shiva is a three-headed figure. The head facing forward is Shiva the androgyne, and, of the two side heads, one is a male and one is a female looking in opposite directions. The implication is that there is a fourth one looking back, the ineffable one that you'll never know.

RW: It's very interesting because it's like a precise picture of how something works in us, our situation.

RB: Yes. It's meant to be an equation. That's what Duchamp's *The Large Glass* is, though it's vertical and the female is on top and the male is on the bottom. Those disks over there [pointing] have the words to the tune called "The Book of Love." Do you know that one?

RW: From the fifties?

RB: Yes. So that's like a cloud above those figures. Another thing going on there is the idea of mythology, and what is that? It's one of the things that special objects sustain for us. What a myth does is mediate between how things really are and the way they ought to be. So the words to that song are like this idealized thing, this cloud above them, but the real facts of it are this cyclical approach and withdrawal, this consistent self-projection and the misunderstandings that come from it. Many people have seen this as a futile sort of thing. I don't. I think it is more just the way things are. And actually, they keep trying, so that's good.

RW: This piece seems to speak to the hopelessness of the situation, but, on the other hand, the representation of it may bring an entirely different dimension, which is a hopeful thing.

RB: Yes. A service you might be able to provide is to objectify a human predicament in such a way that someone might gain some kind of understanding they didn't have before. It might even make something that seems so grinding and inexorable kind of funny-"It's just a little play that's going on." And the light, which casts these shadows on the wall, gives it a dimension that's kind of Platonic.

RW: I'd forgotten that this piece also uses light and throws shadows on the walls. That's an important part of it—Plato's Allegory of the Cave.

RB: In moments of caprice, I've described this as "Howdy Doody meets Plato."

RW: [laughs] Say a little more about that.

RB: The Platonic idea is such a penetrating insight when you think of what a shadow is, and what it reveals. In primitive celestial sorts of things, the most fundamental intersection with the heavens is the aligning of a camp or village or cathedral with a cardinal direction. That's determined by a stick and a shadow. You see where the shadow is when the sun comes up, and where it is when the sun goes down, and you draw a line between those two. Then draw a line at a right angle where they intersect. There's the center of the universe. That's what Eliade talks about in *The Sacred and the Profane*.

Something that relates to what made light central to what I am doing is something Dan Flavin said, "The art is off, or the art is on." The reason I use the lights—and a shadow is a fact, a shadow is an event—is that light is passing from one place to another and producing this thing. Cinema is a bunch of shadows. That relates to the notion of mental projection, which is fundamental to perception—data gets projected on a screen in your mind, the visual cortex of your brain, and you learn to make sense of those patterns. Seeing is not a passive thing; it's an ongoing active thing. So to project a shadow, and to use light in all these different ways—you know that tune by Bobby Bland, "Turn on your love-light, let it shine on me"? The idea of light is everywhere.

RW: I think there is a hunger for anything that can return us to such elemental truths. Some art has been able to do that, but now the situation is in question. There is also the meaning that can come from making a piece of art.

RB: Fundamentally, there is something relevant to the statement, "some people need to do this." It's like this group of people down in Georgia, they call them "clay eaters," they actually eat red clay because there is no other source around them for a certain mineral they need. Something tells them.

There's a rational articulation of what the drive is, but the drive itself is something more fundamental. I think that's what artists are sensing. Something down there tells you there is a lack of nourishment, or balance. It's biological.

There is something about mind over matter, and transformation, which is deeply sustaining to some people. I think most of the time people are separated not only from nature, but also from their own natures—which is

to find some avenue where you can transform something. Maybe it's just a little microcosm where you do have control, and you usher this passage of material into form and have the artifact of that passage to help you do it again.

RW: To exert some control, to have evidence of some kind of mastery, but I have a feeling that's only part of it.

RB: Well, yes, but I think that's where I find my reward. What can I think up? And can I make it come true? But there is something also in that activity, as I am describing it, that connects to deeper activities, into a collective notion of shared ritual, in which a whole bunch of people are doing this, not for the end of satisfying themselves, but in order to make the objects which function to cohere the society and insure their survival. In this book *Homo Aestheticus*, which I use as a text in some of my classes, Ellen Dissanayake makes the point that art-making—her phrase is "making special"—is a biologically driven survival mechanism. To put it simply, "the group that makes-special together stays together."

And by ritual behavior, I mean replicating nature with colored paste that you move with animal hair tied to a stick: painting, or turning a rock into a person, sculpture. And whether it exactly replicates nature or not, there is the fundamental human need to project your image into space in order to understand yourself and your relationship with others. I think it's definitive of human consciousness. It goes with the territory.

RW: Mircea Eliade, who I've been reading lately, says the creative act is the quintessentially sacred act. That idea would be based on the fundamental creative act: God created the world.

RB: Christianity, or Judaism, is even a sculptor's religion. God made man out of clay and breathed life into him. You think of all of the different myths, even up to and including Pinocchio where an effigy is granted the life impulse. So another thing is, how do you isolate and know the life impulse in yourself? Through these objects, through these symbols, through these poems. It's all part of that, and it coheres locally in different forms and practices, but I think it's all the same impulse, whoever is doing it anywhere. The thing I make comes from me; it's so much less than me, even as I am so much less than the forces that made me.

RW: How would you place such an understanding in our contemporary culture?

RB: It's a good counter to our contemporary situation. Things that don't have an immediate quantifiability tend to disappear. You have to learn language and grammar and a lot of things that can be evaluated and quantified, but ultimately, in order to be able to confront what's priceless, you have to become a poet.

RW: How would you describe that?

RB: Knowledge is priceless. You can't buy it. You can buy the book. And the market system follows this computer model—learning is just a disk, which you slip inside someone's head, and then they know something. That's least true in art.

I knew a girl in college who just went through her textbook and wrote down over and over, like Bart Simpson, "the gross national product is…" That's all she did all day long, and she got all A's. But what kind of understanding does that constitute?

RW: It's not just a matter of information.

RB: No. And don't get them mixed up. That's what this thing is [points to his computer]. Suddenly you have endless information. The notion of "what is priceless" in a market-driven society is what I think I'm dealing with in my work—and the question of the difference between "priceless" and "worthless." Because there's a lot of stuff that people regard as priceless, which others think is interchangeable with "worthless."

RW: How do you see the sculptural object in relation to this?

RB: Something Herbert Read says about the modern sculptural object—Modern with a big M, he's talking about someone like Henry Moore—is the confluence of two older forms: one is an amulet and one is a monument. So the monument is the temple, this huge kind of thing, and the amulet is something that is very charmed and compressed and intimate. Gaston Bachelard uses the phrase, "intimate immensity." Duchamp talks about "the simultaneous need for intimacy and distance" in art. These are ways in which people have described a kind of chemistry. When you talk about "the spiritual" I think it's the aching tension between "amulet" and "monument"—intimacy and distance.

From one psychological domain you elicit, almost electrically, an analogy with another domain. It's not done through conventional circuitry, not

through intellectual processing. The definition of intuition is "knowledge that is not arrived at through rational processes." But it's knowledge by induction, nonetheless. That's part of what makes it art. Do you know the objects called astrolabes?

RW: A sort of navigational device?

RB: Yes. And the compass, a little sundial and a sextant. Those are amulets. And what those are, in the broadest sense, in a wonderful sense, are keys to where you are. If you're an eleventh century Arabian sailor at sea, your life depends on this thing. It's just this little thing, but you triangulate off the stars. And you have these sliding disks, which are the accumulation, sometimes, of centuries of observation boiled down into these little things. And this thing tells you where you are.

RW: A work of art could perform that function perhaps?

RB: Oh, absolutely.

RW: That's an area in which I think there is an instinctive impulse on the part of artists, a sense of the need of locating yourself, having your own experience.

RB: What I encounter is the kind of capitulation that has occurred broadly about certainty of any sort. In other words, "you don't know anything for sure, you can't know anything for sure." Everywhere you see a specialist erecting a tollbooth between you and your goal, telling you "you can't get there unless you pay." It's not even always monetary. There are other kinds of strategies. I think that is what a cult is. You have to check with this guy.
    People's confidence in their ability to make decisions for themselves, through just the complications and multiplicity of being alive in these times, is easily undermined. They become dependent on this external presence, which is constantly nattering at them. And I don't think anybody is sitting in a room and dreaming this up. I think it's just the inexorability of a very complex mechanism. Nobody planned it that way.

RW: I have to agree with you. Does anyone have the capacity to engineer this sort of thing? It gives people too much credit.

RB: They couldn't have thought up a hose-job like this!

RW: [laughs] Yes. You've mentioned a phrase in the past, "the alienated object…"

RB: …The poetry of the alienated object.

RW: …And also the phrase, "an object having authority". What is an "alienated object", and when does an object "have authority"?

RB: All of it has to do with context. I think it's a uniquely American idea. It's something that is produced by a culture of things, a culture where things have reached a certain prevalence. There are so many things around that objects can wander from their normal patterns of activities and not precipitate a crisis. In a culture where you kept your tools and objects for your entire life, you couldn't use them in a piece of sculpture like Lucas Samaras did, for instance. It was your knife.

There has to be this middle ground where the use of objects can be a little freer. The alienated object, in other words, means that an object is being used in ways beyond its purely utilitarian use. It's taken out of that role and made to stand for something else. Then the use of poetic juxtaposition, irony and, most of all, the mechanism of humor becomes possible.

How is it that a tiny change of inflection, or a tiny change of context that would pass unnoticed in any other kind of discourse, would suddenly elicit an emotional outburst from someone in the form of a belly laugh? That's a pleasure response that has been triggered by the contextual manipulation of the ordinary into an unexpected circumstance.

It might be interesting to wonder, did they have jokes when language was just beginning? I don't think so. There were not enough words to go around to have gags. So, okay, in this society you have these objects—you have a kind of stage where objects participate in a definitive way. They become statements. The aggregation of objects becomes a signature of a person, like the kind of clothes you wear, what you choose to put in your house. They become a circumstance of identity. So you can take these objects out of their context, put them in new places, like Louise Nevelson did, and then, almost by their commonness, they can become special in the same way the words in a joke do. There are no brand new words in a joke. In fact the more ordinary the words, the better the set-up usually is, and the more unexpected this moment of ambivalence and transcendence can be.

This is a mechanism that can be savored by people who may not understand the dynamics of what is going on. If you told someone in a bar who was laughing at a joke that what was going on was some kind of linguistic inversion of alienation and context etc. he would just tell you to

blow it out your ass. But that's a fact. That's one you can kind of hang on to, this pleasurable discovery that things are not only what they seem.

And so what are the ways you can objectify those discoveries with things? The phrase "things are not what they seem" is a fulcrum from which things like humor and art balance.

My favorite example of how that works is Joseph Cornell. To me Cornell is brilliant because he incorporated a number of different realities in what he did. In each Cornell piece there are always radically different encodings of space in the form of maps of the cosmos, or topographical maps, or sheet music—something graphic signifying either time or space in some very foreshortened and encoded way—and that is the background. It usually works the same way a theater set works: the wash of blue light means "the sky," shorthand for infinity. Then you will have the little cut-outs of "the city," or another more physical, but equally encoded kind of reality, laid out in a sequence, coming toward the viewer, a sequence of encoded spaces that converge in reality from the background to the foreground. There is real furniture and, then, actual people. So it's a convergence into reality. And things can be orchestrated to converge into a new reality.

The object is alienated from its prosaic function and becomes the turning point of a much bigger equation. Its function is the key to the whole thing working. So, you don't have icons, a glowing-light woman with a lily in her hair so you know it's Mary; you have these other things that move in the same way words do to make a statement, or to make a poem, or to make a joke. Poetry and humor are very close together in working that way.

RW: There is something about some art that I see which some people would want to say "is magic." What do you think about that?

RB: I think it happens, but my threshold of skepticism is pretty high about that. Many times, when it exists, it's not grandiose, not enormous at all. You could think of the attribute of magic as the indelibility of the experience, something you don't forget.

What I remember most vividly from three weeks of being in Rome recently, being in this astounding place, is a tiny Giacomo Manzu piece in the Museum of Modern Art. It's a weird kind of cylindrical, modeled room with a woman looking out the window, and the little curtain kind of blowing aside. It's just an episode that is very crystalline, very clear.

That's there, but I think the experience is so contextual, so elusive, so much a projection of the person viewing that you might find it anywhere, in a bonsai tree or a pile of debris in a shipyard. I think we have the capacity

and the need for some kind of deliverance, but I don't know that it's much of a legislated experience. Our intentionality has no bearing on it, really.

For example, in high school one of my friend's mother taught sculpture at UC Davis. One of the things that got me interested in being an artist was getting a job there in their bronze foundry in 1962 when I was in high school. Bruce Nauman was a graduate student there. William Wiley was teaching there, and Wayne Thiebaud and Arneson. I was at parties when I was fourteen, fifteen years old with Steve Kaltenbach and those people. Nobody decided to have a killer art department. It just happened. I mean there were just a serious bunch of heavy hitters who had a great deal of influence in the whole of contemporary art in this little house in Davis, all playing guitars and drinking.

People try like hell to do it, you know, in the same way you try to put together a great football team. "Hey, let's get the best receivers, the best this and that." They run into each other. They drop the ball. They start squabbling. The magic part is, I think, where you can't control it, or it works, in spite of you.

RW: So it's even safe from advertising.

RB: Sometimes I wonder what would happen if there was no institutional support in the arts. Would people just lay down and become philistines? I don't think so. I think it might spread in ways that it can't now because there are all these institutionally anointed practitioners around stultifying people's confidence in themselves. That's a thing of great interest to me.

There's a place down in San Lorenzo, a craft store I've run across in trying to find puppet parts. People go there because they need to make things, they need this kind of anchorage. This place is unique. It's set up like an old Woolworths. On the top of the shelves all the way around the place are these things—I mean they're really weird, some of them—all sort of crocheted or knitted things: giant panda bears and funny vests and dozens of things to put over your roll of toilet paper. Some of them are hysterical. There's a poodle that fits over your bottle of liquor. The head of the poodle fits over the top, all knitted. The place is full of these things.

And underneath each one of these things is a sheet of paper, a sheet of code: "knit one, pearl two." It's the key to this thing. Here it is on a piece of paper, the formula, an incantation. Get your yarn. Go to work—click, click, click—and make this thing. And people are doing it. There's the assurance that we have this scheme that will result, even in a Panda bear! And we can

act on that scheme, and, by God, we'll get a Panda bear where we just had a big long noodle of fiber before!

Those people are, whatever you think of their taste, I think they're participating in something really healthy and really vital. They are acting on a scheme of transformation.

RW: I'm touched by that, and it leads me to something you said earlier about the emphasis on individuality in art school. You said, "It's more significant to consider what one has in common with others."

RB: I think the forces are very pervasive in regards to this battle between commonality and individuality. In my sculpture class I always play music. I let people bring tapes. But there will always be four or five people with their own headphones on. They are not going to join this group. They're going to be in this other space. So the music is no longer the common experience of the group. It's the isolating experience. And I think there are still evolving transitional strategies to further conceptualize space and retain identity.

Maybe human history, in the broad sense, can be seen as this trajectory from total commonality to total individuality. And ironically, as there is greater proliferation, there is the need to have more psychic territory of your own. Biologically, animal groups have their territory; their territory has to do with how much that group needs to maintain its size, but it also functions—and I think this is true of humans too—as a buffer against too many social contacts. In other words, if we're going to hang together and work together in order to survive, we can't get hung up with these other guys. This stuff of tribal warfare, clan warfare, competition and territory runs very deep in human consciousness.

At a point when human consciousness dawned, it was a physical space in the real world, which coincided with a group identity, but when there got to be enough people you couldn't afford all that territory. There had to be this conceptual space, which is inner, a space encoded by art, by things "made special." I think, as there are more and more people and more input, the drive is toward that. It's really a drive to cling to identity, which, for 99% of human history, was determined in terms of a group.

RW: An interesting idea, equating psychological space with territorial space, and making that correlation. It occurs to me, though, that something is missing. A professor I know asked his class, "What's the biggest problem today?" and the overwhelming response was, "loneliness."

So, people may be getting psychological space, but something else is needed too.

RB: Yes. I'm not saying this is an effective strategy, if the psychic space isn't common. So someone might be driven toward something the same way someone might have a chemical imbalance and try to self-medicate themselves in ways that goes wrong. The emphasis on the internal space, to be driven to that space, to seek that more and more, is not to say that that's really addressing the problem. And, yes, loneliness is part of that.

RW: On the importance of finding something "in common," I feel there's something right about that, and we see that impulse. But often, it's happening in ways that may not be so good: mass movements, pseudo-connections.

RB: A friend of mine is a "Dead head." I always had thought they were idiots, but she describes it in a way that has these aspects of community which I think are genuine. They're not mine, but there is a certain kind of courage going on among them. They actually got together; they didn't sit in a room with a terminal. What she says is that it never was the band, it was the people. Like anything that is based mostly on faith, it was totally vulnerable to chicanery and foolishness; so that was part of it too. But I've come to regard that with a great deal more generosity after talking to somebody who's intelligent, and who's into it. I think a lot of the techno-rave things are a little lamer and just about saturation and obliteration of faculties. But the idea of community, as much as I talk about it, is something I participate in very little. So I don't know the answers.

RW: Isolation is a fact for a great many artists. Perhaps even for someone with the relative success you have had. Do you wrestle with this?

RB: I find myself questioning what seems to be a pretty arcane cul-de-sac within which I find myself. In a moment of transient bitterness yesterday, I described it as "squandering my imagination," working in this corner making these things that virtually nobody sees.

I think the best shows I ever had in terms of public exposure—the show at the Berkeley Museum was good—were down in the financial district right in the window of some bank, and at Peggy's place in Alameda where just regular people saw this stuff. People could be genuinely surprised. I want this work to be at a crossroads of human traffic where there is some element of discovery, and a reason to pause.

I think the gallery-experience and the museum-experience is constrained and stultifying for a lot of people. They go into this white room and think that all their critical faculties, all of their intuition that guides them throughout most of their lives, has to be put on hold.

I was talking to a colleague who says, and I think I agree, that market strategy and the dynamics of administration have completely infiltrated fine arts in this culture in this time. The prospect of making art, which was for millennia the instrument of the cultural DNA that kept this societal thing focused, has now become a bunch of different things. Everybody is trying to decide which one of those things is most compelling. And, are any of them worthwhile? That's the question of art in this time.

# JIM CAMPBELL

## SAN FRANCISCO, CALIFORNIA, JANUARY 1999

*I first met Jim Campbell at a party. He was sitting quietly by himself. Earlier, he and my wife had been talking, and I'd noticed that the conversation went on longer than I would have expected. She'd never met him either, and it raised my curiosity. Our host had only told me he was a very special artist. Just before I was ready to leave, I spotted Campbell sitting alone again on a deck overlooking the coastal hills and the Pacific, and I went out to introduce myself. I too found myself drawn in.*

*Campbell's work is widely exhibited. Not long before our conversation an extensive collection of his work had been shown at the San Jose Museum of Art where I'd had a chance to see it.*

Richard Whittaker: I know you have some things to say about the way the word "interactive" is used with computer art.

Jim Campbell: I've always felt that even using the word "interactivity" with computers is completely wrong. Interactivity, historically, has always meant a mutual, reciprocal thing that happens. Whereas, the way I see it, computers are really about control. My "Heisenberg" pieces bring up those issues in direct ways: the more you want to see something and the more you're trying to control the situation, the less you control it and the less you are able to see.

For instance, with the bed piece, as you walk toward the bed with the image getting closer, you don't start to see the pores of the skin, instead, you see the pixels. When you're far away you see these two lovers, but as you approach, you can't make it out anymore. The Buddha is the same way. From a distance you can see the statue of the Buddha, but as you approach, only the shadow is left. What are you seeing? Both refer to Heisenberg's principle. You know it?

RW: You can't know both the speed and the location of a subatomic particle at one time.

JC: Right, but it goes further. It says that if you even try to measure something at all, you affect it.

RW: A very counter-intuitive principle, isn't it?

JC: Yes, but there are ways of talking about little parts of it that aren't counter-intuitive. For example, if you try to measure an electron really closely, you have

to put a lot of light on it. Light has energy, so you're affecting it. That's one way to talk about it.

The non-intuitive notion of Heisenberg's principle is that the universe is probabilistic. This means that not only are you unable to measure the position of the electron accurately, but that it does not *exist* accurately. That, I agree, is totally counter-intuitive.

Those two pieces were about these ideas of Heisenberg and our desire to measure things, to observe things. They also are exploring how that fits into some questions about what interactivity means with regard to computers.

RW: I see that I'm reluctant to embrace the idea that what happens between a computer and me is interactivity in some essential sense.

JC: That's exactly what I'm talking about! Maybe it's just a semantic thing, but I think it's more than that. Using that word brings up certain notions. It also takes away from the old meaning of interactivity, which is kind of interesting. I would regard my relationship with my computer to be a control relationship. So if I use the word "interactivity" between me and my computer that's one thing, but if I also use the word for me and you, then it changes everything.

I do think I can interact with a cat—that's a feeling I have—but not with an ant, for example. With a cat I feel like there is interaction, a mutual thing going on.

RW: That's interesting. If you were on LSD, maybe you could interact with the ant, too.

JC: [laughs]

RW: I say that in jest, but I do have the experience, and I imagine others do also, of a few isolated moments where, in a particular state of mind, I felt a relationship with something like a bee. In that moment I felt that we were both living beings, a rare moment.

JC: Right. But let's say *living beings,* then. That would be a cut-off.

RW: I revisited your retrospective (San Jose Museum of Art 1998). I could see your "Memory Pieces" all at the same time, and, after awhile, a very poignant and sad feeling came over me. These little electronic devices were all ticking away quietly in this white room, but I felt them as relics of deep, human realities—just echoes in this empty white room. All that remained were these little memory machines with wires attached. I was very touched by this.

[*Portrait of My Father* is a small, framed video hanging on a wall with two wires running down into a small metal box, which controls what happens. The video image of Campbell's father alternately fades from view and back into view to the rhythm of a heartbeat, that of his son, Jim Campbell.

*Photo of My Mother* fades and comes into focus to the rhythm of Campbell's recorded breathing.

*I Have Never Read the Bible*—a large old Webster's Dictionary is attached to the wall with wires running down into a small metal box. From a speaker installed in the dictionary, the bible is being whispered letter by letter. To accomplish this, Campbell recorded the twenty-six letters of the alphabet in his own voice and then created a computer program that would read and play back each word in the bible letter by letter. As Campbell recorded the letters of the alphabet, music from Mozart's *Requiem* was playing in the background. So, as each letter is read, one also hears this music in the background. The result is haunting.]

JC: You think it was mostly the audible part?

RW: That certainly had a lot to do with it. Part of the sadness was also about the removed and abstracted quality of it all, the absence of human warmth and touch. Was that part of your intention, or is that just an accident of the objects themselves and my associations with them?

JC: A complicated question. There is definitely an aspect of that in the relationship between the physical and technological manifestation of these human, or supposedly human, memories. There's a clash there that necessarily happens, but which I am also working with, for example with regard to the little aluminum, sterile, cold boxes and the wires and the glass, and the objects.

One of the things I've always said is that the *real* interactivity that takes place in "interactive" works is between the viewer and himself, or herself.

So most of my work is like that, but the memory works are not. Those are definitely personal. All of those memories have to do with me, even the collective ones like the *Bible*.

RW: I'm curious about your piece called *Memory/Void*.

JC: It's similar to the five-monitor one (*Memory/Recollection*). There are three monitors in three jars, which capture your image with a camera. Your image appears first on the largest CRT (cathode ray tube), then slowly fades and moves to the smaller jars and then fades away altogether. The third and smallest jar is sort of buried in ashes, the last screen on which you appear.

RW: A powerful piece, I thought. What was that piece for you?

JC: That's a very old piece. I have a kind of love/hate relationship with it. I think my work has become almost too formal and conceptualized such that I would never do another piece like that these days. Part of it feels like an art-school piece because there is some contrivance to it, putting ashes in, ashes representing time and decay. In other words, throwing a bunch of symbols together.

RW: Would you call it heavy-handed?

JC: I would call it contrived. For me, now, it's the idea of a work that's important, not setting up a bunch of symbols around the idea. The distillation of that piece can be seen in the other piece, the one with five monitors, no ashes, no jars, but your image is decaying just the same. It feels less "art-school." You know what I mean?—doing something to evoke a response. I really try to stay away from that, and it's kind of easy for me to stay away from that, because when I'm working on something I get excited about it. I don't want to finish with it and know where all the meaning is. I'm really excited when I first plug it in to see what happens. I don't know what's going to happen.

RW: There must be, when you succeed—is "joy" too strong a word?

JC: If the opening isn't the next day. [laughs] No, it's true, because the process is so disjointed. There is some sort of creative process in figuring out what I want to do. Then there's the engineering process of doing it, which has nothing to do with the original creative process; it's implementation, and that takes months, although during that I get glimpses of what it's going to look like, and usually these glimpses actually change what the end result will be.

But, yes, there is joy, particularly because the engineering aspect is mostly the labor of doing it. So it's nice to actually finish and go back to the original creative idea, since during that whole intervening time, I'm just focusing on mathematics. I have to be able to figure out how to do it in a mathematical way. That's what computers do. They crunch numbers. So any idea you want to manifest through computers has to be reduced to a mathematical form, which usually is not a process good for communication or creative expression. It's usually a reduction.

RW: You spoke of trying to leave contrivance behind, to put together a representation of an idea in a more pure way, and I wonder, what are some of the ideas that are most important to you?

JC: A good example maybe is the spinning nail with the camera on it. There are a couple of different ideas there: what is "a frame of reference"? In fact, I revised the title of that piece to be *Frames of Reference*. Einstein obviously was very interested in that. That's where Relativity originally came from, that is, seeing something from a different frame of reference or perspective.

So this camera is moving. You could throw that camera and have it swinging wildly and the nail would always be perfect, because it is nailed to the board the camera is on. So no matter what the camera would show, the nail would still maintain the same relative point of reference.

Originally I had a watch at the other end of the board; so it was a camera pointed at a watch on the board spinning. Well, one day the watch fell off. I had it mounted there with a nail, and I realized the nail worked just as well, even better! I saw I didn't need to "hit people over the head" with the watch.

And I was very interested in the notion of something going that didn't have control of itself. Originally it was going to be part of two pieces. One of them would track you very closely, and so no matter where you were, you would see a picture of your face behind it. So it would be a very accurately controlled system. And the second piece would have been just the opposite. One that was not in control of what it was pointed at. So it would have been a simple dual piece that could be about will—a computer, mechanized notion of will, I guess.

RW: I'm not sure I am following this. How do you make the connection?

JC: It wants to track you. It wants to know where you are at all times. The other one has no control of what it is pointing at.

RW: So it has no "will," and the other one does?

JC: Yes. Not that it does; rather, it is "will."

RW: So are both parts a metaphor for the individual? We have this wish to be in control but, in fact, if we're able to notice it, to a really great extent, we're not.

JC: Right. Exactly. That is what I'm saying; we just get kicked, and we respond to being kicked.

RW: What are some of the things you've thought most about?

JC: I spent probably six months preparing for the lecture I gave at the Museum of Modern Art in New York. I spent so much time for a couple of reasons. One, I'm very nervous in front of large groups of people. And it

was the first time I'd really asked myself, "Okay, what ties this all together? What is it that I'm really interested in doing?"

After six months of thinking about what I was doing, and needing to verbalize it—well that was both good and bad. It clarified for me some of the things that were going on at an unconscious level, and it made me become a little more rigorous in terms of actually doing a work. Now a work has to fit into certain ways of thinking for me.

RW: When was it again that you took this time to think about your own work in this broad sense?

JC: 1995 and 1996. It was about a one-year process of really laying it all down for myself. That was one of the major transitions that has occurred for me. Some of the pieces that came out of that, for example, were the "Memory Works." I think those really came out of thinking about what I was doing, and why I was doing it.

Before that, with specific works I was very focused, maybe even more so than now, and was creating something mostly from a psychological perspective. "How can this specific piece work in a psychological way?" That was what I was working with, but there was really no way for me to talk about it except by showing the work, or documentation. So what I needed to do was to come up with this whole structure of the meaning of why I'm doing what I am doing. That was what was needed for a series of lectures and panels that started at the end of 1994. Here's a side point— some people say that this lecture, which I spent all that time working on, has nothing whatsoever to do with my work! [laughs] Which is really fascinating to me.

RW: Do you have any inkling why some people would say it had nothing to do with your work?

JC: Maybe because, in a positive sense, it comes from the fact that my work is more psychologically based and, in some of the better work, more personally based. The text of the lecture is a very precise, logical kind of paper about the problems of interactivity: "Delusions of Dialogue: Control and Choice in Interactive Art."

When I gave the lecture at MOMA in New York, the way I introduced it was to say "I'm going to talk about all the problems with interactivity in electronic art today and talk about why I think it's not there yet, why there really is not any interesting interactive art. And I'm going to use my own work as an example..." [laughs] So that was kind of an interesting perspective, which was kind of a joke, but also not a joke.

RW: A concern with interactivity could easily be understood as a concern about relationship, a personal thing. Do you think the subject has any grounding in this?

JC: It's a good point, and probably a hard question to answer. One of the reasons I do work, and I know this, is because—anyway ten years ago this was true and hopefully not as much today—I'm not very good at communicating with people. I certainly grew up never feeling like I was able to express what I was feeling or thinking. So that's completely why I got interested in the visual arts. I mean, I know that. It was a need to express things I couldn't express any other way. So "yes," to answer your question. The works specifically do deal with notions of human interaction, and I wouldn't even say this is on a conscious level, but if I analyze what I've done, maybe issues that I have with intimacy and interaction and people and socializing and all that come up around interacting.

RW: Just as a personal aside, I find it very easy to relate with you. I suppose I might say you seem less an extrovert than introvert, so to speak.

JC: Which I've never completely accepted about myself, and I used to be ten times worse.

RW: Would you say that's been a good direction? Moving away from that?

JC: I always look at the plus and the minus. There are still situations where maybe I'm with a group of people and I just don't say anything all evening long, zero words, literally. What I have figured out, and what I tend to try to set up with regard to social situations, is really a one-on-one situation. I haven't figured out how to deal with other situations.

RW: It's interesting that your work is obliging you, from time to time, to speak in front of groups.

JC: Which I avoid constantly. I say "no" five out of six times.

RW: What happens on that sixth time?

JC: I hate it. I think it's exaggerated for me because, and I think I mentioned this to you before, both of my parents are handicapped. And so they both have been completely physically insecure their whole lives. They were handicapped in the forties and fifties and sixties when it wasn't accepted

like it is today. They grew up, not as freaks, but definitely as people who were outcasts.

So somehow I definitely picked up that incredible physical notion of insecurity, and I think it's the reason it's really hard for me to speak in front of groups of people. And for example, I've never danced in my life; I've never been able to do physical things that were on display, I guess, like in groups of people. I don't know how the work fits into that.

RW: Well, clearly your work moves you toward more engagement in the world. It seems to be a beneficial thing.

JC: For the work?

RW: For you and for your work. And it's interesting to ponder that in the context of being reared by two handicapped parents. It's easy to imagine you must have many insights others wouldn't have.

JC: I think maybe "insight" is the wrong word. I think on one end it has given me, at times, the ability to empathize and, on the other end, it has made me a little more self-conscious than I might otherwise have been. One of the works I've done actually deals with the notion of being handicapped in a subtle way. Do you remember the one called *digital watch*? Where it takes your body and moves it in staccato movement, once per second? It's often actually how handicapped people move; certainly handicapped people have this more than the rest of us.

Because of its delay, and because of its staccato movement, one of the effects that this piece has, one of the things this piece makes you feel, I think, is that you don't have control of your body. Because you move and your image isn't moving like you're moving. It takes the immediate feedback away. It takes the feeling you have of control over your body away. That was definitely not on my mind when I did that piece. It was just an interesting insight I had after I did it.

*Hallucination*, the fire one, was completely and consciously about my brother, who was schizophrenic.

RW: You'd told me about that. My father's brother committed suicide. He had been diagnosed as having "dementia praecox," which they called it before the term "schizophrenia" had been invented. And this came down in our family; it certainly affected me. It was a dark sort of thing, unacknowledged, and which no one in the family…

JC: ...knew how to deal with?

RW: Right. No one knew how to deal with it. My father died about four years ago and I found some letters written by his older brother, the one who committed suicide, very upsetting material. I know this is terribly difficult stuff.

JC: Oh yes. I think I have a copy of a film about that [*Letter to a Suicide*]; I spent two years making it. I'll give you a copy. The whole reason I started doing electronic, interactive, installation work was because I needed to give up filmmaking. After I'd made that film, and I'd been making videos and film for about six years at that point, when I finished doing that film about my brother, there was no place for me to go. I am not a director. I don't have a "director" personality, so I just gave it up. I stopped doing art for three years. And then the first video (electronic) things I did were on a similar theme: three mental illness works in 1988.

   Just trying to think about where I am these days, and where I've been, I see that one of the interesting cycles that happens for me is "personal vs. impersonal" in terms of the content of my work. Part of the reason I gave up filmmaking and began doing interactive work—it was just called "media installation work" then— was that it gave me a way of doing something that was more conceptual, works that weren't personal in any way. I mean no one would ever get that *Hallucination* is about my brother being mentally ill. So it was a way for me to change the direction of the content of my work to being not personal.

   So that lasted too long, I think. I started feeling uncomfortable, feeling that the work had no meaning to me anymore. That's about the time I started doing the "Memory Works," like the two about my parents, and some of the other ones. They have personal content; in fact, they're all personal. But now I'm going away from that again. It's somehow out of my control.

RW: Interesting just to see that, this unconscious action at work. The shock is really to see that there is such a thing as the unconscious, and that it is an active force.

JC: I think the two other pieces that have definitely a bizarre unconscious relationship to me are the portraits of my parents, because both have been very ill in the hospital at different times. My mother is 85 and she is doing great right now, but she was in the hospital for 8 weeks for one of those eternal pneumonia things that just wouldn't go away. And she also had that infection you pick up from just being in the hospital. My father has heart problems. He's always had heart problems. And I was *completely* unaware of that when I made these two pieces where my mother's image is modulated

by my breath and my father's image is modulated by my heartbeat. I was just completely unaware of that. It's very strange.

RW: That's very striking. There is something just so profound about that.

JC: Yes. I agree. Well, I have to say, I've always considered both the positive and the negative aspects of those works—which one reviewer actually got—which is that my existence is completely at their expense.

RW: As with every son and daughter?

JC: Yes. The one of my father is a very pulsing one, as opposed to the one of my mother, which is slow. The opening was the next day, and, of course, I was literally up all night. When I finished it, I thought the piece was too violent to show. I decided I wasn't going to show it. A friend of mine came over, and it was the usual kind of pre-opening frenzy. I remember I just burst into tears.

I almost never cry about my work, or what I'm doing. And she said, "What are you talking about? It's not violent at all!" But I saw it as violent just because of that pulsing movement. Plus, it's also about me erasing both my mother and father and bringing them back.

RW: That is one of the things so powerful in art—I mean, potentially. It can be an avenue to the deep places in oneself, places where, in a way, we're sort of lost; we don't know our way around. Some feel a draw towards these hidden places, covered-over places, maybe for the purpose of understanding more.

JC: The way I've thought about that in similar terms is that it's a therapeutic process. It allows me to work out something, to focus on it that much, and to understand something about it, to create a work about it. And then…

RW: …and then, what happens if something is worked out?

JC: That's what I mean. Nothing is ever worked out.

RW: But wouldn't you say that something changes?

JC: Oh yes. The best example for me is spending two years on the film on my brother. That was a really difficult thing for me to do, to spend so much time focusing on it. And very self-indulgent, but it was very therapeutic. I think it made me understand some things and accept some things that otherwise I

think I may never have thought about or focused on in such depth. To me that's the easiest example. The other stuff isn't as clear, but I think it's there. It's harder to be specific about. But again, obviously, it didn't get rid of any issues. It has clarified some things. I mean that's how I look at therapy. I don't expect some big revelation one week—"okay, I'm done!" [laughs]

RW: I'm interested in learning a little more about your background. What were your interests when you were leaving high school?

JC: I think I was your typical person leaving high school. I don't think I knew what I wanted to do. What I thought I wanted to do, was what I thought I *should* want to do. In terms of art, I think the only thing that was interesting was a film class that was part of an experimental semester. Other than that, I was planning on becoming an engineer, which I did.

My dad actually worked at a TV station. He was a television engineer. And I think I assumed I would go in that direction. I didn't feel real strongly about that, and I still don't. I feel much stronger about art than engineering. I was good at mathematics and science and things in that direction. Not so good in literature.

I went to M.I.T. and got a degree in mathematics and then in electrical engineering, and then got out and spent three years repairing TV's. In a lot of ways that was very good because I'm the only engineer I've ever known in this field who has that kind of real experience. The kind of engineering I ended up doing and still do, is on video, HDTV kind of equipment. So that experience has been incredibly useful.

Most engineers only know things from the point of view of an engineer, not from the point of view of the user. I've actually been with the same company for 16 years now, hardly ever full-time, but sometimes for short periods. They've been willing to deal with this. Typically I give them a week notice when things come up with art, and, basically, they've been very open for me to do whatever I need to do for the art stuff.

Did I mention that I've kept this life completely separate? I even have a different name. I go by "Jack." So for the first time in fifteen years, the people who I do engineering with actually came to the show in San Jose last August. They saw what I do with the rest of my life. That was really a weird experience [laughs]; some of them really enjoyed it. Some of them, I felt, were threatened by it. Most of them got at least some of it. The more conceptual works some of them didn't get. It was just fascinating to have my two worlds collide. People who knew me as Jim and people who know me as Jack, all in the same room.

# SQUEAK CARNWATH

## OAKLAND, CALIFORNIA, DECEMBER 1992

*At the time of this interview Carnwath was a member of the art faculty at the University of California at Davis. Carnwath is one of the Bay Area's most prominent artists. Currently she is teaching at the University of California at Berkeley. We met in her studio. A number of her paintings were nearby. Somehow we got to talking about art schools...*

Richard Whittaker: There are so many people who graduate with MFA's, but after five years not many are left who are really working at art. It's a difficult path to follow.

Squeak Carnwath: I think it has to do with—I'll give you an example: when I was at Djerassi, there was a guy there for dinner from the Board of Directors. He has an MFA in ceramics. He came to California to do art, and he found that he didn't get the support he was looking for. I think that what people fail to realize is that it has to be self-generated, self-supporting, in terms of having the will to go to the studio every day and face it. He decided it was a lifestyle he didn't want to live. He wanted to have a family. He didn't want to have a day job, and he didn't want to make the sacrifices. And no matter what, there's a certain amount of sacrifice one has to make, to make art. I guess a lot of people aren't willing to do that. For me, it's challenging and rewarding. I get to be alone, and it's a kind of privilege and permission. I am not interested in living a life like my parents did, being a model citizen from the outside. I don't mind being a model citizen inside, but I don't care about living in a neighborhood, coming home at the same time of day, and all that stuff.

RW: The outer conventions...

SC: Right. I think there are people who want to have the outer conventions and make art, but they don't realize how much time it takes, how much unrewarded time is involved, unrewarded by outside standards. In our culture, it's only good if it sells. If someone can make money from it, then it's valuable. I don't think that attitude will sustain anyone for long. When a lot of people get an MFA, they think they're going to get a job, that it's a guarantee of a certain success. It's not. I don't think people realize how hard it is. If you have a day job and a life, it's like having three jobs, when you add the studio time into the equation.

RW: It's hard enough to earn money first of all, but secondly, maybe few realize how hard it is to arrive at that intangible place one hopes to find in the work itself.

SC: And that has to do with self-trust. A person learns to trust their own instincts, to believe in what they're doing, not what other people think. When people are in school, they're geared towards what other people think. That's what happens in school. Others are making determinations about who gets the scholarship or the grant, what studio they're going to be put into and so on. When people get out of school, they think the art world will determine these things.

You know, school's great because one is taken care of in that psychic way, which allows a person to experiment and try things. But when a person gets out of school, she has to create her own safe environment so she can take risks in her own life.

RW: Can you say more about taking risks?

SC: By taking risks, I mean doing things that the artist wants to do, not what is determined by the outside. I think it's about believing in yourself and not being influenced by the public side.

RW: When you say, "trust in yourself," you're talking about trusting that a certain process will occur. One can't really say exactly what it is.

SC: No. If I knew, then I could bottle it. Trust that I'll breathe. Or that I'll think of something; I'll be able to finish a painting, or that a painting will reveal itself to me—or that I will be revealed to myself in the work. It's important to go with that and not worry so much about the critics on my back, which can be a big problem. I think a lot of creative work in our culture right now is based on an extroverted premise rather than an introverted one.

RW: When you say "extroverted premise," you mean...?

SC: Worrying about what other people think. One has to create sovereignty in order to follow one's own path. That leads to true diversity. We're raised to conform; to go against that is not easy. In listening to your own voice, the results can be very subversive. And by "subversive" I don't mean that art has to be didactic, or what I call "baseball-bat art," where it hits you "upside the head." It can be more subtle; it can get under the skin.

RW: Can you say more about that?

SC: Right now we have a lot of artwork being made that is meant to sensitize the viewer, the public, to political injustices and different things, but it's taken on a kind of fascist edge. It demands that we believe in its ideology and its premise. It's non-elastic. It's unforgiving and doesn't allow for the viewer to question or to have a personal area of inquiry. It's statement-oriented and fairly fixed. I think of it as cultural anthropology or cultural sociology, stuff that's meant to teach and be didactic, but I'm not sure it occupies the delicate place that art really resides in, which is a little more fragile and a little less answered. Art doesn't illustrate a premise or an ideology. It asks questions. It won't give you any answers really. It's more ambiguous.

RW: Yes. That reminds me of the idea that shock will help, "shock therapy," you know. I suppose that came with the Dadaists.

SC: Even the impressionists did, because it was breaking up all the forms with those little blobs of color. Seurat's paintings were a big shock when they were first seen.

RW: It's a convention now, and bigger and bigger shocks have to be administered. So what happens if the artist really wants to make an impact? I read recently where someone actually stated, "the real art form today is terrorism."

SC: Yeah. I mean I don't think that's a real art form, but I think that's one direction it's going. If people think that art is about shocking, then they have to go further...

RW: The question is, where does that lead?

SC: Self-destruction. Or, it'll lead to wars and then people will just watch it on TV. People are so used to mediated experiences, used to observing life on a video screen. There is just more and more distance from humanity. I don't think that is what art is about. The value of art is to get closer to humanity. In our culture there's repression, denial and narcissism. People are unable to empathize.

RW: Maybe unable to feel connections to themselves as well.

SC: Right. They create a false self. It looks like they're real, but they're not. We have all these ways of being in the world, and it's all about surface. A lot

of it is TV-modeled, whether people recognize it or not. People care about how people look. There are artists having plastic surgery—men. It's not just women. The youth culture and that model of perfection. If people don't fit into the TV model, they feel horribly inadequate. Just look at the billboards. And it's a fairly limited American view, but it's spreading all over the world. All over the world, you see people wanting those things from our culture that are the least profound: "Big Macs" and blue jeans.

RW: This leads to areas that I think you explore, areas that are not on the surface. For instance with that painting [pointing], I see the questions posed: "What is heard? What is seen?" Can you talk about that?

SC: In my work I'm trying to find the unmediated self. I think there are aspects of self that are unchanged, that echo the past, the present and the future. I'm interested in that part of reality, not the culturally created one, although that's a layer.

RW: I've noticed a number of references to breathing in your paintings. The matter of breathing is something to be understood.

SC: Yes. Yes. The matter of being alive is something to be investigated. I think we take it for granted too much that we're going to wake up in the morning and just go on, do our stuff, run around, go to our jobs, have careers and all that. I'm not so sure we're going to be able to breathe in and out with a lot of ease, because our air is getting so polluted. I think we've forgotten how good food is for us. I don't think it's as good as it used to be. All the vegetables have been altered. The fruits and vegetables look the same to us. It looks like that's air out there. It looks like the water hasn't got anything in it because it's not yellow or black. Things are crumbly, but they sort of look okay. If you go to Russia, the pollution's really obvious. In St. Petersburg you can't drink the water. It's got typhus in it, but it's also a horrible yellow color and it smells. So that's why I put these words in, like "breathing." It's partly because I'm concerned that we're depleting our resources. But also what I was after was understanding something that we take for granted: being alive.

I had to start from some point; I think we start at a point that we can edit and carve away at, and this concern with ecology and the air is what led me to this other place. It gets to be two-pronged, which is more interesting to me anyhow.

RW: I feel some of your paintings are almost like prayers.

SC: Oh, yes. Absolutely. They are. They are. I think of them that way. And the way that I came to that is probably just from the practice of painting. I could have done it through meditation, I suppose. Anything one does deeply, I think you get to that point. The practice of painting, I'm very involved in it, so its natural outcome is this spiritual concern. If you consider it long enough, and deeply enough, a conversion experience will occur.

On the other side of that conversion experience, or transformation, is this understanding of our fragility of being, that we're just specks. And, really, we're just witnesses. It's our job to come to some understanding of that. I want the work to evidence that endeavor.

RW: Would you say more about "conversion experience"?

SC: Something converts. Some people use the word "alchemy" or "transformation." "Conversion" is a word I use. In the simplest way, using paint or using clay—it's dirt—but it converts to something else. It's converted into a life force of its own, or *a recognition*, and when it's really successful there's a leap of faith that the maker and other people make when they view it, that the thing exists on its own. When it doesn't work, we question that object's existence. When it works, we believe it. When it doesn't work, we wonder why it doesn't feel right. We wonder what's missing. And the same is true of objects and paintings. But when it does work, we believe in its reality. The frescoes in Italy do that, and Rembrandt's self-portraits. There's a lot of work people keep going back to because it's so believable.

RW: When it works, it touches something in us that recognizes it.

SC: We recognize it. Absolutely. And I think that what we recognize is our true self.

RW: You're talking about the object working in relation to the viewer, but then there's also the relationship of you, the artist, actually before the work itself.

SC: Yes. I'm like a conduit. I'm the one who takes the dirt and tries to be present with it so that it converts into a painting, an artwork. The job of the artist is to be able to make a place for that to happen through their skills, or their vision, or their surrender to the activity and the material and the ideas. It's a combination of all those things.

RW: So there's both the artist as active agent, but there's also this process you refer to when you use the word "surrender."

SC: Right, or "witness." It's both. It's two-headed. It's a Siamese twin sort of thing. They work together. Artists are; I think of us as radio receivers. Our job is to be available, to accept information and to make it visible. It works best when the information that we accept is the information we recognize as a part of our deeper self. We're all individuals, but we're also kind of the same. And it's personal, but it can't just be that. It can't just be what I had for breakfast or what color hair I have. I think it has to be so that someone else can say, "That's mine." The viewer has to be able to claim ownership.

RW: Some of your titles strike me: "There are secrets in everyday breaths." I think there's a lot to be uncovered in that statement.

SC: I guess I can mean it in a couple of ways. One way would be the excitement of just the mystery of life, the recognition that this is really an amazing organism that we inhabit. The other could be that if we pay attention, there is stuff about ourselves that can be revealed if we just slow down and become quiet. There may be a discovery that is like a secret. I guess I'm interested in uncovering some of those so that the person I am on the outside is the person I am at home. I don't mean home literally. What I mean is that I don't want to be presenting one self and hiding another self somewhere else. There are people you meet who you would never trust that the way they are in front of you is the way they are at home, and I don't want to be that way. I don't want to be that way in my spiritual life, or my art life.

RW: Another phrase of yours is "Mysteries of lives lived in our bodies." That part, "lived in our bodies"—I find that very interesting.

SC: We should be in our bodies. We should be present. That is what we inhabit. It's our job to understand that, and to pay attention to it. And again, I think our culture encourages us to deny that. When people die, there's no ritual about it. Often you don't see the body. It's just denied. The process of being in the body is denied. Hospitals do that. I think we have a series of memories, or lives, that inhabit our bodies. We may have been here before, or we may recognize energies that have been here before. There's a past that we're aware of that's really in the present. So that's part of it. The other thing is that I really think we should be centered and grounded, know when our feet are touching the ground, and know the weight of gravity. I'm very interested in understanding that, whatever that is.

RW: I have the sense that what you're talking about has very little to do with all the jogging and aerobics and so on, about which someone might say, there's a great interest in the body.

SC: No. I'm interested in being in the body and accepting that. If someone wants to "sculpt" their body, that's one thing, but I don't think they should be sculpting it to get away from it. I suspect that, for too many people, it's an attempt to leave their bodies.

RW: All that "sculpting the body," and so on, I'd say it reflects the obsession with surfaces you mentioned earlier, and not really an interest in the body itself, strangely enough. Certainly not being present in the body, as you say.

SC: Right. Well, this is speculation: I think we also live in a culture that is highly melodramatic, which is why terrorism is so fascinating. If it doesn't hit someone "upside the head," it can't be real. They don't think they're feeling. So a lot of concern with the body is on a "melodramatic" scale; it's not the subtleties like just feeling the blood going through your body. You could do that sitting down.

RW: Listening to you, I'm wondering what model we have that would lead us toward ourselves in the way you're speaking about?

SC: Well, the only models are spiritual paths: meditation, or the activity of painting. I think somebody could just count. Actually Jonathan Borofsky is doing that. He's counting to infinity. He's got a stack of notebooks three and-a-half feet high, all with just columns of numbers on it. I think anything that appears to be useless is probably very useful, and art is not considered useful. Only in the last 20 years has it been considered useful, and its use is as an investment.

RW: It seems to me there have been traditions in which the artist was viewed as an integral part of society.

SC: Because the things they made were used for rituals or used for devotion. They were inextricably woven into life's fabric. Even until recently I think art had a spiritual component. I think there actually are a lot of artists for whom art still has that aspect. But the way it's handled in the marketplace, the work is treated as a commodity, something to be bought and sold. Art is not always considered a device to orient us toward being.

RW: Here's another phrase that strikes me: "Nothing is real until you witness it."

SC: Sometimes when I see things I've written I wonder, where did that come from?

RW: We receive all this processed information, and it all comes from somewhere outside of ourselves. And is it ours?

SC: Knowledge. Books. Yes, all of this stuff. Well, it is if we recognize it. But I think we have to pay attention to it. We have to pay attention. We can't just accept it blindly. Often people believe anything they read. They think it's true. It's written down. I don't know where that comes from, maybe the Ten Commandments. It was written in stone. So, people will believe anything on a tablet. But I don't believe it unless I recognize it, unless it rings true.

RW: Yes, I've noticed this same automatic tendency to accept what I read. But sometimes, if I'm lucky, a little bell goes off, something says, "Wait a minute!"

SC: Right. That's what we all have to do more. I mean, I have the same problem, but I get confronted by so much. Right now, in the art world, and in universities, there is so much rewriting of history, people trying to rewrite it. I think there's a lot of "baby" being thrown out with the bath water.

RW: I think it provides a service to your students.

SC: Being skeptical?

RW: Yes. Advocating a little thinking, opening questions.

SC: I hope so, because students will always believe what they read. I shouldn't say always, but for the most part. There's going to be someone in a position of power, a professor or instructor, telling them that this is the truth, and it may only be that person's truth. It may not be appropriate for everyone in the room.

RW: You've written, "I'm an advocate of the unwatched life."

SC: "The unwatched life" is the one that isn't false. To me, it's the one that's the same inside as outside.

RW: Perhaps there's a great deal of life that goes by unnoticed. If one were to take an interest in that unwatched life, who knows what one would find?

SC: Right. But see, we're so driven by "melodrama" and the obvious, that people pass that soul stuff up. I guess my work is concerned with that

subtlety. I love this phrase of Duchamp's, "Art making is making the invisible, visible." I think that's what I'm interested in.

RW: That reminds me. You were talking to the class from Mills College in your studio and made references to the use of light in your work, equating light to spirit—something along those lines.

SC: Light in a painting, for me, is not about reflected surfaces; it's about an inner luminosity. I think sculpture can have it, too. It's recognition of a life force. In the Renaissance, light was a stand-in for life, or spirituality, or the presence of a God or a higher self, a soul. I'm interested in having that aspect of light in my paintings. I think we find solace in the recognition that there's something we don't really understand, that we don't really know. But we do know. You can see, when you look into people's eyes, there's light in people's eyes. That's another place where that light resides. I guess I'm interested in getting light into the paintings because I think we need that. It's about that leap again, that there is something else other than materiality. I'm not certain what it is between being and not being. It's subtle. And it's available to all of us. It's a part of us. It's about recognition.

RW: These things are not easy to articulate. Which leads me to this question: what is it that painting can do that words can't?

SC: I think that the painting is a stand-in for the body. It becomes the host. That's part of its conversion. It becomes a host for the spiritual. It's a symbol for the life force, but I think it actually becomes that. That's why some paintings have such longevity and people continue to make pilgrimages to see them. Good paintings enable us to believe in the palpability of its skin, of the existence of a body.

RW: The painting as "a stand-in for the body." I've never heard anyone put it that way before.

SC: I think it is. Painting in particular. Because it's not real, it's an illusion, it's a two-dimensional surface; you have to make a leap to believe in it. I think it's more complicated than sculpture. Now sculptors will really disagree with me [laughs], but I do. Because it's an illusion of reality, but when it's really successful, it's completely believable and completely real. It doesn't displace your own physical space like a sculpture does.

RW: But I can say, "Well, the painting is a real object, too. It has weight, color..."

SC: But color is light. It's ephemeral; it's cones and rods. It's a perceived reality. What's really great about painting, and this may be why I like it, is that there's a collective acceptance of its reality. But the only time it really works is when it has a presence that continues on into the present, that's always in the here and now. The Mona Lisa works because it's present today. It's believable today. Rembrandt's paintings have that. They're not stuck in the time when they were made.

RW: I also meant to ask you about color. It seems to me that you have a great sensitivity to color.

SC: I think I do. I have a couple of gifts as a painter. One is color. And one is the ability, from time to time, to tap into an emotional resonance, into feelings that other people recognize. I think color is a repository of human feelings and emotions. There are ways to use it to give depth and luminosity and to enhance emotions. I think different colors do different things, and they don't always do the same things. It depends on the context in which they're used.

For instance, I use black a lot. I think it's about any form. It's similar to water. Water takes on any shape: the shape of a cup or glass or pond. I don't believe there's negative space, for instance. Artists are trained to see positive and negative space. Well, why is that? I don't think the air is negative space. Black and white are just different sides of the same rock. They're twins. One is reflective and comes toward you, and one you go towards. It envelops you. I think of black as a really positive color. I think its luminosity is about a life force, and I actually think of white as funereal. That may have to do with the reports of all these people who when they have near-death experiences go to the light. I don't know. But I also see white as a life color, as daylight. I see them as night and day, and so they both occupy this place of positiveness, because it's a whole 24 hours. And other colors, I just use them; they have to feel right.

RW: You arrive at the colors you are satisfied with through attention to your feelings?

SC: Yes. And I couldn't really say how it is that I do that. The only excuse I have is that it's a gift. I'm able to make color kind of breathe and seem like it's alive.

RW: I certainly feel your colors are very strong. They often touch me quite deeply.

SC: That's what other people say, and I'm willing to accept that; I know that's a strength of mine. I just don't know how I arrive at it, but it has to feel right. It has to reach the right weight, the right luminosity.

RW: You use words in your paintings, and I've heard you relate this to time in speaking of your paintings.

SC: Yes. It forces the viewer to slow down and be in real time, whatever that is. That would be being in the present. That would be like breathing in, breathing out, blinking. It would be like being in the body. So the use of words, or even just the letters, it means that someone can't just scan the paint surface, slide across it like they were skating. They have to pick up stones. They have to slow down.

RW: I can look at your work and say that one of the things you're doing is working, in a way, to balance the conditions surrounding us in which we lose our "ordinary lives."

SC: Our life span is whatever we have, and so we're supposed to pay attention to it as it goes on each day, step by step, not to try to get to the end before we've spent time in the middle.

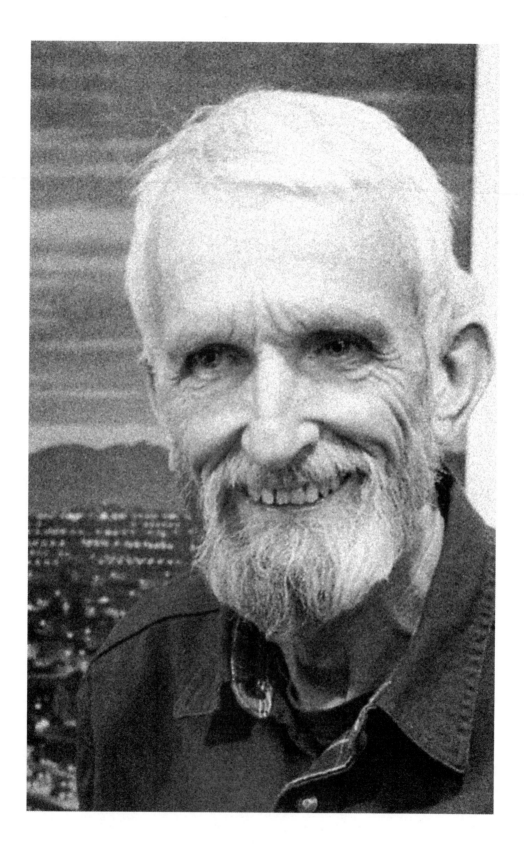

# JAMES DOOLIN
## LOS ANGELES, CALIFORNIA, FEBRUARY 2002

*The day I arrived to meet with Jim Doolin, a construction crew was busy working on the final stages of an extensive remodeling job Doolin and his wife, painter Lauren Richardson, had begun a year earlier. The project was far past its targeted date of completion, but it was one of those mythic warm, sunny days in mid-winter that southern California is famous for and Doolin was in good spirits. As I'd driven out I-10 towards his home, I'd been looking forward to our conversation. I'd met Doolin only a few months earlier, but he felt like an old friend right away. It was one of those rare connections that sometimes happen. I'd first seen his work at the San Jose Museum of Art. Doolin's paintings were beginning to get a lot of attention on the West Coast. He had crossed that line where the art world begins to wake up, as it were.*

*He showed me around and we settled down in his new studio behind his house, the occasional sound of hammers in the background. Immediately I found myself looking at a large, dramatic painting he'd recently finished, quite similar to the painting ["Twilight"] I'd featured on the cover of issue #5.*

James Doolin: It's going to be in an entry hall where you can't get back more than ten feet, so I felt the need to include much more detail. It took me a year and a half to paint it.

Richard Whittaker: Right off hand, I don't see the extra detail, but we don't have the other painting here beside it to compare.

JD: If you look up in here, you'll see there's much more detail. And the whole configuration of the freeways in the foreground has been shifted so that it looks as if you're higher up and looking straighter down.

RW: Yes. Now I can see it. You must have been studying clouds quite a bit for these paintings.

JD: Clouds are one of the most difficult things to paint. If you use photographs they fix your ideas too much, and the photograph you took never fits the painting you're doing. So I've studied cloud formations and what they do. These clouds here [pointing] were not done from photographs at all, although I've had photographs with other configurations of clouds like this kind of *mackerel* sky here. That's a term the weather people use. It's where you get lots of little clouds that form in one big sheet. But this is different in the sense that there's a coastal wind coming in and pushing the

clouds into that curved shape [pointing]—which works well because it echoes the rhythms of the freeway ramps.

RW: Very much so.

JD: So, in a way, I like this painting better. It seems to allow you to get into the picture better. In *Twilight* the clouds are kind of bombastically looming over your head. They tend to block you a little bit. This one is a much calmer painting, in a way.

RW: I've been looking at clouds a lot lately. They're complex, and the way the light plays in the clouds is extremely variable.

JD: Absolutely—because they're translucent, usually. Often light is coming right through them, but there are other places where it doesn't come through at all where they turn so dark and dramatic. The other thing is that they change every second. They're gone, even by the time you get the paint on the brush. So I've spent a lot of time just watching them evolve. I've taken hundreds and hundreds of photographs, thousands probably, and slowly have learned how to make them up.

RW: What's it been like to study the clouds that much?

JD: It's a hard thing to do because, as a painter, I've generally painted things that are still, and the clouds are constantly evolving. It was a long time before I began to understand that I could use those changes to make the skies exactly as I wanted them, and just figure out what the painting needs. I've also found that in the last ten years or so skies have become much more important to me.

RW: Could you say more about that?

JD: I think my favorite landscape painters are the Dutch painters. They often have skies that cover as much as three quarters of the canvas. There's just a small ground level and everything else is just looming sky. That exaggerates the sense of space like nothing else. You don't see it so much on the ground. You see it in the sky going back to a kind of infinity. Constable is another example. His skies were most amazing. So I've looked at Dutch paintings for many years now. They always did what I do. They made them up. You can tell by the way they've done it that they've composed the clouds they needed into the spaces they wanted them to be. There is that incredible painting of

Vermeer's *View of Delft*. It's probably the most beloved landscape painting in the world. I know he made up those clouds. Even if he used optical devices to make his indoor paintings, he certainly didn't have the ability to do that outdoors, so there was a good memory working there.

RW: I'm finding I can't articulate very well something about my own experiences of looking into the clouds. Sometimes it's like going to a place up there in the clouds. It affects my feelings. Does that resonate at all for you?

JD: One of the things that I love the most is being on a plane flying above the clouds, and then coming down into them or maybe just across the top. You start getting holes in the clouds and seeing the ground below, and the scale of that is even more than you think! More than you imagine when you're on the ground. I mean it's not a matter of being ten times larger, but a hundred times larger! And the definiteness of the clouds completely disappears when you're in there. I think one of the hardest things, when you paint, is to make those edges so they're soft enough that they really do seem weightless.

RW: One of the most memorable visual experiences I ever had was coming out of a huge cloudbank over the Rockies at about 35,000 feet. The sun was low on the western horizon. We'd been flying inside cloud cover for probably a hundred miles and we burst out of it suddenly. Luckily I happened to be looking out of the window just at that moment of utter transformation. Layers and layers, looking down, gave you a sense of depth, of how far down the ground was, with the sun's light playing all through this vast cloud-world.

JD: Yes that's wonderful! The spatial experience is really astounding. About fifteen years ago Lauren and I went to Europe to look at art. We took a flight out of Boston in the evening. The sun was coming up about six hours later. We were over France, and it was just light enough that we could see the ground underneath the clouds, which formed pretty much of a cover, but there were holes in it. The feeling of dawn like that, and looking down and seeing those green pastures of the French countryside, seeing one and then another one, and then another one. The grayness and coldness of the clouds, yet the sun was hitting parts of the green land below. Another totally memorable experience!

Another time I was flying across the country in the evening. It was just about when the sun was setting. Rays were hitting the top of the highest clouds. A major thunderstorm was going on below, but you could see these places where the sun's light was being captured, there, there, there, there. You could see fifty miles! You could see them all over. I'll never forget that!

RW: What is it about seeing something like that in nature, what is it that's so meaningful about that?

JD: Well most people on a plane won't even put their magazines down to look out the window. They're bored at the idea, but being a painter, I mean just watching things happen is so important. Just watching everything! The whole way that nature works. Probably I'm more of a landscape painter than anything. Some of the other best times I've had in my life have been hiking in the Sierras and really getting into the backcountry. Climbing mountains. Looking down and seeing a vast wilderness as far as you can see. You never get tired of that kind of thing.

Anyone who has a relationship to that reality out there, I can't imagine how they could not be absolutely rooted. I mean, I don't have any religious convictions. I don't like organized religion, but, looking at nature, that's what my religious experience is. It really is. The three years I spent living in the desert was probably the high point of my life, in a lot of ways. You could really feel, with the sky the way it was, and the sun coming up and the moon going down at the same time. You could feel the planet doing this almost [gestures a turning motion].

Looking out into what people call "barren" landscape is anything but. It's so loaded with geological miracles—incredible geological violence everywhere! I was just stunned.

RW: You spent three years in the desert?

JD: I was teaching at UCLA and getting very sick of it. I had just finished a major painting, the shopping mall.

RW: The Santa Monica one?

JD: Yes. And I was getting restless and didn't know what I was going to do next. I applied for a Guggenheim and an N.E.A. grant, and to my surprise, I got both of them! So I had twenty-seven thousand dollars in my pocket just like that! And my marriage had just broken up.

I had written that I wanted to go to the desert. I'd spent all my time living in California working with the urban landscape, and it was time to get to the desert. They accepted that. I went out there having no idea what I would do, except I'd done some small paintings there on camping trips. I found a cabin in a very remote area, no electricity or water. No telephone. Nothing. It was wonderful, the most perfect thing for a painter who needs time alone a lot.

RW: Where was this?

JD: About 130 miles northeast of Los Angeles in the northern Mojave Desert. There's a range of mountains there called the El Paso Mountains, and there's a big black volcanic mountain there. Behind it were sacred Indian burial grounds; behind that were a whole series of canyons, the main one was called "Last Chance Canyon." I spent three years painting Last Chance Canyon.

RW: And you say it was such a meaningful period for you.

JD: I think I was the most content there, most awed by what I saw.

RW: You're not a religious man, but there's something in your experience in the desert that you associated with religious feeling.

JD: It has to do with nature. There is a clarity in the desert that is really astonishing. Having come from the East Coast where everything is covered with trees and bushes; it's green. To see rock, just plain rock, and plain dirt, and to see it going so far, to see the most incredible configurations of plants that look like scientific inventions; it was a revelation. I always had the idea in my mind that it was a place I should paint for a while. It came just at the right time in my life.

I remember a French philosopher who said, "The desert is God without compassion." It is. It's very cruel. You see death everywhere. Half of the living stuff is dead. It turns gray in the desert. I just became completely happy with all that. And of course, there are all these miracles that happen, too, in the spring when you're just surrounded with millions of wild flowers! Then there's the whole time when all the plants are dormant just waiting through the dry period. There's the time when the rabbits all die, and other times when there are tens of thousands of rabbits, all over. The wildlife in the desert is extremely complex, lots of little animals that live in the ground and lots of flying animals—owls, hawks, eagles, snakes.

When Lauren lived out there with me for a couple of those years, we had a lot of encounters with snakes, deadly snakes. I've always had my fears of snakes, and, at one point, one of my neighbors shot a "Mojave green" (rattlesnake), a very deadly snake, and so we dealt with that. We cut it up, and we cooked it; ate it.

RW: I wonder if you have any thoughts about what it is, when you say, "There is such clarity in the desert" —obviously, the way you say that, it's a very positive thing.

JD: Yes. Really positive!

RW: Why is that? What is it that is so positive about the clarity? It feeds something? Or what is it?

JD: I think one thing it feeds, and has fed all my life, is searching. I'm a searcher. I've searched all my life. I don't know; it's just wanting to confront the great things; great space, to a certain extent, danger—moments in nature when you see things you would never see unless you're out in the wilderness and you're alone. That was why the wilderness trips in the Sierras were so important for me. I used to go with my sons, and it bonded us in ways that couldn't really have happened without that. It bonded Lauren and me too. It's always a situation too, where each day is full of unpredictable things.

I remember one day when Lauren and I got up early. We were camped near the side of a lake. It was very quiet, and the sun wasn't up yet. The lake was absolutely still. There was a peninsula sticking out into the other side of the lake, and, without warning, another camper on the other side began playing a flute, playing beautifully. You can just imagine what that sounded like in that moment coming across that placid lake. You hear about those things and they sound, "Oh yeah, well that's cool." But it made me shiver. So I guess it's looking for that sort of thing, accepting the danger; sleeping on the ground even though there were snakes around sometimes.

One time at sunset, Lauren and I—we both had just those rubber flip-flop sandals on—we were walking around in front of the cabin. I looked around and said, "It's so beautiful. I want to die in a place like this when it comes time." I turned around and right behind me, just where we had walked, was a coiled Mojave Green with his mouth open like this [gestures with his hand]. What I saw, in that moment of surprise and fear, I saw this bright red mouth, open and ready to strike. I saw his green-gray, bright green surface. I really saw a vision, in a sense, because of the exaggeration of my surprise and, probably, total fear. It was one of the most beautiful images I've ever seen. I'll never forget that. I don't think I could ever paint it. It was that astounding.

RW: You could never have planned that.

JD: Never. [laughs] Extraordinary! But that's the way it was out there. There was another night when we were sleeping in the back of my truck and a great horned owl came down with the idea of landing in the back of our truck. At the last minute, it saw us in there and just hovered over us like this! [gesturing] Its wingspread was probably this much! [arms outstretched]

There was just this huge thing hanging above us in the air! And then it flew away. The archetypal images were always out there.

RW: That must have been an amazing experience.

JD: It was. Basically, as a young artist, I always felt that I knew nothing. I was raised as an innocent. My family was very puritan. We came from Vermont, and so I had this need to see the world. The first thing I did way back, before I went to art school, was that I hitchhiked across the United States twice to come to San Francisco. The first summer I came to San Francisco, I couldn't get a job. I went to Yosemite Park and worked there all summer, which was wonderful, and I hitchhiked home; I was eighteen. The second summer I came and knew how to get a job. I was there three months. I worked at a restaurant during the summer and had an amazing time. That was in 1952.

RW: Had the Beat thing started by then?

JD: It hadn't started yet. I saw Dave Brubek at the Black Hawk, an amazing musician. The beat thing started around the mid-fifties.

RW: Everybody read Kerouac's *On the Road*.

JD: After I got out of the army and was working as a commercial artist in New York City, I discovered that book and read it. I felt I'd failed as a hitchhiker, because he'd done it so much more fully. [laughs] It was so powerful, and he had all these contacts with people, but I was pretty much of a loner. There were a lot of strange encounters, but I never had any real danger; mostly good-hearted people stopped for me.

RW: I wanted to get back to something you said earlier. How do you see your sense of yourself as a searcher as related to your work as an artist?

JD: It's almost completely related. I grew up in a family that knew nothing about art; it was something remote that nutty people did. Because of a wonderful fluke with a high school teacher who insisted that I apply for an art scholarship, I applied and got it. It paid my tuition for the first three years. My father was unhappy about it but went along with it. The art school was more of a commercial art school, very high quality, but mostly teaching people how to be part of the capitalist machine. I didn't know any difference then.

I got out of art school just as naive as ever about anything in life, but I had a lot of techniques I could use. I felt that I would graduate and maybe be

able to make magazine covers. That was when Norman Rockwell was still hot. The only job I could get when I graduated was working at a god-awful little place where we designed ads for the Yellow Pages phone book. We'd each do about ten a day. It was just dismal, dismal, dismal. Then I went into the army and worked as a draftsman for a while. I went to New York when I got out of the army and got a job at another ad agency. At this one, we did ads for Vics Vapor-Rub and that sort of thing. I designed packages, did a lot of lettering and things like that. I was just going crazy.

That was about the time I was reading *On The Road*. I quit finally, just couldn't stand it! I thought, I've got to come up with something better. People I'd met there started calling me and asking me to work freelance, so I did that for the next four or five years. I was just going crazy, but I'd begun to meet a lot of serious painters in New York City.

RW: How did that happen?

JD: Partly because of my girlfriend. I began to see what they were doing, and I felt, absolutely, this is the direction I should take! They didn't have any respect for me because I was a commercial artist, and that was a tough thing. Some of them I made friends with, but there was always an element of "You're a great guy, but why do you do that stupid commercial art?"

Eventually I finally decided just to get the hell out and go to Europe where I'd seen a lot of really great art when I was there in the Army, and I did that. I took a ship to Norway. I had enough money for six months. Eventually I went down to Italy and bought myself a Vespa. I went back to France, went through Spain, back to Italy. I went to Greece, and by then it was winter. I went to the island of Rhodes and found a nice little house in a small village and stayed there for nine months and painted. I was living on about $50 a month in that little town.

I really started painting seriously. It wasn't very good, but I felt I had gotten a grip on something. I read a lot. This would be in the early 60's. A woman who was there in the same town and I began living together. Eventually we went to Athens and got married. Then we took a trip to Turkey. I got to see some of the Middle East. Then I took her back to Europe. I wanted to show her all the things I'd seen. It kind of reinforced everything. I looked at the great painting of earlier times, but I was equally influenced by contemporary painting.

We went back to New York. We had two children by then, and I started trying to figure out how to get what I'd learned together. Within six months I had something, my first abstract painting. It was about the landscape of New York City, but it was all flat. The paintings were meant to offend people.

They were angry paintings. They were real colorful. They confronted you. They were often symmetrical. I just wanted to convey my sense of hatred for the kind of places we build for ourselves and what we do to the landscape and the world. The paintings got better and better. I tried, literally, to make them as ugly as I could, but they became more and more beautiful in spite of that.

RW: That's fascinating.

JD: It was amazing. There was such a passion in those things. That was the beginning of one the big lessons. Go for the truth, the way you feel it, and everything will take care of itself. Then it was getting to the point where I could not find a gallery to show that work. Eventually my wife said, let's go to Australia. It's much easier there. We packed all the paintings, got a little Volkswagen van and drove across the country. We went through Mexico and then up to San Francisco and got on a ship to Melbourne. All of these things were an education. All the travels I'd done in Europe. I've met people from every kind of country, from youth hostels and cheap hotels, bars and all that sort of thing. I'd begun to get a feeling for people who had real visions.

I got to Australia, a very middle class situation now, but there were lots of painters around. Within a year I was able to get a show. I showed a lot of my New York paintings, and some that I'd done there. The show was a complete flop. People hated it, except for a handful of artists. About a year later I got another show in Sydney with almost all the same paintings, and it was openly accepted. Sydney was a much more liberal city, but, by that time, I had the idea of going to California and getting more education so I could teach.

I came back and went to UCLA and got my MFA. In that process I made a series of abstract paintings and sent them off to Australia with the idea that it would make a nice show and they would send them back because I would need them for my master's show. They sold every single one before the show opened! The most successful show I've ever had! So I had to make a whole new body of work, and I was already beginning to feel that I'd come up against a wall with modernism. It was too easy to get a way of working and get people used to it, and then just keep churning them out.

RW: Now if I could just remark at this point, that your narrative began in relation to the question of how your art related to yourself as a searcher. So what you've been telling me is really an account of this search.

JD: Right. Yes. I'd gotten to this point with my painting, and I felt it's too

easy. There's more to art than that.

RW: So, see if you'd agree with this. There was a sense of something, not really an articulated sense, maybe something not even possible to articulate, but nevertheless, towards which you were moving. You just knew you hadn't gotten there.

JD: That's right. There was always the sense, "I don't know enough." They gave me a teaching assistantship at UCLA, which was great. I didn't think I'd ever sell work and be able to make a living, although that show in Australia had given me enough money after I graduated to keep me going for year. But I started teaching at UCLA, and I really enjoyed it immensely. The students were real bright. I had to teach a traditional drawing class, which I enjoyed doing. I began to get more and more interested in what I was teaching, and, eventually, I began to go out secretly and do landscapes and things like that, very traditional things.

RW: So what would the year be about this time?

JD: This would be in late 1969.

RW: So you begin following this new interest, which was quite out of step with the current art scene.

JD: Yes. Nobody at UCLA liked my work at that time, so there was that problem, too. I made friends with some other students who were very much into more pictorial art, and, gradually, I got more and more interested in that. The next thing I knew, I found myself out there doing drawings and paintings just as I had done back in the first art school I'd gone to!—except with an entirely different grasp and basis for doing it. Through all the abstract work, I'd learned about structure and color. The abstract paintings gave me pictorial structure that, for me, is maybe still the most important thing. The images are secondary, always. It's kind of like not caring what the tune is when you're listening to the music. It's how the music is put together, like a symphony. I see images in the painting as being sort of the frill on the surface.

RW: Are you saying there is something about form, per se?

JD: Yes.

RW: Can you say anything more about that?

JD: Form includes the structure of the painting, the composition. It includes the use of color and tone. It includes how you orchestrate all that. It doesn't matter what the subject matter is. If it reflects a certain emotional feeling, that's fine, but even that's not as important as the fact that it's a very satisfying thing to look at.

RW: What does it satisfy?

JD: That's hard to put your finger on. Well, people love color for one thing. One of the major things about a painting is that it must have balance. Otherwise, a person's attention is diverted to another painting, or something else. It has to be really balanced. It's got to engage you for some reason. Actually, that's about it.

A person will say they saw a painting sometime ago that they really liked, and you'll ask, "what was it about?" They'll say, "Oh, it was a woman in a red dress." Well, it was the red dress. I don't think she cared a bit about the person who was being portrayed. I keep thinking of Thomas Eakins' paintings, and how he used that device.

RW: So there's something subtle here, because you could have any number of paintings of a woman in a red dress, and they might all be very forgettable.

JD: But if you've got the right colors in the background and you have the red dress in the right place.

RW: The right relationships of everything.

JD: The right relationships. Yes.

RW: If everything, and that's the question, what is "everything"? What does that mean? Isn't it actually very subtle? The colors, the relationships, the forms; if all that really reaches a certain level, then the word *sublime* actually can be used, right? At a certain level.

JD: Right. And that has more to do with the way it's balanced and worked out abstractly. The way the colors are used, the tones are used. That's it.

RW: You'd say there are laws here? Some sort of laws involved?

JD: I wouldn't call them laws, just truth.

RW: Okay, but if it works "just right" that means there's a right and a wrong.

JD: Or there's a good and there's a better. And there's a failure too.

RW: A good and a better, and a failure. Well, that all implies something: principles.

JD: Yes. And the only way I can test it now, because it's become intuitive after so many years, is that it just feels okay.

RW: So one might want to shy away from the word "laws" or "principles." Those terms imply that a certain part of our mind can write them down, so to speak, and we know that's a deadening thing.

JD: That rigidifies your thinking.

RW: On the other hand, you're saying there is something in the feeling. "If it feels right." In a way, there is an intelligence of the feeling that becomes a measure. This is not the same thing as laws you could write down. Does that make sense?

JD: Absolutely. I mean I stand in front of a painting. I look at them a lot when I'm working. Sometimes I'm almost physically looking at the painting like this [moves his face forward and tilts his head making a dramatically exaggerated expression of concentration]—just trying to get this feeling, almost as if I'm steering a giant airplane. Is the balance right? Does that work? Is it flowing in the right way?

RW: You could say that every painting itself constitutes a search.

JD: The great thing about painting is that you don't know what you're going to get. You have an idea, but it never really comes out very much like the original idea. So the painting is really about the process of making it. It's not something where you copy an idea, or illustrate an idea. That was what I learned in my first art school, which was, what are you going to illustrate?

The illustration is just right out the window. It appears, finally, but it tends to make a painting more interesting because it's more complex—in this picture here, for instance. To me, it's an improvement over the other one because of the way there is now harmony between the sky and the ground, and I've got absolute contradiction between the basic color in the sky, that kind of golden yellow, and the basic color below, the violet that's strewn all

across the ground. You've got complimentary colors. But that would be totally dead without the sprinkling of all those yellow lights [car headlights] on the roads. So it's how they resonate together. It's more interesting to me than whether it's a freeway. But, if I didn't have the freeway, I probably wouldn't have the patience to make it so complex.

RW: Yes. And it's clear that to complete that painting, that besides having a great sensibility, you have to—I was going to say, you have to have patience, but I'm not sure that's the right word. You tell me.

JD: That's part of it, discipline and patience.

RW: But also in the process itself, there must be something being given back to you.

JD: When you get something right, it's thrilling. There's just that *ahhh*! And it sometimes comes out much better than you thought, and you're given gifts all the way through. You do things by accident, and it's just right!

RW: Maybe a central meaning of the search—as you say, you went into the desert where you had very powerful experiences, and you wanted to paint. Can you say anything about having those experiences in the desert and how that impulse to paint relates to that? Is that a reasonable connection?

JD: The reason I went to the desert was because I wanted to do interesting paintings. That was the first reason. Before going there I went through a lot of fear, because I thought it would be very hard on me psychologically to be isolated; although about the middle of the second year, Lauren came out and stayed with me. So I did have a lot of time alone. I loved it! I suddenly felt I had peace and a sense of control over my time and what I did. No phones. I'd go to the nearest town once a week and shop. That was my only contact with the outside world. I spent the first two or three months just walking around out there, all through Last Chance Canyon, climbing the little mountains, exploring little canyons. Just making all kinds of incredible discoveries, picking up rocks and taking them back to the cabin. Picking plants, just looking at them, and wondering what I would do next.

I didn't know what to do next. I'd just finished that big aerial view painting and I thought, well, I'll do that maybe. The harder I tried, the more I began to realize that a desert painting without a sky is only half a painting. I had to eliminate that whole idea. Thank goodness! This painting here [from an exhibit catalogue], this was the seminal painting for me from that period in

the desert. That painting is ten feet wide. It's a view from Last Chance Canyon. The green you see there was actually green rock. It's not exaggerated! An astonishing place. You'll see something like that in Death Valley too.

RW: I've spent some time in the desert, and I love it, too.

JD: Like I said, the clarity and the sense of extremes, of order and disorder. It's so different from how we usually live. I think that's one of the great lures.

RW: Would you say it brings one a little closer to essentials?

JD: Oh, absolutely! Literally rock-bottom essentials.

RW: Rather than being negative or despairing, that can have the opposite effect.

JD: I find it a relief because, if there's a danger, you can deal with it out there. Somehow living in the cushioned way we live in the suburbs, even in the city, we're not so aware because we're so overwhelmed with information and stuff going on; we're distracted all of the time. I make it a point to really look at the sky in the evening. We have a good view here, but not like in the desert where I would go and just pour myself a beer and sit outside for an hour watching as it changed from being very light to being very dark.

RW: That reminds me, you used to call your paintings "artificial landscapes." I wanted to ask you to talk a little bit about that.

JD: It involves the word "art." But artificial also means false. Well, art's false too, in a sense. It creates an illusion for you. The illusion might be true, but it's still an illusion. So I saw the landscape, especially when I was living in New York, as being extremely artificial due to the nature of the density of living there. Basically everybody lives in these corridors with buildings rising to outrageous heights and the walls covered with graffiti and other things. Buildings painted idiotic colors, which look kind of wonderful when you see it all together. At first I defined it as any place that has been altered by man. I guess I still pretty much think that. Nature is another thing. We have a way of altering the land like no other species. We're just destroying the planet, actually, with our artificial dreams.

RW: What do you think of when you use that phrase "artificial dreams"?

JD: Dreams about power and safety. Getting more. I think it's true with

every species. They just want more. Plants do, too. They just crowd out other plants. They just take over. That's life, isn't it? People really can't resist wanting more.

RW: That does seem to be a very basic drive.

JD: But I prefer to have less. That's why I like the desert so much. I had so little there, just an old beat-up cabin.

RW: There are these fundamental drives—to satisfy myself, to make sure I'm safe, but is there another drive?

JD: There's another drive—for vision.

RW: That goes in another direction.

JD: It's the opposite. It does seem like less is more, in a lot of ways.

RW: This "more" that it gives one, and I agree with you, what is that?

JD: The feeling of being in connection with the basic things that go on in the universe. That doesn't mean looking through telescopes; it just means looking at the sun falling on a rock. It's so powerful. And it also makes you realize it's such a miracle that you're alive.

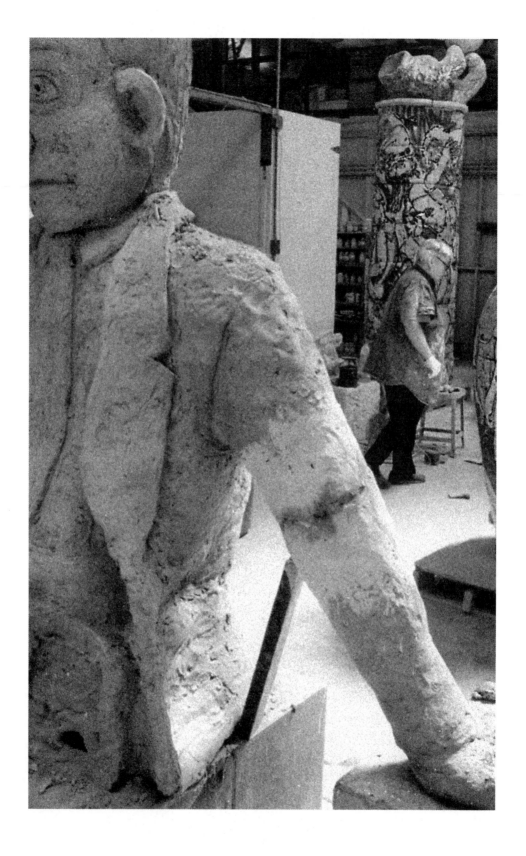

# VIOLA FREY

## OAKLAND, CALIFORNIA, JULY 2000

*I met Viola Frey in her large West Oakland studio. We sat in a section of the studio where she worked out designs for her larger pieces. Several paintings and drawings leaned against walls, and the room opened out upon a much larger space where many of her monumental ceramic figures stood about, some finished and others still being worked on. Besides what was visible from where we sat, there were other rooms full of Frey's works, two entire floors of them. I'd taken my time wandering through these spaces and among a great variety of her large ceramic pieces. There was very little noise in the building, and, after awhile, I found myself in something of an altered state. In a large back room, a collection of seven to nine foot tall figures stood silently. One high wall held fifteen or twenty of Frey's large bas-relief plates, colorful compositions ranging from scenes of whimsical mayhem to visions bordering on nightmares. Walking among this collection of work spanning decades, I began feeling myself in the presence of something one associates with movies about artists, the romantic vision of the great artist. Viola Frey was such an artist.*

*In July of 2000, Frey had already suffered a number of serious health problems including one or two strokes. None of this stopped her from working, however. She was at her studio each morning. Before talking with her, I'd read a number of articles about her work. One of them described some pieces that had found their way to Bellagio's in Las Vegas…*

Richard Whittaker: Last year I was in Las Vegas for the first time in twenty years. I just drove through it.

Viola Frey: It's all fake, all fiberglass. Just all copy. Who makes originals ever? But I would like to see it.

RW: You haven't been there?

VF: No. I have no plans of going there.

RW: I read that there is a piece of yours in the Bellagio collection. Do you like what that writer said in that article?

VF: Yes, because she gives a sense of place in the beginning of the article. I thought that was very good.

RW: A phrase in that article sticks in my memory—"Frey's work gives back what has been taken away."

VF: I wonder what is taken away?

RW: Do you have a sense of what she might have meant?

VF: It's all fiberglass and imitation. Someone has to create the original, so it's all a hollow thing. It has a big vacancy in it.

RW: Did you come from a background that was supportive of the arts?

VF: I came from Lodi, a background where there was none. They didn't even know what art was. They didn't know it was something "you shouldn't be doing." I was able to do anything I wanted.

RW: You're not still teaching, right?

VF: No, thank goodness.

RW: What do you think about teaching art? Can it be taught?

VF: I think technical things, you can teach. I think you teach because the students need something. Otherwise they would just be out there with no direction or anything. So you have some power as a teacher.

RW: What was it that drew you to art?

VF: You have to be an artist to survive. That's one thing I learned. A lot of extraneous things were eliminated because of that. I learned how to concentrate on doing my work.

RW: Why do you say you have to be an artist in order to survive?

VF: I don't know the "why."

RW: What is it about it then?

VF: That's a hard one.

RW: If you were not being an artist, you wouldn't survive. That's what you're saying?

VF: Yes.

RW: There's something crucial there.

VF: Yes.

RW: Has your work evolved in essential ways, or is there something that is the same from very early on?

VF: I think there is something the same from early on. I'm not sure what it is.

RW: Have you reflected at all about that?

VF: Not so much, because there is so much work involved in these things. You just have to be a good worker, and you have to like that. I remember in the sixties I did a lot of work that involved the artist as a worker. [Looks for a catalogue] Here's a double self-portrait. At that time I liked doubles because the eye couldn't be passive. The viewer had to go from one to the other to see why they were similar and why they were not similar.

RW: One writer observes that in the large figures the women often seem to be in positions of reaction while the men, though stiff, tend to have aggressive body language. You must have given thought to all that.

VF: All those things I've thought about a lot. But what I thought about them, who knows?

RW: Why do you use the bright colors?

VF: Because when I originally started, I started in my back yard. It was just a way of creating something against all of the greenery. Everything grows like crazy in Oakland. I just had to do something, and these colors all pop out against the green.

RW: Then the pieces would move into a gallery where they would no longer be in that setting against the green, and here in your studio [no longer in her home] there's no problem like that, but you keep using the bright colors anyway.

VF: Yes. That's just the way it goes.

RW: You like them, I guess?

VF: Sometimes I try—that thing in Bellagio's [Frey goes to retrieve a photo]— you can see that the colors here are very subdued. And this is the kind of article I like, which gives a sense of the difference between the artwork and the environment, the alienation that is part of it.

RW: The alienation in the environment?

VF: Yes. And this environment is Las Vegas.

RW: ...in a way, the essence of alienation.

VF: Absolutely. I think that's perhaps what it's about, what Las Vegas is about.

RW: It's certainly about being distracted, entertained.

VF: Well it's amazing how the entertainment industry has overtaken everything. It's even overtaken the arts, to a great extent. That's the reason for the big installation pieces. I just feel that my art is like installation art while it's here in the studio. So I don't have to go to the effort of doing specific installation pieces. I think a person has just one installation piece and all they do is keep on repeating the same piece over and over again. But that's true of everything.

RW: What's the beginning of a piece for you?

VF: I usually know what I'm going to do. You have to know where you're going to be ending in order to be able to start.

RW: You can visualize the piece before you begin?

VF: You have to. What I do is I start the piece—[we walk out into the working area where a large, unfired piece is in progress] I have to build and fire the legs first.

RW: You visualize the piece, and then, as you're working with the clay, you just keep that image as a guide...?

VF: Well, not until after they're glazed do they finally—it's a long time lag between the start of the piece and the completion.

RW: The figure over there, for instance, with the shoulders hunched, you envisioned that from the start?

VF: To some extent, not completely.

RW: How do you decide, while you're working, whether to make it more hunched or less hunched?

VF: Just the way I feel when I'm working. These two pieces, the yellow one and the red-legged one here are early pieces. Those were done at the time when I had the show at the Whitney; I didn't send these to the Whitney, I kept them.

RW: Are these pieces more current?

VF: These are from the last couple of months.

RW: In your earlier pieces, were your men more tense, in general?

VF: They vary, but they were more tense. These were done in the 80s, and there was a lot of tension in those figures, it's true.

RW: The current figures have less tension. Does that represent some kind of change in yourself, do you think?

VF: It might, who knows?

RW: This is an interesting piece here [a tiled wall piece underway].

VF: This is something for the Julia Morgan building in Sacramento. I also did that piece at the international terminal at the San Francisco airport.

RW: You're not much given to intellectualizing about your work.

VF: Probably not. You can look at the catalogues; they have a lot of stuff in them. I don't want—people can say what they want. I can't really direct it. You put it out there, and all you can do is accept what other people feel and have to say about the work.

RW: Is there a place for what the artist feels and thinks?

VF: Well apparently there is now. There seems to be a lot of interest in it, but, for the artist, it usually comes down to a very simple...[long pause]

RW: ...for the artist, it comes down to a very simple...?

VF: To build it, do it, to understand the skills. I mean the amount of stuff required just to make a piece is just enormous.

RW: The technical aspects...?

VF: ...which I don't like to emphasize, but they are there. These are double walls [pointing to one of her large figures made in sections]. They have walls this thick [holding her hands apart about 8 inches]. They're hollow.

RW: You make these large figures one piece at a time?

VF: They're constructed all together, and then they're sawed apart when they're dry. There are all these little technical things you have to go through in order to be able to arrive at this point [indicates a finished figure].

RW: You have to overcome cracking, for one thing, right? Shrinkage.

VF: The shrinkage with this clay is not too bad because they dry altogether. They're built wet, and then, when they're completely dry, they're cut apart and put into the kiln for the first firing. Then the second firing is the stage they're at now.

RW: When you were in Lodi—is that a farm community?

VF: It was grape vineyards. God knows what it is now.

RW: You just wanted out of that life.

VF: I never wanted to go back.

RW: When did you come to the Bay Area?

VF: 1955, I think.

RW: Now you taught at CCAC for a long time. Many students attend and maybe they have dreams of becoming famous artists. Of course, very few…

VF: …ever have the internal fortitude to do it. They just stop. It's such a difficult area to go into, and times always change.

RW: Was this a topic you addressed in your classes?

VF: Absolutely. I also told them that anyone could be an artist, but whether they wanted to be an artist, that was the real question. The need to be an artist, which was always primary. And some people just don't need to be artists. That's the real question students have to ask themselves. Whether they really want to do it or not, and most of them don't.
    There was an equation I learned. For every two years you spent doing artwork, you could afford one year off. But the majority of your time had to be spent doing artwork.

RW: There can be a lot of discouragement involved. Maybe a certain kind of work can't be done until one reaches certain levels of discouragement.

VF: You have to reach a plateau. I remember in the 60s I was very much aware I was reaching a plateau, and I had to pause to gear up for another reach.

RW: Did you stop, or what happened?

VF: No, I always kept working, but there was a plateau. That's why my backyard was so important, because there I was able to see the work. Here, since I've bought this building, I don't have the same sense.

But in my backyard, it had to be vertical because, if it went horizontal, I didn't have enough space for the work to exist in. Storage was always a problem.

RW: In the process of working, do you have special moments of feeling? How is it for you, an even-keel sort of thing or…?

VF: Well, it's a very long process. It's gotten much more even, but there were a lot of ups and downs.

RW: Do you have a point at which you feel satisfied with the process?

VF: Well, the process—I don't think it takes over, but there's a point at which the work just has to stand on its own. An artist can't always dictate what the piece is going to be like. You can try, but that's about it.

RW: Agnes Martin, the painter, talks a lot about how the artist struggles in the process of making art, often failing. But then sometimes, almost miraculously it seems, something is reached or achieved, and she calls that a "moment of perfection."

VF: I can see that.

RW: And she says, you can't hold on to such moments.

VF: Well right now, these big vases, they're perfect, but they can't stay that way because they're not fired yet. I like them right now, the way they look. [Frey walks off, and I follow around the studio.]

RW: Now these are drawings. Do you draw sometimes before you do your sculpture?

VF: Not before, just during. I like drawings because drawings are really direct; they reveal the subject matter much more clearly than something that takes a year to make.

RW: [standing before one of Frey's eight foot high vases with colorful glazes and figures painted on the surface] Why the vases? Do you like those ancient Greek amphoras with the painted figures?

VF: They're very handsome, yes. I used to be much more interested in them. This one is actually a model of the Roman vase that Wedgwood copied, and so these are all take-offs on that form. What I liked about Wedgwood was that he was a very enlightened employer. He had this huge factory where he was the artist in charge, and he had good labor policies. He had good health and safety procedures, and the workers liked working there. This is in 18th century England. The Portland vase was a copy. Originally it was in glass.

I did another piece based on Wedgwood, a group of ten or twelve figures, which ranged from Wedgwood to a man holding a gun. The way Wedgwood started out was as an individual artist, and then it became a committee—decisions made by a committee—then it became a company. Ultimately it became a big conglomerate, and now you could blow Wedgwood up and no one would even notice.

RW: How did the gun come in?

VF: That's because I was held up with a gun near where I live, and those things sort of stick in the mind. So I incorporated the gun imagery into the work. I did about ten or twelve bronzes. I've never done them in clay.

RW: Did you start early on making these very large figures?

VF: No, they just grew larger, and now they're getting a little smaller because you realize that when they get that large you can't really see them.

The slip-cast pieces, which is another group of work I do—it's just interesting how molds over hundreds of years remain in the culture. You can't push them out. I spent three or four years at the manufacturer De Sevres in Paris, which is the original place where they make slip-cast pieces. I must say that whole factory exists and is just kept going, I think, for the workers. It was an interesting place to be.

RW: When were you there?

VF: A few years ago. Once I was there for three months and other times for one or two months.

RW: Do you speak French?

VF: No. But when you encounter people who are working, it doesn't matter.

RW: Did you notice any interesting differences between France and here in relation to art?

VF: Well I just got the feeling in Paris that everything was not as avant-garde as they think it might be.

RW: Is that an interesting question, what is, or isn't, avant-garde?

VF: I don't think it's a very interesting question, because things are only avant-garde in terms of the time you're in.

RW: What makes art good or bad?

VF: All I know is this one thing from Salvador Dali, who's an artist other artists don't even like to mention. It's a quote, but I can't quite remember it…

RW: Maybe you could just give the idea of it.

VF: Well, it's that good art only comes from bad taste—which, when you think about it, is true. When you try to make art based on the best examples around, nothing ever happens. But if you do it from things that are considered bad taste, then you have a chance to create something.

RW: That makes me think of just looking for something which is your own, not trying to copy what one thinks is the desirable "thing to do."

VF: And if you do it based on what is stylish, or is acceptably good, then you have nowhere to take it.

RW: I can't say I'm satisfied with what has been written about you and your work.

VF: Well, there's always that.

RW: But I understand you like the way the term "bricolage" has been applied to your work.

VF: Bricolage. It's a fine word. "Bricoleur" is used a lot in France. It means "handyman," so that's why I had to change it to the feminine form, "bricoleuse." It's putting stuff together and is connected with Structuralist stuff from the 70s.

RW: Part of what I understand in how the term has been used in relation to your work, and I'm not a student of Levi-Strauss, is that by working with figurines you've found, say at flea markets…

VF: …The leftovers.

RW: Yes. That by including them as parts of larger pieces, you bring in the meanings embedded in these figures, the cultural aura, so to speak. So, it's not just working with figures, it's working with meanings, in a way.

VF: Sure.

RW: I was talking with an artist who makes figures. She said that in some cases she experienced a direct physical effect in her own body when making her figures. Does that make sense to you?

VF: Yes, but in my case it's much more general. It used to be very specific, but it's gotten much broader, more of a worldwide view.

RW: That makes me think of the piece out there you're at work on with the man and the world.

VF: The man kicking the world.

RW: The man is kicking the world?

VF: That's right.

RW: Does the man know he's kicking the world?

VF: That's the big question.

RW: One runs into the phrase, "making a mark." That's a big thing.

VF: Well, it is. You have the first thumbprint when you work with clay. That's very important, making a mark, and making your own mark.

RW: It occurs to me that there's even more to it than making a mark.

VF: Well sure. That's just the beginning.

RW: It seems to me that the phrase has become like a slogan. People say it, but they may not know what they're talking about.

VF: They may not.

RW: Beyond just making a mark, there's actually building something, making something.

VF: Making something as a physical manifestation. Yes. I think that's very important.

RW: When you speak of finding out that it was necessary to make art to survive, isn't it in the making of that work that something gets fed?

VF: I think so.

RW: A term we don't use much, the soul, perhaps.

VF: That's always part of it.

RW: You come down here to your studio around 9 in the morning and work until?

VF: ...until 3 or 4.

RW: Are there other things you do, say, to amuse yourself?

VF: It pretty much comes down to just doing artwork.

RW: You're a woman of few words.

VF: Probably.

RW: Some say artists don't need to talk because language isn't their form, it's the artwork.

VF: It is. That's true.

RW: Although some artists talk quite a lot.

VF: But usually, the ones who don't talk much, they're much more successful.

RW: On the other hand, there are very successful artists whose work doesn't seem to be all that much, and who have made it on the basis of their abilities to talk.

VF: That's true. There are artists like that. Well, I'm not one of those.

RW: I wonder if you might have any advice for people wanting to become artists.

VF: The first thing is to get a place to work, a studio of your own. The second problem is to be aware of the art community that you're in. That's about it.

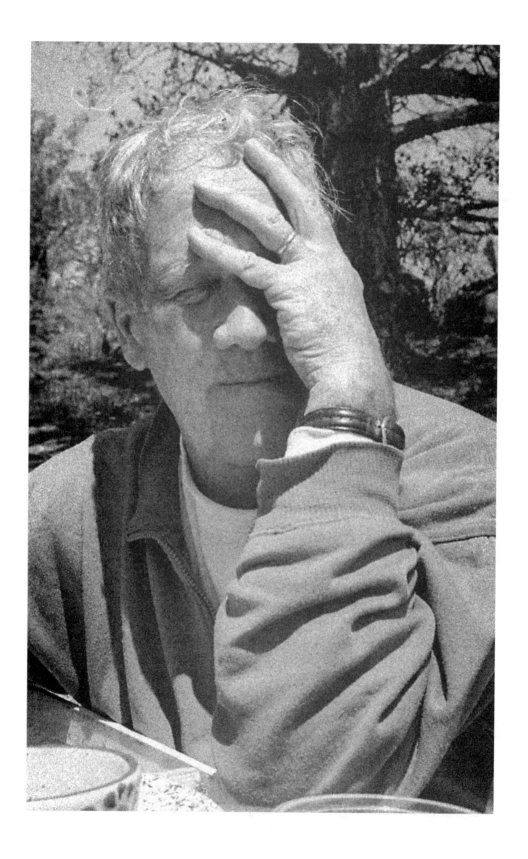

# JAMES HUBBELL
## SANTA YSABEL, CALIFORNIA, APRIL 2002

*When I arrived at the compound of eight unique buildings that comprise the home and studio workshops of James Hubbell, I was given a walking tour. Besides well-equipped workspaces with all kinds of tools for working in wood, stone, concrete, glass and metal, there was a large diesel-fired ceramics kiln and a foundry furnace for casting metal. Hubbell favors a teacher-apprentice relationship with each person who makes up the group that works with him on his projects. A comfortable atmosphere prevailed in which Hubbell was never too far away to be reached for a moment of advice or clarification. By the time we sat down and I pulled out my tape recorder, I was feeling relaxed, too. Our conversation had already covered a lot of ground.*

Richard Whittaker: I'd like to go back to something you said about the need people seem to have to be told what to think.

James Hubbell: Well, the *Bible* has this saying, "In the beginning was the Word." We interpret that to mean, "the written word." I think that historically in the arts, but probably in a lot of other fields, unless we write it down, it doesn't exist. All of the periods in art history, down to the present, have always had somebody, a philosopher or writer, who was the voice of the artist, and who put it in words. I'm not sure if people really know how to look at things without first being told how to look at them.

There are a lot of interesting things. Because we did this park in China last year, I spent a lot of time reading about China. With the Chinese, because they use a scroll, the painting has to be rolled out. You don't see the painting all at once. With us, the painting is in a frame. It's there all at once, and I think we tend to see time as if it's framed. But the Chinese see time as if it's continuous. They talk about life as being a river. Basically China is built around the Yangtze and the Yellow River. The culture developed in relation to those rivers, and so the river was very important to them.

If the Mongols came and took over China for two hundred years, to the Chinese that was just a stone in the river. It changed the patterns in the river, but it didn't change the river. It's so interesting the way you can look at things from different angles. They become different things.

RW: In the PBS program I saw about your work, you mentioned that you'd had an important experience in Notre Dame looking at the light that fell on a column coming through the stained glass windows.

JH: The reason I got interested in windows was probably because of that. I was on my way back from Africa. It was really the light falling on the columns. It wasn't the windows; it was the light that got me interested. The thing about all the different arts—the thing is, it could go into talking about art; it could go into philosophy…

RW: That's okay, wherever it goes.

JH: I do a lot of painting. I started that way. You do a small painting. It's like you're making a keyhole into another world. If you take that same painting and enlarge it so that it's six feet, you confront it as if it's another person. It's completely different. It can't be a keyhole anymore. Now it has your scale.

If I do a horse that's five inches tall—you can see this in some of Henry Moore's things—some of his small things feel like they're 20 feet high, but when he blows them up, they don't always seem that way. If I do that same horse and blow it up to three feet, it begins to read like a dog. Do you know?

RW: I follow you.

JH: You approach sculpture as if it were something like you are. It casts a shadow, and light changes on it. So you approach it very differently than how you approach a painting.

What's interesting about windows is that the window has, in some ways, both qualities. It also has qualities that neither of them has. With the window, you're working only on a plane, say with the lead lines. You use certain colors like a red, which will come toward you, certain ones will go away from you; some glass is transparent, other glass is opaque or translucent, so that moves into the three dimensional. Also the light will come down and fall on you, which the painting doesn't do and the sculpture doesn't do. The light from the window, coming down, has that quality like music does of wrapping itself around you, which is very interesting.

RW: When you were looking at the light in Notre Dame as it fell on the columns, what was it about that experience that made such an impact?

JH: I don't think anybody has asked me that. Possibly it was—one of the things I'm really interested in is mystery. I don't know if all scientists would agree with me, but I think science is basically the search for Truth. And art is the making of mystery, a celebration of the unknown. I think the way the light hit the column, the column was no longer a column. It was still holding the building up, but it was no longer a column.

RW: What was it?

JH: It was diffused into shadow and light. You've got this column, but the light hits it and transforms it into something that is alive, and kind of moving.

RW: Oh, yes. When the quality of light is a certain way, it almost doesn't matter what the objects are that it falls on.

JH: In one of your articles [issue #2, James Turrell interview], I thought it was very interesting, what he had to say. I also think that the shadow is of equal importance. One of the things that got me thinking about the shadow is that I used to make paintings with a lot of light in them, a little bit like Turner. I remember one time looking at some of the prints of Goya's and thinking you could take all the line away and just take the blacks, the shadows, and it would be beautiful. Usually things happen because of something going on inside you. I think I decided I needed to use black in paintings.

RW: What do you think happened?

JH: I think art leads you, tells you where to go. I don't think your mind leads you. Well, a number of years ago a very good friend of mine and I were really into this beauty thing: what does it mean? Why did Dostoyevsky talk about beauty? Why did he say you could save the world with beauty? The way I try to explain it now, and it's just a fringe of an explanation, is that being human is having both pathos—you know about death, about suffering, you know all of that, and you can't get away from it—but the other side of being human is joy. You have friends, you can touch things and, in the long run, you're related to the universe. There's a great joy in that, and beauty is somehow the line, the edge between the two—the edge between the shadow and the light, and both of them become richer when they're both there.

RW: You said a few minutes ago that science is interested in truth and art is interested in mystery. And of course, you might think that some scientists have a sense of mystery too, although science generally tends to erase mystery.

JH: I think you're right. Like any definition, there's always the exception. In physics and astronomy, certainly a lot of things they're discovering are really metaphysics. But still those guys are trying *to explain* the metaphysics.

If I do a painting that's any good, I create a mystery. Just like if you had been able to invent a tree. In a sense, you can't explain the tree. Every person and every culture can come to the tree, and it's a new thing. It's an endless story.

RW: A friend, as a child, had a deep ambition to become a scientist. He felt that the study of science was a way of approaching the wonder of things. But unfortunately, before he had gotten very far into graduate school, it became clear to him that he could not hold on to his feeling for wonder and still complete the required training. He didn't continue.

JH: See, I don't think that is science's fault. I think that is education's fault. My guess is that the same thing could be true for someone studying architecture, or studying art—or even literature. By the time you get through, you're so steeped in analysis and logic that there is nothing left to wonder at. Our culture is not happy with mystery.

RW: It's a culture that values answers, isn't it?

JH: I think we're paranoid. [laughs]

RW: Say more.

JH: I think we're terrified of anything that might be open-ended, and which we can't control.

RW: Yes. Truthfully, I have to admit that there is a constant automatic tendency to try to get things under control, to get a grip on things, to pin them down even though, in another part, I don't agree with this attitude.

JH: Well, there's a huge force pushing you. You know when 9/11 happened you would hear people say they felt vulnerable. But nobody ever said—at least I never heard this—nobody said that vulnerability is a huge gift.
  I've known a couple of people in my life who seemed to have no fear. They were vulnerable to everything, and they seemed to be able to change things without even trying. I think that feeling of openness, where things actually begin to move in different directions, as a culture, we're completely closed to that; we just close that completely off.

RW: Our popular heroes, the muscular, powerful people are the opposite of being vulnerable. Krishnamurti described how the new growth of green leaves was how we needed to be, completely tender and open in order to be able to receive something. As you say, we don't understand that at all, it seems.

JH: Our education doesn't encourage it.

RW: You have some interest in education.

JH: Probably because I did so poorly. [laughs] I went through a really good school with some wonderful teachers, but I got terrible grades. At one point I think I told myself, this isn't my problem, this is my teacher's problem.

Now I love to get jobs I don't think I can do. They're the only ones that are really interesting. If you know you can do it, why do it? Let somebody else do it.

RW: You told me that you went to Cranbrook.

JH: I went two years. I couldn't have gone the whole way. I couldn't pass a lot of classes because I couldn't spell. And I married a schoolteacher. They didn't tell me that you didn't have to spell; you could just marry a schoolteacher!

RW: Another creative response. How did you get into Cranbrook?

JH: I was in Korea, so I applied from the military. I couldn't get into the painting department, so I had to take sculpture.

RW: Something else you said in that PBS video—that, in your priorities, being a human being came first. What does being a human being mean to you?

JH: I've got a whole bunch of papers I've written I'll have to give you. There is one I wrote quite a long time ago about architecture and what I thought was missing: "The Architecture of Jubilation."

When somebody asks you to build a building, you go through this checklist. Permits. How much money? Elevations—all of this stuff. But you don't ask a lot of questions like what about the history of the site? The myths? What does the owner read? What does the light feel like? Questions which are more interior, but which are real and are important. When we describe the human being, you have to include those kinds of things.

When you talk about educating kids, you can't just talk about the mind. You have to talk about how the kids relate to the earth. How they feel within themselves. It's seeing that infinite potential that we basically are. We have millions of years of evolution in us, all this information, but we don't use it. We don't trust it. You know the golden mean? Well, if I'm doing a column, I could take that golden mean in maybe twenty or thirty directions. I think we all know those things in ourselves.

I think a lot of what I'm trying to do when I work with kids is not only trying to get them to trust themselves, and their neighbor, but that the universe is theirs and they are part of it. They can trust it.

RW: That would certainly include trusting what they see with their own eyes.

JH: Oh, absolutely! But also realizing that their eyes are only one way of seeing things.

RW: What are some of the other ways?

JH: When I make a model, working in clay, I will find that my hands do things that I don't know they are doing. Then I look at it, and I know it's right. I think my hands do think for themselves.

RW: There's an intelligence of the body.

JH: Yes. And the body really doesn't end here.

RW: Would you agree that there is an intelligence of feeling?

JH: Yes.

RW: And our culture doesn't recognize that either. One of the pervasive influences of science today is that authority has become vested solely in the mental faculty. That's a big constriction.

JH: I don't know if anybody would agree with me, but I think the Renaissance is where it began. Leonardo is, for me, part of that. Anybody who could paint as beautifully as he did, and yet turn around and make machines that would hack people apart really, in his mind, had separated these things. What our culture has been really good at—and it's really the reason we've developed the way we have—is separating things. So you would see things not as a whole anymore, but as parts. It's probably reached the point now where that doesn't work anymore.

   When I went to high school, we had this machine you'd crank and it had the planets turning. The universe was explained mechanically. Now the astronomers talk about the universe as a mind.

RW: I wonder what someone means when they use that word. I suspect a lot of people would tend to extrapolate from what's in here [pointing to my head] just...

JH: ...clicking away.

RW: A poor idea of what mind might be, wouldn't you agree?

JH: I would agree. There are several reasons I've been doing these parks around the Pacific. One of them is that I think a new culture is beginning. With Atlantic culture, mostly European and Harvard and so on, the world was understood in definitions—if you could write it down, it existed. But I think what we're coming into now is so complex and so interwoven that you can only understand things as facets. There's the William Blake quote, "to see the whole world in a grain of sand"—is that it? It's seeing, in small things, a much larger whole. I think we're trying to put the world back into a whole piece and trying to be part of it.

RW: When you say, "we're trying," who is that "we"?

JH: Holistic medicine is an example where the heart is not a carburetor any longer. But I think, in general, it's the public, just people. I think where it's harder, is for educated people. [laughs] Because they're educated, you know? But I think most people want that wholeness. That's really what they'd like to have.

RW: Last night I was staying at a motel and watching the news. Leading off was a big thing about the pedophilia problems with Roman Catholic priests. Then cut to the Middle East—"a fire in the church in Bethlehem. Palestinians holed up inside." It all started to get to me, but, judging from the way it was all being presented, it was all just exciting stuff, entertainment. So incongruous. How does the average person defend him or herself from the world I'm describing?

JH: I don't know. We're working with these high school kids. The week before last we went out to this site, which is absolutely beautiful. We told them about the site and had them write some poetry. We had a whole lot of volunteers. One of them is kind of a hippie friend of mine. He wound up doing Tai Chi with the kids, and having them do breathing. We were unsure about that because there were some people from the board—very straight, you know. But more than half of the kids wrote about how much the breathing meant to them! Just a chance to stop! They felt so tense! I have no idea how our kids can live with what we're doing to them. I just don't know how they deal with it.

RW: I don't either, and, I must say, it distresses me.

JH: I go through optimistic and pessimistic things. But if you look at history, history never goes in a straight line, just never does. You absolutely knew that when people got really excited about dieting, that sooner or later they would go

back to chocolate. [laughs] You absolutely knew that when you had Communism that sooner or later you'd get some of the grandkids who'd say, "I don't remember the revolution! What was that?" You know? The human being is amazing. I think that we'll muddle our way through to some other period.

RW: You're making me feel better already.

JH: I tell kids, "Well, we're living in the time of the compost pile. Almost everything is rotten, but the compost is where the good things grow." Now what you're doing with the magazine is really the right thing. What you want to do is to go look for green shoots, look for the new stuff, because it's all there.

RW: I think that metaphor applies to you, to the point of view you have; what you've made here; what you're doing. You constitute one of those green shoots. I think it's interesting that from a mainstream point of view, you're existing and working somewhere on the fringes. I know you're very successful, but you certainly haven't shown up at the Whitney.

JH: I don't even exist in that world! Thirty-five years ago I had a black and white photo of a sculpture in *Crafts Magazine*. That was the last time. I've had quite a bit of stuff about architecture and some about windows, but generally, it's "fringe" architecture, not mainstream. And often, when I'm asked to talk, it's the students who are asking me. Not always, but often. For the art world, I don't exist.

RW: The problems of the art world have to do with the problems of our culture. It's not separate. That means understanding the art object via some acceptable methodology: art history, art theory. I'm not even getting into the role of money here. All this stuff about "being human" isn't something that concerns science, and the art world is really sort of an abstraction. Therefore what you're doing isn't going to be picked up.

JH: It doesn't fit either. My problem, more particularly, is that when I went to Whitney Art School in Connecticut I had this great teacher. In about a six-month time, he gave you the whole world. We went through every style, every method. When I got through, I realized I could do whatever I wanted. That's very confusing to the art world.

   This teacher also said, "If you want to be famous, find something that is easy to recognize. Every time you paint a picture, put red dots around it. That way anyone can walk in and from the other side of the gallery can say, 'oh that's a so and so'."

RW: Who was this teacher?

JH: Lou York. I think he taught at Yale for a long time. He was just a really great teacher.

RW: You mentioned someone else who made a big difference in your life.

JH: Sim Bruce Richards. He'd worked with Frank Lloyd Wright in the 30s. When I was about 21, I did my first job with him on one of his homes. Over the next 25 years I probably did something in every one of his buildings: windows, doors, columns, pools.

RW: You said it was unusual for an architect to hire an artist.

JH: Yes. I don't know why. I think architects think that artists are just another problem. They bring in stuff that isn't standard. In Berkeley, I think, the architecture department is in the science department. It's not in the humanities where it should be.

RW: People don't know how to categorize you, I suppose. I first heard of you as "an architect."

JH: I'm not even an architect.

RW: But you've been involved in the building of some buildings and you've designed them.

JH: Yes.

RW: So I wonder if you'd talk a little about the buildings that are being built today, and the relationship between the buildings that are being built and human beings.

JH: I think that, more than we realize, that what we do as a culture reflects what we think. You look at a glass building, which the architect will tell you he does because it's cheap to do—which it probably is—but it also has these qualities: it's very fragile, it's kind of narcissistic, because you can see yourself in it, and it's elusive. These are all qualities that reflect how we either feel about the way we are, or the way we think about the universe.

If you think about the flat surfaces of buildings—so many look like they've been rolled on with a roller or something—there's no shadow in

these surfaces. That probably says we're uncertain about mystery. In the gothic buildings, half of the surfaces were shadows. Half of the building had to do with mystery. So I think that the architect really reflects the culture in what he does.

When we had these kids here in San Diego doing this park [one of three collaborate park projects Hubbell has done in recent years], one evening we were sitting around after dinner and talking. The Russian kids wanted to know, "How come the Americans smile so much?" This subject went on for over half an hour! Finally the conclusion I came to, you know, was that cultures have different ways of doing things.

The artists' role is to do what is honest for them. So if you're in New York and everyone is looking at the floor, you can look up. It's not your role just to be a mirror of what's happening. I don't believe in the word creativity or originality. I think they're nonsense words.

RW: Say more about that.

JH: To me, creativity means to be *honest*, to do what's your own thing. If you do that, there's nobody who can compete with you. Nobody can do what you do. We put it in this realm where this guy is better than that guy, but it's not like sports. That has nothing to do with it! I don't know if that answers your question about architecture.

RW: I was thinking about something you'd said in the PBS video about buildings in our cities: that if the scale is not human and the building is impersonal, then the response would be to turn away, to withdraw. There was that poignant clip showing that man on the street, and how he just withdrew. You could see so clearly in his body language.

JH: Yes, I think that is really true. I think the artist really can bring the human quality into places that are very impersonal. That's possible.

RW: I've heard people talk about scale, and, like so many things, it was just talk. But now I feel I'm beginning to have a little understanding of scale, and so I wondered if you wanted to talk about how your own understanding of scale has evolved.

JH: In some ways, scale is the hardest of all of the qualities for people to get. It's not only scale, but also the three dimensions. If you notice with poetry, music and math, the people who do it are often like teenagers. With painters, their best things are usually in the middle of their lives. Not always.

But with architects and sculptors, the best things are often done at the end of their lives. Michelangelo is a huge example. In the academy in Florence, the *David* is there, but also about six or eight sculptures; they're called "unfinished." They're great masses of marble, which are partly carved out, but you walk around these things and it's remarkable. From one angle, the figure will twist. Go around a little bit farther, it pulls down. Go a little more, it opens up. You can't anticipate what it's going to do from one side to the other. With the *David* you know what's happening on the other side. So I think there is something about that quality. It's scale, but it's also something about the three dimensions. It's not that easy to get to a point where you can do that. I have no idea how he did that. [laughs]

RW: A basic question about human scale, or proportion, would be, what fits? In other words, it's not just about what I can conceive of, but how far can I walk? What do I feel when I'm in a particular place? Our technology has made much about this question seem irrelevant.

JH: Yes, but *it is relevant,* and it is necessary. Because of the hydraulic pump and because of the car, we can basically build anywhere. LA's done it. But because you can do that, you take on the responsibility of making choices. If you can keep people alive forever, then you're going to have to decide who's going to die. We don't seem to want to take the responsibility for the things we are taking away from nature. We're continually trying to take nature's roles away and make them our roles, or the mind's roles.

RW: I don't meet many people who are able to find a path that's really their own, and I think you are such a person. It's hard to do. How can someone do it?

JH: Oh, it's tough, and you can't judge artists by who they are.

RW: Say more about that.

JH: Well, too many times a person does wonderful art but is just an awful person! One of the things about being an artist is that you really have to believe in yourself. You know, when Matisse or Botticelli drew, often the proportions were wrong, but they put the line down like God made it! Do you know? And that's right. It's that belief that allows you to do that. Children do that. That's why they do good things, because they don't know that they can't do it. Often that belief becomes egotistical. It comes out sometimes in sort of an unpleasant way.

RW: Well, that's a generous thing you're saying.

JH: I don't think it's just generous. If the work is good, you don't want to throw it away because the person isn't good. It's awfully hard to do both things.

RW: When you reflect on your own life—you weren't exactly a person who fit in with the system, you had trouble in school, and yet here you are. I'd guess you're in your sixties...

JH: ...Seventy

RW: And you've made a life following a path of your own. How have you managed?

JH: Oh, I'm just really lucky. I don't know. I'm very organized, probably too organized. [laughs] We do a huge amount of work. I have a lot of friends, and I work a lot for clients over and over and over again—sometimes for twenty years. I'm just lucky. I happened to marry a good lady. I have great kids.

RW: You have some faith in something in yourself. Is that fair to say?

JH: I hope so. I find it terribly exciting being alive. I'm really glad to be alive at this time, even though I feel like a complete misfit. I would have worked in the Romantic period, or the Symbolist period or some other period, but I just don't fit. Yet it is terribly interesting living in a time when everything is falling apart. You know, the cathedral falls, but, for the artist, with all those blocks you can build another cathedral.
   Maybe what allows me to do it the most is that I really think people can change things. I don't think we're at all stuck in some kind of machine where we can't make a difference. You know, in history it's just dinky little things, and all of history turns! You don't know what they are.

RW: It reminds me of the statement Margaret Mead made when asked if she thought she and a few others would be able to make a change in the world. Her reply was something like, "what other way does it happen?"

JH: I think that's why the artist is absolutely critical to the culture. In evolution, things change physically, but in man, basically, things change emotionally first. Things go wrong, you have plagues, atomic bombs, all of these things, and the artist is really this raw nerve out there in the culture wobbling around, suffering. They're really trying to make sense of it, not for the world, but for themselves.

I think it's almost that we need, first of all, to find the pattern that this new world exists in before we can tap it intellectually. It's a sense that the music comes before the idea, do you know?

RW: You'd said something earlier before we were recording, that the present was from yesterday, that what is really here today was… I can't quite bring back what you were saying. Do you recall?

JH: I think most of the culture is living with past patterns and the forms we've been taught. It's really very difficult to actually see what's happening around oneself in this present time. There's a book called *Lives of the Cell*. Remember that?

RW: Lewis Thomas. Yes.

JH: Do you remember the article about sound? There are millions of sounds around us that we're not aware of. He winds up talking about Mahler and talks about the music of the spheres. You kind of wonder if we're not like metal filings that vibrate differently when the music changes in different periods of time.

That may be a little far out, but I do think that history is like music that changes, and this change is like an open door. Sometimes scientists see it, sometimes philosophers, sometimes artists, sometimes musicians, but it's opened. It has to do with a different rhythm. It doesn't have to do with somebody saying something different.

RW: You know, there are people writing books about "the end of science," "the end of history," "the end of philosophy," "the end of painting" etc.

JH: You remember when they said you couldn't paint a figure anymore? The figure was out. It's ridiculous.

RW: With the amount of money and expertise that goes into surfaces today, I think people are accustomed to having pictorial surfaces deliver, boom! Painting is up against that.

JH: I agree, but I'm not sure that's going to be forever. I remember being in the Tate in London when the Falklands War was going on. Everyone was talking about it. I remember standing in front of this little drawing by Constable of a wave. It was so beautiful. I thought why in the world would anybody be interested in a war when they could look at a line like that!

I think—and I really believe this—that it's possible to draw a line that changes the world. In a sense it's that simple, but how do you draw that line?

RW: Well, to speak on a smaller scale—the front door to my house is arched—I've noticed when I look down the sidewalk at a front door to a house, that seeing a curved door really creates a different feeling than the usual rectangular shape. It's a subtle effect, but it's a real one.

JH: Oh, absolutely! I think that's true. One of the things that fascinates me— take the park in Vladivostok. The place in which we were building it was very masculine, towers and electric things. When the head of the architecture school wanted to show us Vladivostok, he took us to a lot of bunkers. The bunker was their gift to architecture.

A lot because of the students, the Russian kids, we wound up doing this thing that is so feminine it's almost embarrassing [laughs]. What happens when you take something with this shape and put it in the middle of all these masculine shapes? Well, a lot of weddings take place there now.

When you go to Tijuana and build a school that the people of La Jolla would be jealous of because it's so beautiful, for kids who have dirt floors, what does it do to those kids? What happens? The thinking no longer can go in the same line.

RW: When was the school done in Tijuana?

JH: It's still going on. Volunteers are working on it with me. We began about 12 years ago and it's been used almost from the beginning, but they've run out of money. I don't know when it will be finished. There are about 150 kids there all the time.

One of the interesting things is that the lady who runs it got a grant to bring two Russian ballet dancers over from the Kirov ballet. They've been there for over two years teaching these little kids. Teaching the Russian structural ballet dancing. It's amazing! The kids will never be the same.

RW: How did you happen to get involved in this project?

JH: Christine was looking for someone who was interested in beauty. And I was really interested in Mexico. I always thought Tijuana and San Diego were the same city, or at least, two parts of the same city. It was a chance to kind of get dirty and find out what I was talking about.

RW: I gather it's been a fruitful experience.

JH: Yes, but it's been very difficult, too. San Diego's not only about being on the Pacific, but it has this fascinating thing of having Mexico right next to us. Even though in Tijuana you get people who are very poor, they tend to have the feeling that their world is coming. And on this side of the border, even though we have mowed lawns, we get the sense that we're at the end of our time.

So what happens when you get both of these cultures together, a wave going up, and a wave going down? How do they affect each other? What kind of culture develops here?

# ENRIQUE MARTINEZ CELAYA
## LOS ANGELES, CALIFORNIA, MAY 2003

*Martínez Celaya's credentials are unusual. On the very brink of taking his doctorate in quantum electronics at the University of California at Berkeley, he switched directions and turned toward a career as an artist. But he'd already had a long relationship with artmaking, too. As a boy of eleven, Martínez Celaya had apprenticed to an academic painter in Puerto Rico. From his high school years, he pursued art and science side by side. Science promised to set the world in order while art provided a place to wrestle with all that resisted order.*

*As Martínez Celaya writes in his ongoing autobiographical book,* Guide, *"To make an artwork requires measurable things like discipline, ideas and some skill, but also requires other things that come from the inside as well as from mid-air." He adds also that "some things are not signs to be decoded by a specific culture," and that "basic human emotions and desires, and things like trees, animals, landscapes, the sun, the moon, and so on, will still matter and will still define human experience."*

*Carl Jung writes that we are, each of us, embedded in nature. The statement seems self-evident, but to what extent is it possible to feel this truth today? An investigation into this hidden realm is an essential possibility of artmaking. What can serve as a guide for my actions in life? This search for clarification is not abstract. One might say the real is that which must be inhabited. Ultimately, it is fundamental for ethics. Martínez Celaya wrestles with such basic questions, questions, which, in the conversation and discourse of the art world, seem to have been left behind.*

*As I threaded my way up La Brea Avenue toward the artist's studio, such thoughts preoccupied me. Martínez Celaya's large studio occupies the top floor of a two-story building. The artist showed me around, and by the time we sat down to talk, I knew there'd be a lot of material we wouldn't even get to. I posed the following as a place to begin...*

Richard Whittaker: I can't help feeling you've come an amazingly long way having left science only a few years ago, but I don't really know your history. I know you were living in Spain as a child.

Enrique Martínez Celaya: Yes, my family emigrated from Cuba to Madrid in 1972 and then to Puerto Rico a few years later. Spain back then was not an easy place for foreigners, but the difficulties and the lack of distractions helped strengthen my relationship to drawing, so when we moved to Puerto Rico I became apprentice for a painter and took courses at the academy there.

RW: What academy was that?

EMC: La Liga del Arte de San Juan. Most artists from the island, at one point or another, have been associated with it.

RW: So when you were apprenticing to a painter, how old were you?

EMC: I was around ten or eleven.

RW: Would you talk a little about your apprenticeship?

EMC: At first I did many still-life drawings, pastel portraits and copies of Leonardo's paintings—not very well. As I got older that interest in academic drawing continued, but it took the form of narrative paintings, allegories of what was happening around me. I still have a few of those paintings, and I like some of them.

By my mid-teens expressing my feelings didn't seem good enough anymore, so I devoted more time to physics, which was appealing, partly because it gave me access to an emotionally simpler world. Physics held the promise of an orderly life.

The summer I turned sixteen, I worked for the U.S. Department of Energy and built a laser in my spare time. But I continued to paint and read, and was fortunate that at my high school everyone was encouraged to explore all disciplines.

RW: What was this school you're describing now?

EMC: It was a school founded in the nineteen-twenties by the University of Puerto Rico as an extension of the College of Pedagogy. By the time I was there it had evolved into one of the best schools on the island.

RW: What a great stroke of luck!

EMC: Yes, it was. My life would not be the same had it not been for that school, especially its bully and its principal. Back when I enrolled, it was a custom for the upperclassmen to grab new students by the arms and legs— like pigs—and humiliate them by forcing their butts onto a pipe located in the middle of the courtyard. I got the treatment three times, so I modified a kitchen knife to stab the ring leader, a bully named Chelo, next time he tried to bother me.

Luckily, I laid the knife on the desk of my high school principal before I could use it. And that exchange, which could have gone many ways, started a relationship that lasted the whole time I was there.

RW: With these gifts, sometimes one feels the wish to give something back.

EMC: Yes. When I started teaching, one of my motivations was to give back some of what I had benefited from; to put myself out there, to be honest, and to be interested.

RW: You're teaching art at Pomona College right now, although you've tendered your resignation, something I'd like to ask you about later; but a basic question arises; you must have thought about this: what is of value—potential value—in the pursuit of art and art making? I don't see our culture as particularly supportive of the fine arts, and yet you are teaching that; it's what you yourself are deeply involved in. A big question.

EMC: Many people want to change the world in a big way, but that's difficult to do in art or in teaching. Broad political work is better done in the streets. In the classroom, or with an artwork, the transformations are one at a time. And if in ten years you touch twenty students, that's great. Maybe some of them will push forward and make something out of it.

RW: Driving out, I was thinking about this thing we call "art." We say "art" and have an idea, vague, but an idea of what that means. Art is something, right? But the concept of it we have today is not old, historically. What? Four or five hundred years old?

EMC: About that, maybe less.

RW: So we read that whatever we now look at and call "art" was totally integrated with some societal, institutional form in the past. Then, at some point, the phrase appears, "art for art's sake" which, in a way, defines this separation; that there's something we call "art" that stands alone. Can art really have some kind of meaning without an integration in some other structure?

EMC: I think this separation you are referring to began with the Enlightenment. When Kant proposed that art must be disinterested, he erected a barrier that we should now tear down. Only art for life's sake makes sense to me. And by that I mean art as ethics: a guide clarifying one's choices and life.

RW: You've made a connection there between ethics and the process of clarifying for yourself, your own life. I've never heard it put that way before: ethics and coming to a clearer understanding of oneself. Can you say anything more about that connection?

EMC: I don't see any useful distinction between understanding of oneself and understanding of one's duty. I think that much of what we are shows up in how we view what's right and wrong, and how consistently we live by that view.

RW: "What is the Good?" In a way, that's the foundational question, as I hear you. And it's not an abstract question, right? It cannot be an abstract question. When the question becomes abstract, when people speak of "the good," and there's no connection with a real person, it becomes very dangerous, it seems to me.

EMC: Being ethical away from the world is easier than when we are involved ourselves. I think some people see the path of abstraction as pure, uncompromised, but it's a purity of avoidance instead of the distillation of what's essential. And that goes for art too; artists who insist on removing their work from human struggles take an easier path, an easier path that seems particularly wasteful when we know that many live themselves in turmoil and confusion.

RW: Intuitively, it seems to me that among artists there's some form of the wish, if not always consciously, to find what truly comes from oneself. The need to find my own thought, my own step, my own perception. It's a profoundly difficult thing to do, but when one has that experience does that not, in itself, give meaning to one's life?

EMC: To find oneself in a gesture or in an artwork, even if vaguely, becomes a hint of our possibilities, which invigorates life with the sense of purpose. Of course, these discoveries don't happen everyday, but struggling against one's limitations is often good enough to give meaning to one's life.

RW: There's always our egoism—I don't mean that pejoratively, it's just a fact; but intuitively, one knows that's not the whole story of "who I am." So isn't it confusing to say, "What the artist can discover is him or herself?" Maybe that's not so clear. Would you agree?

EMC: Much confusion comes with the "am" in "who I am." There's much in oneself that has little to do with individuality, per se, but which instead is part of a much larger continuum. To discover oneself is also to discover one's connection to the world. As one recognizes these connections, a prison sometimes becomes apparent; the prison of what we've established or imagined ourselves to be. For instance, wouldn't it be nice if something were to come out of my mouth that I do not expect? Of course, but it's unlikely.

RW: Oh, yes. Now the students at Pomona College are a pretty high-level group, and I don't know if they're representative of this, but I get the impression that among young people today, "deep questions" are thought to be unacceptable. They're "cornball," or something. Do you know what I'm getting at?

EMC: Yes, big questions can be exposing and ungraceful, and many students stay away from risks like that; and if a student is not willing or capable of taking risks, there's not much one can do as a teacher. Nothing that matters can be solved with "put more paint on the canvas" or "let's talk semiotics." But it's not just them. I think we are evolving into a society afraid to pose certain questions because we're too embarrassed about the implications.

RW: I was reading a post on an email list where discussions often got pretty interesting. In a philosophical exchange, one fellow wrote, "Courageously, grin, grin, face burning with shame, I'll admit that I'm interested in meaning." It's a curious thing, this cultural milieu where one would feel this sort of apology is necessary.

EMC: The average person still says, "I'm interested in meaning." It's only among the intellectual elite that the need for meaning has become a sign of weakness. I think many contemporary intellectuals consider "claims of meaning" to be in inverse proportion to mental refinement.

RW: Sometimes it seems there's almost an attitude of pride among the most rigorous reductionists: "I'm strong enough and smart enough to take it."

EMC: In my experience many of these people are enamored with science's authority and want to make themselves into scientists of the arts and humanities, which leads to nothing but fancy terminology, detachment and those attitudes you mentioned. Of course, there are works—or thoughts— that are too soft because they have no emotional tautness or intelligence. But there are also works and attitudes that are "hard" in a very facile, predictable way. The "look" of objectivity—the arcane language, the pseudo-science journals, the hard expression in the eyes—only points to what science is not.

RW: Yes. Clearly, one sees this. That's well put.

EMC: I remember the first time I saw *works & conversations*. I was curious, but not very hopeful. As I began reading, I was surprised by your courage, surprised that somebody intelligent was willing to take risks. I think you're

going exactly where people need to go if they want to change things. But doing that requires a certain willingness to not wear the badge of the "cutting-edge" intellectual.

RW: That makes me think a little about the avant-garde. For quite a while the whole concept has come under question. But there's still this tendency to aim for shock value, an old avant-garde strategy. Look at Damien Hirst, for instance, just to take one example and maybe over-simplifying it a bit. This has all long since become a convention of the academy. I think what you're saying has some relationship to this.

EMC: The idea of the avant-garde has become a fanciful convention of the ruling class it once disrupted. Now, the bourgeois collectors, institutions and galleries are out there looking for the new, the different and the shocking.

Hirst is not challenging the bourgeoisie or its values, but rather catering to its expectations of hyper-fluff, amusing theatrics and restaurants, without ever annoying them where it hurts. I think the reactionary work of Thomas Kinkade poses more of a threat to the art elite than the work of Damien Hirst.

RW: Interesting point. I've said before that what would be radical and shocking nowadays would be something that's quiet and that doesn't call attention to itself, something that requires your time and attention. That'd be shocking. Do you know what I'm saying?

EMC: Yes, I think you're right. Anything that demands serious and sustained engagement is revolutionary today. We are in the age of entertainment. I don't think the last century will be remembered as the age of computing or nuclear power, but the age when entertainment finally took over our consciousness. Now, most other fields—art, politics, war—are defined through, and in relationship to, their entertainment appeal.

Not even Orwell could have imagined that, in our time, control and uniformity would be accomplished without the built-in cameras and microphones, but with family programming and by cultivating interest in all superficial things. And, unlike *1984*, it's hard to see a way to rebel because dissent is now part of the rules.

RW: Dissent; I wonder if there are other words which would also be worth thinking about? That's a word that points you in a certain direction just like the word "subversive" does. But to become more present, to find something more real. The system doesn't care, one way or the other, I'd say. Language is problematic.

EMC: I understand what you're saying. It's uncomfortable to speak this way, but it's a battle against loneliness, against the dissolution of the idea, problematic as it is, of quality.

But I do agree with you that language gets us in trouble. Every time I give a talk there's someone in the crowd who says, "Yes, I know exactly what you're saying." And as they continue to speak, I realize that they misunderstand me.

RW: Well, yes. I struggle with this myself in pretty much the exact way you describe it; this problem with language. In so many areas the available words are essentially dead. One searches for alternatives, mostly without much success. "The middle ground" for instance; it's not as dead as a lot of phrases, but, still, it's burdened with dismissive associations...

EMC: ...and it's always heard as some sort of compromise between the two sides.

RW: And you know, there should be some pretty good associations with "the middle." The center. Balance. If you're off-center, eccentric, which in the art world, I suppose, is thought to be a virtue, it means you'll fly off in some direction. A high level of energy combined with a lack of balance isn't so good.

EMC: "The middle" is difficult. It usually rubs against the edge of language, which leads to confusion and misunderstandings.

RW: It comes to me that there is a word that bears a deep relationship with some of the things we're talking about. *Being*. Now that's a term we don't hear used too much. One thinks of Heidegger here. It occurs to me that when one is connecting ethics with the pursuit of art—as you described earlier—as a search for clarity, clarity of oneself first, would you not also be willing to say that it's also a search for being, for one's own being?

EMC: Yes, I think you're right; many of Heidegger's ideas are helpful in thinking about the connections between self and world.

RW: And anyone who loves Heidegger's thinking, as I do, is dismayed by the Nazi connections. Yet I cannot reject the quality of his thought, so much of it. Do you ever feel hamstrung about that?

EMC: Not really. Our lives, unlike fairy tales, have contradictions that resist resolution, and to insist that these shouldn't exist is to invite falseness. Heidegger's mistakes and weaknesses don't cancel his contributions, even if

some people try to argue that his Nazism was already brewing in his philosophy. I hope that the value of my own work is not measured by my human frailties.

Even more challenging than Heidegger in this regard is Wittgenstein. He wasn't a Nazi, but he was both saintly and cruel. And I don't think that the similarities between them are just lives with contradictions; their philosophies have a great deal of connection, even if not always apparent.

RW: Well, Wittgenstein pretty much reduced what we can say to language games, right? No deep questions need apply, I guess. But with Wittgenstein, there's this category of "that of which we can not speak." And he also said, "that which cannot be said, sometimes can be shown." This is pretty interesting, don't you think?

EMC: Yes. And life, like art, is one way "to show." Wittgenstein wrote about logic, mathematics, language, color, but the concerns that seemed most important to him—ethics, belief, spirit—he lived. And as a moral man facing the contradictions that I spoke about, he struggled with himself and judged his actions by standards that he often failed.

Maybe this goes back to the beginning of our conversation. To talk about ethics, to talk about what is good or bad is interesting, but somewhat useless and academic. To live life with integrity is the thing. And the purpose of art is to support and clarify that endeavor.

RW: I'm reminded that you've tendered your resignation—of a tenured position too—at one of the best colleges on the West Coast. I wonder if you want to say anything about that?

EMC: It was a hard thing to do. I thought about it for three years before I did it. My approach ultimately failed, and that is partly why I quit. I couldn't teach in the environment of the institution as it existed and be happy about it.

To give up a tenured position in the fickleness of the art world is a huge decision and, possibly, a stupid one. But I felt I was moving in the wrong direction by staying there.

RW: This is not the first time you've made a big change like that. You were just on the verge of taking your doctorate in physics and you made a big turn there, didn't you?

EMC: Yes, and that decision was especially difficult because I knew I was going to hurt my parents. Despite my fellowships, they had made many

sacrifices to put me through school and dreamed of me being a great scientist. When I told them "I want to be an artist," I couldn't offer any assurances of success. I definitely felt foolish, careless, leaving the promises of my research at Berkeley. But I still did it.

RW: Maybe it's the only way. It brings me back to your concern with ethics; a life in which one embodies what one represents. Wouldn't you say that we face these questions, and that we don't know the answers? It's necessary to take a step sometimes in order to find out.

EMC: Yes. And also it's an added motivation when the one direction has shown it has no answers. I might not know where the answer is, but I know where it isn't. To realize that there's no answer in something is an important breakthrough. Then it's just a matter of coming to terms with the personal sacrifices one has to make. There's nothing unclear in that. There may be pain. But that's different.

# MICHAEL C. McMILLEN
## SANTA MONICA, CALIFORNIA, MAY 2002

*I met Michael C. McMillen at his home and studio in Santa Monica on a sunny afternoon. My first meeting in person had taken place a few months earlier at the Pasadena Armory, where he was working on an installation in a large hole in the middle of the floor of the main entrance to the building. Finished, the installation would be covered with a sheet of heavy plate glass so that people entering and leaving could walk right across it—or stop, as I did, and get down on their hands and knees to take a closer look. Peering down through the glass, one saw a robot sitting in an easy chair watching a strange movie on an old television set. Strewn around the chair on the floor were what looked like miniature beer cans and, indeed, the robot had one in his hand. The robot seemed to be at home, maybe relaxing after a hard day's work. The room in which he sat was full of various other articles from his robot life, including, as I recall, a typed letter lying open on his desk. Everything about the letter evoked the late forties or early fifties. It was meticulous in this respect—no doubt actually typed on an old Underwood, perhaps including a couple of whiteouts with corrections, and I can still recall studying the letterhead, something like "Acme Robot Works," with great appreciation for its deft period design. McMillen's attention to such details revealed, to my eye—besides other things—a special quality of feeling for these miniature worlds brought to life.*

Richard Whittaker: When you showed me the little lawnmower gears, you'd mentioned you found them beautiful in themselves. I know that feeling so well myself. I wondered if you've reflected about that, how some objects one finds are perfect just the way they are.

Michael C. McMillen: Yes. You can't think of doing anything further sometimes. When I see an object, especially a discarded object that looks interesting, I think about who made it and why was it made, because a lot of times you don't know what these things are for. They're so abstract when they're taken out of the context of their application that they become little sculptures in themselves.

Even as a little kid I used to take my wagon up and down the alleys in Santa Monica. I'd bring home old radio sets and take them apart and put all the parts into different boxes; there was an interest in finding things and then using those parts to make something else.

RW: So it goes way back.

MM: Since I could walk, pretty much. My grandfather had a little workshop out in the garage and had these little jam-jars full of nails. He used to take

107

apart fruit crates and re-straighten the nails and save them. We're talking another era. He was born in 1873, so he grew up in the nineteenth century. To me, as a kid, that was very normal behavior. I didn't realize until later that it was cheaper to buy a box of nails than to spend the time re-straightening the old ones. But that was the paradigm I had growing up.

RW: Were you with your grandfather a lot?

MM: Yes. My grandparents pretty much raised me. He passed away when I was eleven in 1957.

RW: And your dad. He was traveling around?

MM: He lived here part of the time too. He got married again and was living elsewhere. I was pretty much raised by my grandparents.

RW: Have you reflected on the ways in which art making might connect one to early experiences?

MM: Yes. That question comes up periodically, maybe not always overtly. I'm always dealing with the idea of history and the past and meaning in the future. Where are we on that continuum?

So a lot of times that idea of using societal discards—there is something poetically satisfying about that for me, taking something that seems to be at the end of its useful life and then re-inventing it. It's like a re-birth. Let's say I find a "widget." A widget was made to do what widgets do. The device gets destroyed; the widget is thrown away, and here's this discarded widget. Maybe it gets re-incorporated as something else that's no longer a widget and transcends its first identity and becomes a vehicle for an idea.

That's kind of a goofy idea about—I don't think it's a spiritual idea—but it's something about time and meaning that I'm always trying to come to grips with.

RW: Time and meaning—and where are we on a spectrum of past, present and future? Can you say more about that?

MM: It's an intriguing question. Some aspects of Buddhism have a lot of appeal in that area for me: the idea that all things have a time of existence and a time of disappearance, endlessly, the wheel of life going on forever. Everything around us is the same, and yet distinctly individual, simultaneously. Everything we see is part of the earth, which, by extension,

is part of the universe. I don't want to sound hokey with some homespun theology, but that's kind of how I see it. We're all an expression of some kind of energy.

RW: There's the problem of how to speak about something that's really profoundly true and not sound hokey, or feel apologetic.

MM: Exactly. Yes. How do we do it without sounding like a Hallmark card or some kind of pop-psychology book? It is profound, and there are questions that are unanswerable, but we can always ask the question.

It's really about the journey. We are going from A to Z and it's the journey that is the interesting part. We're going to get there eventually anyway. In our own lives we follow interests and pursuits and goals and every day is a new beginning, a new birth actually. It takes us in directions that we can't imagine. That's kind of wonderful. It's about being alive. We don't know what's coming next. It's got to be a curse to know the future.

RW: Some have observed that, to the degree I'm set on an agenda, I'm unable to be open to these possibilities that are appearing all the time. To find that attitude of being open is not so easy it seems to me.

MM: No, it's almost against the culture. We're trained to acquire things and to have these long-term goals. I guess these help to give one direction and help one to define things, but it's all an illusion. Things happen. I mean, look at 9/11. Do you think any of those people in that building thought they wouldn't see their retirement day?

Someone once told me—a friend who is into Buddhist philosophy—he said that God's idea of a joke is planning for the future. Basically we have no control over it. That's not to mean we shouldn't work towards goals, but maybe…

RW: It is a most persistent illusion, isn't it? It's a rare moment when something shows me I'm not in control, after all. In other words, I'm not privileged to be aware that my illusions are illusions very often.

MM: I think most of us—certainly a lot of times I am totally deluded by my fantasies of being in control. I'd be the first to admit it. It's human nature. We want and need to feel that we are in control.

RW: So how do you think you've come to value this deeper truth that our control is far more illusory than we would think?

MM: Part of it may have come from being raised by two adults who were children in the nineteenth century: my grandparents. I think growing up as a little kid when your parent figures are in their seventies has got to have an effect on you. All their friends were elderly and there was a lot of talk about the Civil War and World War One, a whole shift in time back to way before I was born. And watching them age and eventually pass away. All of those were things I had no control over. I think accepting that was an important revelation of the temporal nature of all matter, and how it will change regardless of our desires one way or another.

I was also a science major in college before I went into art, and one of the basic tenets of physics was this idea of constant motion and change—by implication. Nature is not static. It is totally dynamic. Even in depth, things disintegrate, decay, break down and are then re-incorporated into other systems. So our molecules will remain after the corporal collection called "us" goes away. They will be incorporated into other manifestations of the earth.

RW: It's sometimes said, "we stand on the shoulders of those who came before us" and for me this was just a platitude, until recently. It had never really occurred to me how much all that I consider inherently "mine" has been given to me, may stand on what has gone before. Am I making any sense to you?

MM: Totally. We all have so much that we owe to the past, to the people before us, the culture. Art, for example, is basically all built on the history behind it. People we've met have influenced us. We're an amalgam of all these experiences.

RW: Now your artworks are elaborate constructions and they have many facets. Can you say anything about how your pieces relate to, or say things about our social reality?

MM: Sure. I grew up here in Santa Monica. As a kid it was pretty much a small, blue-collar town. One of the biggest employers, now gone, was the Douglas Aircraft Company and most of my neighbors worked there. I can remember going on field trips in elementary school to see how they manufactured airplanes back in the fifties. They still had propellers. I didn't read art books. I read *Popular Mechanics* and *Popular Science* because I wanted to make things. I always liked to work with my hands. Part of what I draw on, I think, is a remembrance of America of the milieu where, if you wanted something, you had to make it yourself, or you fixed the old one yourself instead of getting a new one. That is pretty much gone now.

One of my neighbors was a guy named Ken Strickbatten who did the special effects for the original Frankenstein movie. My grandmother and his wife were good friends. He lived up the alley. I can remember countless times coming home from elementary school and walking down the alley. If his garage door was open, I'd go in there and say "hi." Usually he'd have a Tesla coil running or a Jacob's ladder zapping. He was building all those things like out of Buck Rogers, and he used to rent them to the movies. So that's where I got my first impressions of science, watching him in his workshop, and I wanted to do that too. What I didn't realize was that what I liked was the aesthetics of science and not the math. Later in college, I realized I wanted the expressive qualities that liberal arts, writing or making art offered. But nonetheless it gave me a perspective that people who only studied art wouldn't have. I studied chemistry. That was what I wanted to do. I used to have a chemical lab behind my grandfather's studio.

RW: At what point did your pursuit of chemistry lose its luster?

MM: Second year of college. I just dropped my calculus, dropped my German class, dropped my other classes and switched to art and never looked back.

You remember when Sputnik went up? And all the duck and cover drills? At that point science was really being emphasized, even in elementary school. I started thinking about going into science then, and all through junior high and high school. That was what I wanted to do. It wasn't until I got into college and had to take an art course for non-art majors that I realized that it brought me back to something. My father was an artist; he made this dinosaur for me as a kid out of papier-mâché, an anorexic tyrannosaurus rex. So I grew up being very comfortable with that procedure, but I never thought I'd make a career out of it until later. I came full circle and it was an "Aha!"—a revelation, one of those epiphanies you have in life. But I couldn't have gotten there any other way than how I did.

RW: There's a drive, something inside that compels one to this endeavor of art making, wouldn't you agree?

MM: I think so. I like problem solving. I like the idea also of communicating with other people, and, although I work by myself pretty much, I'm not a hermit. What I like about the art is that it's the vehicle for communicating the ideas. There's some kind of need to reach out, I think. Whether you're a singer, a dancer, a painter, writer, musician, composer, those are all ways of giving something. You're putting something out there, whatever that is.

People take, or they ignore it, but that begs the question; why are you doing it anyway? What's the point? Well, what *is* the point? Sometimes I like to make things I'd like to see that don't exist. Sometimes it's just for your own entertainment, but I think it goes beyond that. I think we have these feelings about deeper issues, although they may not be illustrated by each piece we do. That's probably the value of a retrospective. When you look back on a career of work, the subtext is always there. Specific pieces may be different, but there are ideas that are consistent.

RW: In science, we have a sort of head brain approach to knowledge. But this leaves a lot out. I'm having some trouble formulating this, but take the lawn mower gear, isn't there something, sometimes, in an object, in regarding an object, that is deep?

MM: Yes. You can see that in nature sometimes, in a seed or part of a vertebra, or a rock. In this case, it's a man-made object, which is still nature. You're right. There is something that can transcend the object—the transcendental meaning there.

RW: Sometimes there's something deep about some things we tend to disregard or overlook, don't think of as offering such a possibility.

MM: It's like the poet sometimes makes visible the invisible by calling attention to it. I mean "poet" in the broader sense; a musician can be a poet, a writer, an artist. By poetry, I mean something that transcends the structure of language that maybe hyper-communicates something beyond language. It's a funny area, because words fail sometimes. That's why we make visual things sometimes. Or we might use the words in conjunction with the visual.

When people try to categorize you as this kind of artist or that kind of artist, it's kind of a meaningless term because it's all open for you, whatever you want to use. It can all be art. Those sub-categories are just arbitrary distinctions for ways of expressing feelings and concepts.

RW: When I think of "the art world," I don't even think of artists, exactly. I think of institutions.

MM: Yes. Galleries and commerce, and that whole other—it's like an inverted pyramid with the artist at the bottom, the little point. But there's all the stuff he's supporting, this mega-structure overhead. [laughs]

RW: It's a curious situation. The art world exists on top of the artist, as you say, but it doesn't—as I see it—really have much of a relationship with the basic things that move the artist. And I wonder, why is that?

MM: Maybe because these things can't be sold or commodified that way. It's like grabbing smoke. If you grasp it, it goes away. And so you have to accept that, and work with that. You work with smoke by appreciating it and enjoying it, but you can't hold it. Whereas art, as commodity, becomes product, something that is tangible. It can be bartered, traded, leveraged, all that stuff. So once the artist finishes the work, he's finished with it. It becomes a physical object, subject to all the forces of the marketplace. It's now in another category.

One of my first shows was a reaction against this idea of commodification, way back when I was in art school. I built a whole installation of phenomena that couldn't be possessed. There were bubbles running through a spot light in a black room, little sprinklings of glitter through a light beam in a dark room, sounds, things that were totally experiential and intangible. You had to look at them and remember them. That was a show back in the late sixties, an early reaction against the commodification of ideas. But I'm not opposed to objects. I love the physical world. I love dealing with things and touching them and playing with stuff.

RW: I've noticed that a lot of your pieces have qualities that suggest the margins, the outsider point of view. In the Armory piece, your robot, for instance, sitting in front of the really great looking, but funky, TV. Do you feel yourself sometimes as an outsider?

MM: I've always felt like an outsider, on some kind of edge somewhere. I always felt like some kind of misfit, even as a kid. I always felt different, not with any implied arrogance, but I felt I didn't quite fit in. So I was happiest working by myself in my garage workshop. Even in high school, some of the guys would come over and want to go out, go to a game, and often I would just stay in my shop with my test tubes and listen to some old jazz on the radio. I'm still doing it! [laughs] I just loved that! We live in our heads so much. That's where all the synthesis takes place, but every so often you have to stop, put down the tools, and go out and see your friends, reconnect with the human race. It's this funny dance between the public and the private.

RW: There's a tendency to assume the outsider comes with a lot of negative things: alienation, resentment, etc. If any of that fits, I'd be interested to hear about that, but I get a feeling that there's a very affectionate quality towards these worlds that you're building.

MM: I'm glad you mentioned that. I'm not looking down my nose at anybody. I'm the last person to do that. I see perfection as an illusion, so I

want to get right past that from the get-go. I don't want to make things with perfect surfaces, or perfect whatever, because that's an illusion to me. So I always try to depict my objects with some indication of their own mortality. Often the buildings are depicted in some state of having a history behind them. I like the idea of things having a history of existence prior to when we encounter them. So that installation in the pit out there [Pasadena Armory Show] was really made from old stuff. It looks like it's been there for a long time: this whole little habitat happening under the floor of the armory. It's meant as an affectionate observation of our proclivity for accumulating objects around us that are important as an expression of who we are.

RW: I do feel a lot of affection connected with that piece. And in talking with you, it does seem to me you are a person of warm feeling.

MM: Oh, I love people. I really do. I love my friends dearly, and a lot of these things I build for them hoping they will see them, or it will make them happy, or it will do something for them. And by extension, whoever is interested in them, I'm glad to have them look at the work.

In a lot of ways, the work really isn't complete until it is looked at. The viewer is really the last link in the puzzle. They complete the piece. The meaning of the art is different for each person who looks at it. We all have different histories and points of view.

RW: I'll tell you my own little story about your piece at the armory.

MM: I love hearing how other people see my pieces.

RW: I saw the robot sitting there in front of the TV, and I watched the movie he's watching. He's sitting there with a beer in his hand. That was what I thought he had in his hand.

MM: Perfect. [laughs]

RW: I thought, "Yeah, he's having some brewskis." So the next time I looked at the piece earlier today, I saw that the brewskis are actually cans of oil, maybe brewskis for the robot! And strangely enough, I'd imagined the empty cans on the floor as having been crumpled.

MM: No, just dropped. [laughs]

RW: My mind did that little trick. So the robot is watching a movie on TV. I saw the movie as representing an account of the world, or an account of

something important for the robot to understand. But the movie is not easy to understand. Mysterious things are happening, and it's hard to understand what they are or what it all means. So I decided the robot was feeling anxious, and the brewskis were for dealing with his anxiety. I saw this as a general reflection on the times we are living in and the problem of meaning.

MM: That's valid.

RW: How did this piece evolve for you?

MM: I got a call one day from Jay out at the Armory who said, "We've got this hole in the floor. Want to do something with it?" I went out and looked at it and decided this would be the perfect place for a little world underneath the floor. I knew I wanted to have this lonely, singular figure. The principle tension in this piece is this robotic figure looking at this strange television set. Everything else is supporting that. On one level, it could be me. I look at my own studio and see what a mess it is, but it's much more complex than that. There's obviously metaphor upon metaphor in that piece: the brewskis, the clicker and the TV, and that passive interaction there. It could be related to society or technology.

RW: Words are a faint reflection of your pieces.

MM: There is something about being with some object, or in a situation in real time, that you can't reproduce. Whenever I take photographs of an installation, I'm always disappointed because it's only one little moment and one point of view, whereas being in it and walking around in it is another matter, like "The Garage" over at LACMA [Los Angeles Contemporary Museum of Art]. There's all the time you spend in there, the things you hear, and the things you see and smell and touch. It gives your mind time to free-associate, to go back in time and to zoom ahead in time.

I started out as an artist making paintings. I still do, but most of my work went toward installation. At one point, way back when, I had a revelation that, although I love painting, I really wanted to surround the viewer in the experience. The only way I could figure out how to do that was to make a three dimensional space that you could enter, and to work with sound, smell, lighting and with tactile things all at once. So I've been doing installations since the late sixties. Even as a student, I began building installation works. But at times I'll work in photography or drawing or painting. People ask me, what kind of artist are you and I answer, "Well, I'm a visual artist." That covers a lot of territory.

RW: When you visualize a project does it sometimes turn out exactly as you imagined it?

MM: There are always changes, which is fine. It's always part of the Zen surprise. But you need a starting point. You think you're going here, but you end up over there. That's fine too. Usually the overall effect is pretty close to what I was hoping for.

RW: Do you ever have a problem with a project that doesn't get to a place you want it to go?

MM: Yes. I once had a painting I started. I put it down, and one day I picked it up and finished it. It was ten years to the day from when I had started it. It was just a coincidence. What I learned early on was that you can't beat up your muse. She doesn't like to have her arm twisted. Whenever I've done that, I've paid for it. I learned just to let go and to move on to something else. I always have a couple of things going at any one time. Usually I have multiple pots on the stove. It keeps me fresh, and, that way, if you're having a problem, you move to another project. Meanwhile your subconscious is working on the project you left behind. When you're ready, you go back and the solution is there.

RW: The film in your piece at the Armory is titled, I believe, something like *The Motel Beneath the Earth*.

MM: It's called *Motel Under the World*.

RW: That's a wonderfully evocative phrase.

MM: I think titles are very important. A lot of times pieces will come out of something I've written or something I've read somewhere. Or sometimes, a title will suggest a piece. So you'll never find one of my works that says *Untitled*. I love titles. Titles are little gestures towards the viewer. The viewer can take them or leave them, but they're important.

RW: It's important for the title to be right. This is a question of poetry, isn't it?

MM: Exactly. It's poetry. The title of an artwork is a poetic gesture. It informs the work. It informs the person looking at it. It helps guide them in the general direction.

RW: Words have atmospheres like clouds around them, and those clouds are active. They have a kind of alchemical effect, right?

MM: The poetic, alchemical, ethereal kind of gestalt—the kind of milieu of vapor that informs. I like that. It's true. So titles can form the piece, or they can inform the piece. [McMillen suddenly excuses himself and rushes outside. Coming back in, he says, "That was a B-25!"]

RW: You recognized the sound.

MM: I'm a big airplane buff, especially propeller planes. It was a North American B-25 medium bomber, a Mitchell. They have radial engines that have a certain sound. When I was a kid, Douglas Aircraft had a surplus shop that would be open from 8 to 12 on Saturdays. I used to go down there with my allowance. I'd buy sheets of aluminum and bags of rivets and stuff. I'd come back and make suits of armor out of them: breastplates, helmets. It was wonderful.

My dad worked in television at that time, so I would get to see behind the scenes in television, and, of course, the movie studios were here. So this was very much an active physical manufacturing center when I was growing up in the fifties. There was an abundance of surplus materials.

RW: It seems your work exhibits this influence from being exposed so much as a kid to the world of Hollywood. You must have really absorbed the joy of the drama of it—the theater of objects!

MM: I loved that! My dad had wanted to be an actor. His career never took off. He was in amateur theater, and did some television work early on. So we would drive up Olympic Boulevard past the old Fox back lot, and we'd see the castles and bits of the Norman fishing village and all that stuff. Up the alley there were always trucks from Paramount Universal loading up Tesla coils and mad scientist gear from my neighbor. So I grew up in this crazy place where it was all possible. There was definitely the element of the theatrical here. I'd go see my dad in plays at the Miles Playhouse. I was in that whole world, so, yes: guilty as charged!

RW: How would you describe the joy, or what is it about this world you have described that attracts one?

MM: I think it takes us out of our normal lives and lets us be somebody else for a while. And while it does that, maybe it addresses basic questions of

humanity too: *Death of a Salesman, The Glass Menagerie*—those are heavy things, but once we get into them we just slip off into that world and live with those characters for the hour or two it takes to tell the story. It's all storytelling.

RW: Your installations are little worlds in themselves, theaters in which stories are invited to appear.

MM: I see them as open-ended narratives where the viewer really completes the equation as the last missing element. The piece at LACMA certainly works that way. It's a full-sized simulation, to use a buzzy word, a simulacrum of a kind of typical mid-century American garage, everyman's garage.

When we go in there, we're suddenly ten, twelve years old. Where's Mr. Jones? He's not here, so let's check it out. You go through these special doors I built, and you're instantly—Richard; you're no longer in the county museum; it's no longer the year 2002. You're swept back in time in an instant to another era: it's night; there are night sounds, crickets; some lights are on. There is a short-wave radio playing in a little laboratory room. The guy is gone, so we can look around—it just transports you to another world.

It's best when you're there by yourself. It creates a spell and lets you revel in your own memory. There are a million stories in there. You just have to look.

RW: I'll go see it tomorrow.

MM: If you have any trouble finding it, just ask a guard, "Where's *The Garage*?" That's the generic name that everyone knows it by. Its real title is "The Central Meridian." I was thinking about the meridians of acupuncture and those yoga things, chakras. I did it as a kind of portrait of Los Angeles, in a funny kind of way. It was done in 1981, originally. The model I built it after was the Egyptian tomb where the pharaoh is buried with all his possessions. But instead of his canal barge and all his gold and furniture, we have a typical American garage from mid-twentieth century with a car and all the artifacts the person has saved. Instead of the Afterlife, it's retirement as the afterlife here in a working culture.

RW: That strikes me as very poignant.

MM: It comes out of what we talked about, growing up in Santa Monica in a working class neighborhood with this work ethic, and with the acquisition of things as indicative of status and who we are.

It's an amalgam of a lot people I grew up with. I have some of my father in there. It's really my homage and reminiscence of being a kid in America

in the twentieth century, and also being an American and what it means growing up in a land of plenty; how that skewed my vision of reality, and how I look back on that now.

I remember one time I was in the installation years ago and a woman was in there. She didn't know who I was. She was explaining to her sons what this was, what a *garage* was. They had grown up in an apartment building out in the San Fernando Valley.

RW: That must have been an enjoyable moment for you.

MM: Yes. I love people. I guess that's how I tell them that. I make these things that I hope they will get something from. I like to make things that I myself would like to stumble upon by surprise.

RW: I wanted to ask you about a piece I saw in your big Oakland Museum exhibit a number of years ago, *Train of Thought.*

MM: It was done for a gallery that is no longer extant. It was part of the Security Pacific bank. They had a gallery space down in Orange County, and they did some wonderful programs in their brief existence. At one end of the gallery, I build a "domestic tableaux" with that cabinet of curios over there. There was an easy chair, wainscoting, some funky wallpaper, a window, a reading light, a chair and some newspapers. At the other end of the gallery, across the expanse of an empty gallery, what you saw coming out of the gallery wall was a miniature trestle about six or seven feet high. It looked like some kind of strange mining operation jutting out of the wall into the gallery. At the end of this trestle on the floor you see a yellowish, amber conical pile of what you might think is sand or earth. Then you notice there's a conveyor belt on this trestle, and you see that, very slowly, there's a steady dropping of these yellow bits of sand, or whatever they are, piece by piece. This installation ran for six months, and so the pile got quite big. It engulfed the whole two end pilings of the trestle. If you walked up to it, and were at all curious, and put your hand out and let the sand fall into your hand, you'd see each piece actually was a letter. So, suddenly the sand pile wasn't sand, but a pile of deconstructed words.

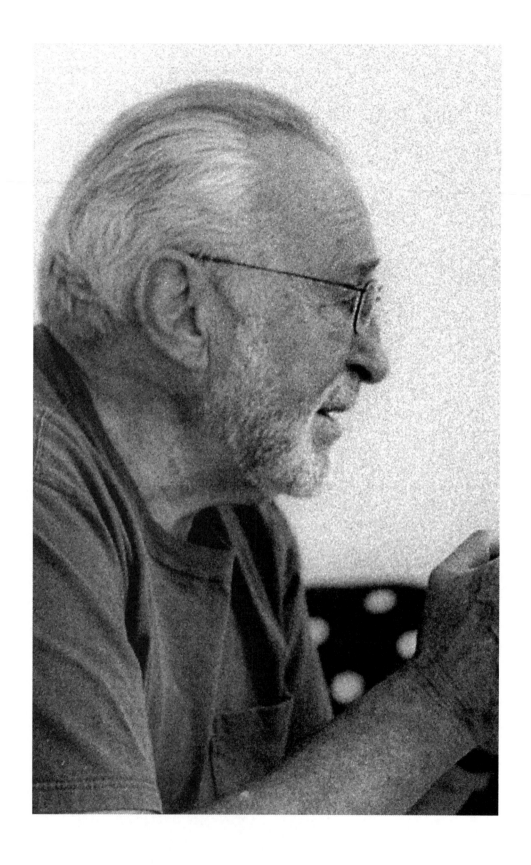

# NATHAN OLIVEIRA
## PALO ALTO, CALIFORNIA, JUNE 2005

*As I drove down Hwy. 280 toward Palo Alto to meet Nathan Oliveira, the anticipation I felt was familiar, mixed with a little of the anxiety I usually feel before meeting such an important artist. My only contact with Oliveira had been brief and by phone. Others had spoken of him; respect and admiration were the dominant themes. I knew he'd taught at Stanford for something like forty years and was now professor emeritus. The inclusion of his work in an important exhibit at MOMA in the mid-sixties curated by Peter Selz had established his reputation, and although I knew some of his work, the real extent and power of it had only come to my attention as I prepared for the interview. The stretch of 280 running south from San Francisco is beautiful, threading south through the coastal hills. Before long, I caught sight of the Page Mill Road exit.*

*At the front door, Oliveira greeted me and invited me in. As my eyes adjusted to the subdued light, dozens of pieces of tribal art—masks and figures hanging on walls or standing on tables—caught my attention. One of his large paintings hung above a fireplace.*

*After taking some time to look around, we sat down at his dining room table. Already, I'd begun to feel comfortable.*

Richard Whittaker: I thought a good place to start would be to ask, what are the roots of your artmaking?

Nathan Oliveira: Well, as a child, I did a lot of drawing. I spent a lot of time amusing myself copying from magazines. I loved those wonderful illustrations that you found in the *Saturday Evening Post* and other magazines. Remember, I was raised in the country and there was very little opportunity to see paintings. This was in the 1930s and there was little interest in art in my grammar school.

RW: When would you say were the earliest drawings you remember?

NtnO: I guess my first drawings were when I was about four years old. My father took me to the zoo in San Francisco, and I came home and made a drawing of a crane standing on one leg. It was pretty convincing.

RW: You remember that.

NtnO: Oh, yes! And I remember a lot of other things from there, around Niles and Fremont [Southeast Bay Area], where I was raised. We had an

apricot orchard. I have very fond memories of all that and how beautiful and important it was.

RW: Close to nature.

NtnO: Close to nature. It was wonderful to grow up on an orchard with chickens and gardens—vegetable gardens—and wood stoves and things like that. It was important.

RW: Any moments which really stand out? I ask because I can remember some of my own when I was a kid.

NtnO: I remember being in this small little house with a very thin roof that absorbed the sound of rain and wind, and the trains going through the town in the middle of the night. I remember feeling pretty secure within all of that and with the kind of drama that created inside my head. The sound of the trains, you know. They really puffed through the town just a few blocks from where I lived.

RW: Some of us are old enough to have had that experience—of the steam engines, right?

NtnO: That's right. Those were great moments. And, certainly, nature was very important to me as well. I remember the way it was after a rain, for instance, and the meadowlarks that were out in the bush, singing a very beautiful song that I still identify with and feel good about.

I enjoyed the summers and the whole ritual of the apricots growing in this little orchard: getting ripe and being picked, and then being cut and put onto big trays and then smoked in the smoker with sulfur. Then, after a certain time, the trays were laid out in the sun where they'd stay for a while. Then they'd be stacked until the apricots were dry.

The whole ritual of the summer was kind of guided by the production of these apricots. And I remember living through the summer with an almost continual case of diarrhea because of the apricots. Both my wife and I still love them! You can't get decent ones around very much, you know.

But, anyway, the war came, and after the war, we moved to San Francisco out in the Richmond district. I was about seventeen, I would think.

RW: So most of your childhood was spent around those wonderful orchards?

NtnO: Yes. It was incredible! And it was beautiful because it was just before that whole war which changed everything for all of us.

RW: Are you a fan of Carl Jung, by any chance?

NtnO: I knew of him, but not especially a fan.

RW: I had to ask because you've got so much tribal art here in your home, and I thought of Jung. He writes about archaic man and that part of us which still has a direct connection with nature. That's so important to Jung, and I sense this would mean something to you, too.

NtnO: Yes. I still feel that very, very strongly. And there are some ancient Chinese pieces in our bedroom, and in the kitchen. I believe in a kind of fundamental man—human—and the cultures they create on our earth. That's been part of what I do.

My work has usually been universal. The figures have never really been that specific. They're not clothed; they're not identified with any trappings that specifically tie them down to 2005. It could be today, but they could be from some other time, a long time ago. So I do connect all the way back to the fundamentals of the cave.

RW: So art can sometimes reconnect us a little with some of these experiences that are more basic, fundamental, that may come from our childhood when we're still whole, and before we've been divided up so much.

NtnO: Yes. I gave a talk at the New York Studio School about two months ago where the first slide I showed was a Hellenistic death mask of a beautiful woman. I made a claim that this face, this ancient beautiful face, was no different than the beautiful faces that were in that audience that night, or that might be in an audience ten years from now. It's a perpetual, ongoing identity that is fundamental, and we are simply part of that.

This is what my art is about, but without making anything specific, without making the paintings Anglo-Saxon or black or green or blue.

RW: Well, I'm leaping to a very big question. You'll have to forgive me. I have this tendency. What is painting? Of course, I mean, what is it for you?

NtnO: [laughs] For me painting is that magical material—that beautiful stuff that was invented, the ground-up pigments in oil, which makes it very malleable. It can be manipulated and changed, darkened, lightened, given different hues and colors, so that by manipulating this material somehow I can find that figure I'm looking for, that figure that represents all the issues I'm bringing up and addressing: from my own autobiographical moments in

Niles, fundamental experiences as a child being raised on a farm, all the way up to what we are about today.

Painting is a matter of somehow manipulating this material, and I can start with an idea in mind, or I can start with no idea and I will end up with a figure. It will be there.

RW: As Richard Berger says, it's this amazing thing of taking colored earth on the end of a stick and [gestures].

NtnO: Yes. Pretty much like the cavemen did. You know, taking a piece of charcoal, they inscribed themselves on the wall. It's pretty amazing.

RW: It's a search, a process…

NtnO: …Yes. This is where Abstract Expressionism was really important to me. I was just a kid when I went to art school. I went there to be a portrait painter, but I haven't explained yet how I was moved by painting. It happened very simply.

We moved to San Francisco as a family and lived around 30th and Balboa out in the Richmond district. Since I didn't know anyone, on Saturdays and Sundays I'd wander around the community, and one day I found myself at the Palace of the Legion of Honor. I walked in and was surrounded by all those paintings in there. There are a whole series of portrait galleries that went back along one wing, and as I walked through one gallery, there was a painting that attracted me; it kind of beckoned me over to see it, and it froze me in my tracks. It was a Rembrandt, *Titus*, a painting that Rembrandt painted of his son. There was something emanating from that painting that other paintings just weren't quite doing. Other paintings in those galleries could seemingly be more realistic, more precise about what they were, who was being painted, but somehow *Titus* became a kind of universal kid in a way. There was something captured in it, something frozen in that paint that created a living quality that the other paintings didn't have. I was impressed.

RW: Is that something for which one continues to search not quite knowing how to get there?

NtnO: It's like anything you don't know anything about; you just proceed and find little bits and pieces and parts of that. It has little to do with movements within art or movements within society. It has something to do with maybe an artist like Giacometti or Van Gogh. So this is what really affected me, and when I finally got to art school, I found that all over again when I was working with my teachers.

I wasn't at all concerned with Abstract Expressionism then, but that came a little bit later. As I found out, the whole gist of it was the gesture of painting, the great mark that could be made, or the energy, the living mark, a large mark of life which could maybe inscribe the whole size of the human being.

RW: It's mysterious, is it not, how in a mark something can sometimes be conveyed? One can feel that. You know what I'm saying?

NtnO: Yes. There is something there. Something comes to life that doesn't normally come to life, but it's something rather rare because you can paint and keep putting material on and on and on and nothing can happen. It's something you simply have to find, and, at a given moment, there is something there; it is extraordinary! A sort of signal occurs, a living signal, a signal of life.

RW: The conventional idea is that art is a picture of something. But what's not understood so well among non-artists is that making a painting can be a process in which something is being sought which isn't about a likeness, let's say.

NtnO: That's right; the act of painting creates the painting and its idea. That's what led me to Abstract Expressionism. As I grew older and got more involved, I saw people like De Kooning who was trying, really, to be an abstract expressionist. He applied material in such an abstract way, but he tried to make figures out of it. And he failed; he continually failed and he'd destroy it and redo it again. I'm speaking mainly of those early women. He would paint, and if it didn't work out, he'd scrape it down. He didn't know where he was going; it had to present itself, and after a period of time, there it was. He was important to me, and there was Max Beckman too, who manipulated the paint in such a way that wasn't so refined, but somehow the experience of the paint created those great images of Beckman's. Combined with his great sensibilities and his mind and intuition, he created these images that were phenomenal!

RW: I remember reading something Beckman said about how the important things of art have always originated from a deep sense of the mystery of being.

NtnO: That sounds like him. That sounds very much like him. And his paintings, again, were all discovered. I mean he could paint whatever was expected of him as a painter, but that wasn't what he was after. So it's a very hard, difficult thing to do—to take that challenge is incredibly difficult, and many times it's misunderstood as well. So when you see some paintings that

are very active and abstract, there's nothing much there. Often they missed it. They missed the whole point.

RW: What we're talking about, just to bring it to this moment in the art world, do you feel that this kind of search is not currently much appreciated?

NtnO: Oh yes. [laughs] Well, the art world today is pretty much controlled by the museums, the curators and the collectors. They've reinvented Duchamp a thousand times. Poor Duchamp can't die. They're all claiming him for themselves, and the curators are all waiting for the next most phenomenal thing or person to happen. They can't really deal on this simple a level. It's passé for them; it's gone, in so many ways.

But it's not gone. This thing is so difficult that each new generation really has to rediscover itself in this way, as artists. That's what I'm doing in my own work—at least, that's what I figure I'm doing, as Beckman did it in his time, and as Picasso, Matisse and the rest of them did. They all meant to find out what they had to paint.

RW: I think it's important to be reminded of this. Now I wanted to ask you about color. Here's this word "color." It doesn't take us very far, that one word.

NtnO: No. What does it mean? Usually people think of color as red, yellow, blue, green, purple. I don't look at it that way. I think color is like one's appetite. One develops through time, in living, a certain appetite for certain kinds of food—nourishment—that really sustain one. And painters do the same thing. They gravitate to certain colors that simply become identified with them or part of their nature, their health, their vitality, or whatever you want to call it.

A lot of my color comes from a lot of these things [arm sweeps around room]. There are some Ban Chang pots from Thailand, very ancient pots made of clay, and then there are some ancient, Neolithic Chinese pots and clay objects. Then the earth around Santa Fe, New Mexico is really very beautiful. The Native Americans made pots out of this material. There's something about using the earth's substance to make objects.

RW: Would you say that it's fundamentally kind of mysterious? That there is this little band of the spectrum like a musical note: yellow.

NtnO: Yes. But yellow has to mean something too. Yellow is yellow. But if it really then begins to take on some significance when you use it, use it in such a yellowish way…

RW: Can you say something about that?

NtnO: That's hard to say. It's like trying to find out why do you like lamb chops.

RW: Okay. But yellow is a whole world, right?

NtnO: Absolutely. My show in New York was made of nothing but red—red figures—and I'm going into a series of paintings right now about red oaks. I'm going to make them red, actually red. I may change colors, but we'll see—whatever the discovery is, or that moment that comes that rings the bell.

RW: You were saying that color is like a food, and that there are certain ones you're attracted to. I'm guessing that over time new colors have appeared that become interesting.

NtnO: Yes. That whet your appetite.

RW: Have you ever pondered what that's about?

NtnO: No. I accept it. I am very thankful that something, which has been sitting there for so long in my mind and in front of me, suddenly becomes relevant. My sense of color isn't that, in order to "be a colorist," one has to use all the colors of the spectrum. I think one has to be very selective. Certain sensations of color kind of assist you in the inscribing of whatever it is you're trying to find, and that's very difficult to do, too. It's incredibly difficult.

For the last maybe twenty years or so, I've been using fundamentally earth colors with some highly charged colors, but not too many of them. I use them because I became very interested in New Mexico. I wanted to go and live there. There was something about the desert and the pinkness of it and moments of whiteness that happen there, and Native American objects that were made, fundamentally, from carbon or dirt. That all became important for me. I used it.

Now those rocks in the bottom of that case there are all pieces of stone that I brought back from New Mexico, from a piece of land that I almost bought. I almost moved there because it was so beautiful—to look down at the earth and to be moved by it; that is pretty amazing.

RW: Yes. Is there an analogy between color and music? Some artists have been fascinated by that, Klee and Kandinsky for instance. Does that mean something for you?

NtnO: I guess in some ways it can. I don't know. I bought a recording of Stravinsky's small orchestral works, and it was so beautiful. What I thought about was just the interaction with silence, mostly, when I listened to it, and the rhythms of all that, but I didn't think of color. There's color in the broader sense, of how he put the sounds together in such a way that he "colored" that period of time during which the music was being performed.

RW: I'm thinking of colors being used together so that the effect might be something like chords in music.

NtnO: Maybe in some way. Painting can be a very quiet experience. Elements can be loud or they can be softer, but I don't really think about something becoming yellow or blue.

RW: I have just enough experience in painting to have tasted a few things, and one thing I'm used to is coming to a place where I like what I've got, and then the next day I look at it and wonder, "what was I thinking?"

NtnO: [laughs] It lies to you. It will do that. You're sitting there with your muse and your muse is telling you something and you're following it, and you end up the next day looking at it and thinking "what the hell was the muse saying to me?" Yes. But of course color, oil paint, is organic. It changes. Even overnight it can go from something very brilliant to something very dull. That's just the nature of the material. But yes, I know. You simply believe it. One can fool oneself so easily.

RW: How do you get beyond that?

NtnO: Well, there's looking at it the next day! That isn't working! So then you have to go back into it again. So there's a whole series of questions and answers, and many times it takes a long time, quite a while, to find the answers to that particular problem. It can involve a whole different set of colors or values, or whatever. It's complicated.

RW: Are you familiar with Agnes Martin?

NtnO: Yes, pretty much.

RW: She writes that there are moments that can come in artmaking in which it seems that everything comes into order. One can see the road ahead, she says.

NtnO: That happens. My scientist friend says that an experiment becomes worthy or important when it develops a certain level of elegance.

RW: But then the moment goes away, she says, and you can't find it.

NtnO: Yes. But that's exactly the way it works. It's the most difficult thing in the world to do, to paint. That's why I can't understand why so many claim that they enjoy painting: "it is exciting and wonderful!" It's really a rather painful experience because it gives you so little. You have to coax it out so much. You're always falling short.

But what else is there? It's such an incredible privilege to be able to spend my time doing that rather than going out and shooting people in a war or becoming a stockbroker.

It gives you the opportunity to find something. When that moment happens, it's miraculous! Because suddenly things do fall into place and a certain sense of life occurs. And then you don't want to touch it anymore. You want to go ahead and find something else, if that is possible.

RW: I was going to ask, what are your paintings to you when they're finished?

NtnO: They end up, if they're good, as solutions. There's that moment for me. So it does exist; the paintings are a kind of evidence that it does, in fact, happen; you find that moment of elegance.

In the early days, I used to question it a lot because I thought even that was a lie. I would paint something and be satisfied with it for a period of time and then, foolishly, I would go into it again and destroy it. I would reawaken it, but then it would become a totally new escapade, a whole new exploration that would lead to either finding something again or not. I usually didn't find a bloody thing that was more important!

RW: And there was no going back, either, right?

NtnO: That's right, and that's painful. That became so painful that I stopped painting for about five years. This is when I first came to Stanford in 1964. I'd get to a place, maybe an ecstatic moment, or, probably more than likely, not so good, but somehow it was concluded. Why go and mess with it? But the idea would come to go back into it, assuming that the more times I'd go back into it, the better it'd get. Well, it's just the reverse. It doesn't work that way. It's a gift. It's kind of given to you, if you pursue it properly. And this is so beautiful and so wonderful it's kind of hard to see why so many youngsters can't find it today. I can't understand what this is about. It's a

challenge at a time when there aren't too many challenges, unless you're in science or certain other fields.

RW: What you're describing, the challenge of this inner discipline of painting, seems to be part of life which is falling more and more out of the mainstream. In our age of science, speed, power and these incredible feats of technology, we're trying to deal with this inner world in terms of our technology, as though it was part of this outer world we're so good at manipulating. And first of all, this work, artmaking, takes time, right?

NtnO: Yes. [laughs]

RW: And that goes against the grain.

NtnO: Absolutely.

RW: And there needs to be someone who can tell us that this is important!

NtnO: Yes. Someone has to get out there and say, "Hey, I see it!" You know, this is something that I can't quite understand, because once I was back east at Harvard and I walked into a gallery at the Fogg, and like that experience of seeing the painting of Rembrandt's son, I walked in and I was suddenly startled. There was a group of Impressionist and Post Impressionist paintings in a gallery and, suddenly, there's this incredible scream! A visual scream! You couldn't deny it. It was Van Gogh. It was just, whhoooo! [laughs] There it was! And none of those paintings in that room—and there were some awfully good paintings—but nothing could come up to that.

RW: I saw some of Van Gogh's work at the Metropolitan about ten years ago. They have some great ones, and I found myself moved to tears. There was something about the color. You would understand that, I think, because how did he get there, to that color? And where was he, at that point?

NtnO: Oh, yes. You see all these strokes. They're not just marks; they're really bits of his energy, the intensity of his energy, the speed of his energy or the anxiety of his energy. This is all put together in those paintings. When he made his *Starry Night*, he really made this thing, you know. Yet people can put dabs down. That's a lot different. With Van Gogh, every stroke—and I think that had something to do with Rembrandt, too—each stroke means something. There's a sense of credibility in the stroke itself. Then when they come together and are representing a head or a landscape, then you have

something that is really moving, and it can move you to tears. That's what it's about. One feels the inner drama of this great artist.

RW: I just realized as I was listening to you that a painting from the hand of a master is actually an object of knowledge, if only we knew how to read it. A kind of knowledge we don't have good words for.

NtnO: We don't have people who have been speculating about that kind of language very much. It's too bad. When you get people who can operate on that level, who knows what we would come up with? People who are far more articulate than I, and capable of putting words together at that level, would make experiences like I have described truly incredible.

RW: I must say that as I was looking at your paintings in preparation for talking with you, I was amazed by so many of them, even just in reproduction. There are several I can picture in my mind right now and one in particular struck me as pure magic, a single bird in flight. It's from a catalogue called "Singular."

NtnO: It's the one with the bird in the middle.

RW: It's just magic. I don't know how you did that.

NtnO: [laughs] Thank you. Who knows how one does those things? Certain ones, you hit on it and it's wonderful. I work for that, and seek that kind of aliveness, or credibility, or whatever you want to call it, but there are so many artists who don't understand that, who work for some kind of superficial reality of a subject. That never really interested me very much.

Sometimes this visual language can be very special, the fact that it can transform—transcend just the making of a picture of a bird to something that is moving, expressive and important. Maybe this is true abstraction!

As an artist, these are hard things to come by. Once Dick Diebenkorn was talking to his students and was asked, "Why is painting so difficult?" He replied, "But what did you expect? Painting is probably the most difficult thing in the world to do!"

But it's quite wonderful to pursue it! So you know, you get used to all the moments of frustration or insecurity that artists have, and we're terribly insecure people—at least, the ones we're talking about. There are a lot of them who aren't. Are you going to be able to find this?—whatever it is. You've done it all these years, but it isn't so easy to find it again! It doesn't happen automatically. So in the process of painting a painting, one goes

through a kind of traumatic experience of questioning: questioning myself, my ability, my sight, my vision.

RW: That's certainly the reason Agnes Martin called the life of an artist a life of suffering, exactly as you were saying. Now, in reading about your work, I ran across the word "ethics" used sometimes in relation to your work. Maybe it wasn't a word you'd chosen exactly, but the writer's…

NtnO: The reasons for painting have to be very strong and sincere and honest and ethical. You have to be challenged by all these unseen qualities, and these are all ethical issues, I think, in painting. There are painters who are not ethical, and one doesn't really care about those concerns.

I just saw Bob Bechtle's show in San Francisco. He's such a fine painter! He shows you a way of looking at things you've seen over and again, but he shows you in a different way, the way he's looking at it, and it is so genuine and honest a way of looking at something that you can believe him.

So we're bound to the ethics. When you're not ethical—and there have been moments when I've moved away, and I knew it; they were there…

RW: So when one is searching for things that are real and true, one doesn't want to fall prey to lies or vanity or something else, because that won't take you to where you wish to go, right?

NtnO: You can't get there. It's impossible. Sometimes I try to knock something out, so to speak, and it just doesn't work. Your whole self has to be there. You can't cheat. There's no cheating. [laughs] No cheating! That'll come up and slap you! If those things get out, eventually they come back some way, and they hit you, and you feel very badly about it, and possibly many years later.

RW: I think I know what you mean.

NtnO: It's a mysterious kind of scolding that you get, like your mother used to tell you, "if you do this, it's going to come back and hurt you; your nose will grow!" [laughs]

But I don't know. Painting is just a hard and difficult thing to do, and it's a worthy process. My big problem is that I have all this time behind me and I'm seeing this abstract world move along with me as I keep trying to find these abstract figures, these figures that are made out of paint. I've been kind of anguishing about "why have I been painting these damn figures?" Once you commit yourself to a figure, it's loaded with content, with what it

isn't and with what it is. And here I've spent fifty years fooling around with this. There have been some moments where you kind of liberate yourself and deal with abstractions, but I still can't get rid of the figure. I question if this has really been that good a vehicle for me because it's been done so beautifully so many times by so many great artists, and, you know, who am I to think that I can bring something new to it? Except that I'm here in my moment, in our time, and Rembrandt isn't here. He's passed.

RW: It sounds like you're facing some new questions right now.

NtnO: Yes. New questions, and that's where the tree comes in, but as I think about the tree, I think about people, figures coming into it in some way. I don't know what that means.

RW: That reminds me of something a friend said about trees. He was talking to a group of us and he asked, "How many of you realize that when you look at a tree, you're only looking at two-thirds of it?" And of course, that relates to people, too. How much is always unseen and unknown?

NtnO: They have lives underground. Also there's this incredible sense of rings, of an inscription of so many years. Yes, certainly with people, we don't reveal our lives. There's so much about people you don't really know.

RW: This makes me think of Jung again and how we've lost touch with so much of ourselves and nature. He was a wise man, and why don't we listen to him anymore?

NtnO: There are a lot of wise men out there we don't listen to anymore.

RW: It leads to another question I was going to ask you. Something like, what have you learned over the years? In a way, of course, you've been telling me this.

NtnO: [laughs] That painting is still difficult as hell! But the one thing that I've learned about it is that the more you give to it, the more it keeps giving back to you. Not that it always provides you with great moments of ecstasy, but there is something about even the failures you have in painting that are important, that lead you somewhere. It has never failed to be something of real substance over all.

Then to see other artists that I have a special fondness for, whether it's contemporary artists, or—I think the painters of Pompeii are incredible! Or

the Chinese painters! A student gave me a book on four thousand years of Chinese figurative drawing. Four thousand years! Well, you know, there's a kind of allegiance I feel that this art has given me. It's given me a kind of company that I feel wonderful to be part of.

RW: Another artist I know said, if we don't think art has something deep and true to offer, then why is it that some pieces of art made a hundred years ago, two hundred years ago, a thousand years ago, two thousand years ago, why are they still alive right now? You can't argue with that.

NtnO: Absolutely. Again, looking at that beautiful ancient mask, she was so alive. Or you can go back to China or Egypt or the cave paintings! It's amazing that things from so long ago are still alive. But so is the writing. Those writers who wrote well and meaningfully, they're still alive too. So I guess that's the connection. That's what we have to do, try to do it. Whether we fail or not, that's another story.

It's something I feel quite privileged to have been able to do; to have a career, in spite of my questioning what I'm doing now with these figures, I've been really privileged and blessed, in a way.

When I started out, I was told you couldn't expect anything as an artist, but I've had an incredible life. I've been shown all over the world. I've received all sorts of attention for my work. I've rubbed elbows with really significant people. It's been a great privilege and an honor, and I feel that what I've done has been significant. I think some things, at least, will stay and hopefully will be looked upon as relevant in the future.

RW: I certainly feel that.

NtnO: Well, I've taught here at Stanford and taught elsewhere. I've been given much. I remember the early days when it was so hard just to find a place to paint; painting in garages, and things like that. But I don't have that problem now. And now it's up to me.

RW: You're invited to give talks I'd imagine.

NtnO: Sometimes. The Philadelphia Academy of Art has just asked me to come there and give a talk next year.

RW: I wonder if you ever feel called upon to say anything to the younger people in the audience?

NtnO: That I did at the New York Studio School. I told them to have faith in what they believe in and to pursue that. So many young artists are being told what to do and what to anticipate. I think that is the wrong thing to do. They really have to reach down within themselves. As I've been saying, this has been a great and wonderful responsibility, to somehow reach within myself and find whatever I am. The artists that I care a great deal about have done that as well.

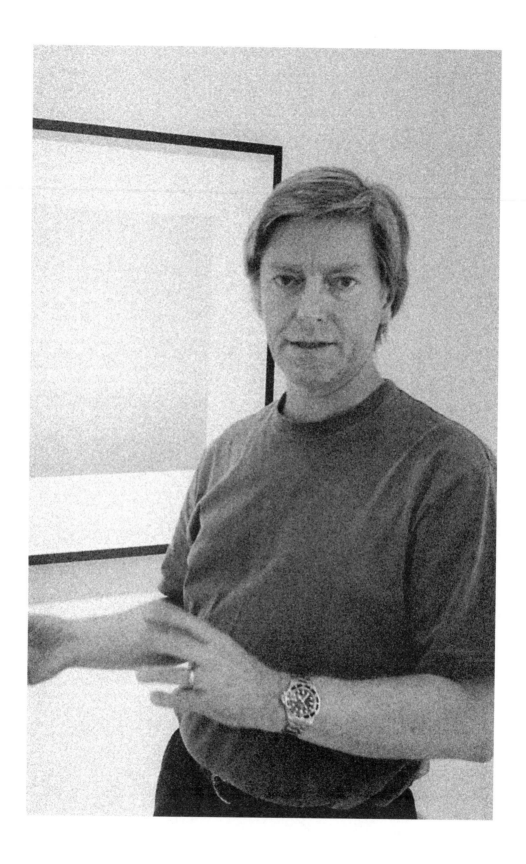

# DAVID PARKER

## SAN FRANCISCO, CALIFORNIA, SEPTEMBER 2004

*I'd seen Parker's remarkable photographs in the Robert Koch Gallery a year before I met him. My efforts to get the gallery's help in contacting Parker were unsuccessful, but they did tell me he'd be in San Francisco for an exhibit a year later. At Parker's opening, I was just another stranger in a crowd trying to get some of his time. I handed him two copies of the magazine and hoped for the best. That evening I got a call. Yes, he'd find a way to squeeze in an interview. Maybe he could spare an hour. It went longer than that. We met in a back room at the Robert Koch Gallery...*

Richard Whittaker: What are the beginnings of what I see here now, these wonderful photographs, *The Sirens?*

David Parker: These seascapes are the latest manifestation of a project that was originally conceived back in 1993, primarily as landscapes. My main interest was in what I call the big geology of the U.S. Southwest, plus other interesting geologic landforms elsewhere.

Eventually I realized that the identity of the locations was unimportant; the mere fact of their existence was what excited me. That work eventually became *The Phenomenal World*, which incorporated a few seascapes, but at that time they certainly weren't the primary focus.

I realized that I was looking at a kind of epic landscape that, for me, had mythic, symbolic and metaphoric overtones. It was clear that putting a set of geographical co-ordinates to such photographs would anchor the images, not to the spectator's psyche, but instead to a set of map co-ordinates, removing in the process any mystery the images may have.

That started me on a track that allowed me to think in terms of what, if anything, the grand landscape could still offer, post New-Topographics, and certainly in a post-Ansel Adams era. Was there any mileage still left in the monumental landscape? Was it a gross anachronism at the present time? And could it be approached without falling into the trap of what Eliot calls a "worn-out poetical mode"? For a while, I doubted that it was possible.

RW: I gather that you keep up with the critical conversation, so to speak.

DP: I think it's vitally important to be aware of the latest developments in the medium specific to my subject area but not to be unduly influenced by them.

RW: Well, before going off in that direction, I wanted to go back to the question of the antecedents of this work. What led you into photography?

DP: Okay, my background. Leaving school, I trained as an engineer. I went through the full five-year apprenticeship followed by three years of design work. I spent eight years in diesel engineering; I learned a lot from it, but didn't really like it and spent the last two years thinking of how to dig a tunnel to the perimeter fence. [laughs]

RW: At your place of employment?

DP: Yes. Since childhood, I've always been pretty good at drawing and painting, and that was my passport out of engineering and into commercial illustration. I was too old at that stage to become a student, so I learned on-the-job really, doing newspaper advertisements and moving on to brochures and general design work. But I was always interested in photography from a pretty early age, too. My father bought me a developing and printing outfit when I was ten or eleven, bits of which I sometimes still use, and I'd have periods where I'd be avidly taking pictures, developing and printing them, but then move on to something else, and then come back to photography.

As time went on, I stayed more and more with photography, and it became my abiding interest. I was living in Staffordshire, which is where I was born. Then I moved to London where I spent a few years doing graphic and scientific illustration for magazines and books, usually with an airbrush.

An opportunity presented itself to go off taking pictures in Peru on an archaeological dig for six months, so I chucked my job in and had a great time. Twelve years later, my first book *Broken Images* was published, a work set in Peru.

RW: Something in doing photography was meaningful in ways that engineering and the commercial art wasn't.

DP: Yes, absolutely. The photography was a vehicle for release from doing the kind of work I felt I had to do to make ends meet. There was a real passion there that was taking hold of me, but also taking a long time to focus. I'm kind of a slow developer, you might say.

RW: Well, I can relate to that.

DP: I take great comfort from the fact, for instance, that one of my great heroes, Anton Bruckner, wrote his first symphony when he was forty and went on thereafter to produce an impressive and searching body of large-scale works.

Music has been quite important; it's been linked into my thinking about photography, particularly with these projects. I'm drawn to what might be called "the large forms," the great symphonies and operas, Homeric epics and the great traditions in landscape painting; large-scale works in any medium require a strong embracing concept, held together by a complex organization and a controlled formal definition. It's a philosophical as well as an aesthetic challenge.

I suppose the catalyst for me was listening, at age nineteen or twenty, to Wagner's Ring Cycle and being completely astounded that one man could have created something of such staggering depth, coherence and complexity.

Without going into that too far, Wagner's development of what he called the *leitmotif* system introduced a new formal rigor into the work. Musical ideas, or motifs, referenced specific symbols or characters within the drama, and, as the drama develops, these musical motifs interact and evolve with the other musical motifs. Organizing that over a fifteen-hour cycle was something that impressed me very deeply.

RW: Do you find yourself in any difficulty with the art world in trying to articulate what it is about your work, your passion, that draws you onward?

DP: That can be tough, particularly since I try to build into my work a high calorie count of interconnected ideas, which is difficult to put across succinctly. The tenor of the work, being black and white, can also be an obstacle. Obviously in recent times, color is the favored mode of expression, and I have no problem at all with that, but someone, such as myself, working traditionally has to face up to misunderstandings and an entrenched hostility to anything which isn't superficially, at least, "cutting edge."

I have to admit to moments of doubt in the early days of this project when considering tackling the epic landscape in black and white with sepia toning. I could hear the dissenting voices in my head saying, "Can you be serious? Why are you returning to the 19th Century?" Again Eliot, a poet whose preferred perspective on time was the eternal, comes to the rescue here: "The way up is the way down, the way forward is the way back."

RW: When I look at your work, it puts me in front of something like the sheer mystery of the world, and rarely have I seen photographs with this power. It's a difficult thing to talk about these days, you know?

DP: Yes. And then people start to say, well the work's "very spiritual," a word I generally tend to avoid because it's so loaded, referring as it does, back to artistic traditions which I'm expressly trying to avoid. If anything, I'm more

interested in re-exploring now-abandoned photographic traditions. I'm speaking of the work of the early photographers, Carleton Watkins, Timothy O'Sullivan etc., because I feel that the vocabulary they developed is perhaps capable of being articulated in a modern, contemporary way; accumulating many images to produce a singular statement.

Because one of photography's primary instruments is this process of accumulation rather than the making of a single bold statement, I often feel that its natural form is the book, which allows you, meditatively, to turn the pages almost mantra-like. It can put one in a mental state analogous perhaps to meditation.

RW: Speaking of meditation, these photographs are like moments of presence.

DP: Yes.

RW: It's not easy to come to this moment.

DP: Well, that's right. It's a realization of something quite ineffable. An image is often a better equivalent than a description in words.

RW: You've given the title *Sirens*, the idea of something powerful that draws one in, I take it.

DP: Yes.

RW: I realize these are difficult things to bring language to.

DP: Exactly. In some respects I feel that the siren song is, amongst other things, the song of art. All art attempts somehow to draw the spectator in, but what interests me is that moment of sudden engagement and seizure we feel before a work of art.

If I can just digress slightly, James Joyce makes a distinction between what he calls proper art and improper art. "Proper" art he describes as art in the service of art and is static. In other words, you get that moment of what he calls aesthetic arrest. For me, this is what it's all about. You're not thinking about anything else, seeing only the image. You are in a state of enchantment with the image, probably because it is acting as a kind of vehicle to take you somewhere beyond itself. The image is therefore acting as a symbol, and a good symbol, if it's worth anything, refers to something beyond itself.

On the other hand, he talks about "kinetic art," which he calls "improper" art. I guess he's referring to commercial art and didactic art—art in the service of something else. I was always much more interested in this static moment of deep abandon, really, to the image before me, and there is no reasoning taking place here. It's the surrender to a psychological moment.

RW: We're full of confidence in the power of our thinking to grasp things, but very little is understood or even referenced about the fact that there is more than ordinary thinking. There's the presence of feeling, plus all that comes from being inside of our bodies, sensate. All these things are part of the entire ontological sphere of experience, and it seems to me your work speaks to some of these other parts.

DP: Yes. It's almost opposed to the "rational" world we find around us. It's asking us to open ourselves to something that is not amenable to language. Mendelssohn said that "the meanings behind my music are too precise for language," or something like that. So I feel that this is where the challenge lies with any kind of artwork; it's to evoke a sense of mystery about this world that we think we know.

It's kind of a paradox, really, that there should be any mystery at all. But photography shows us a different world to the one our eyes see, and becomes the medium for translating the world's strangeness to us. The English painter Turner sagely observed that "the truth of the imagination is more important than the truth of the eye." The camera is a tool for arresting a moment, which is often invisible to us.

RW: Quite interesting. True.

DP: With my previous landscapes, the view that they present describes an angle of about 180-degrees, and is absolutely beyond the grasp of the eye!

RW: With your interest in the monumental, the epic, the big themes, I wonder if you've studied Jung's ideas at all?

DP: My knowledge of Jung specifically is not deep. I've taken what I needed from Jung, but my interest is primarily in the various mythologies, which, comparatively speaking, throw up the same basic archetypes everywhere, though in different guises. For instance, Thor, Indra and Zeus are essentially the same guy. Likewise creation, quest and fire myths share many correspondences.

RW: What are your thoughts about evoking archetypes today?

DP: It feels like what I'm doing is using the landscape as an arena for exploring these symbols and mythic archetypes and, in a sense, doing what has been done for countless generations. I think that geology has been very important in shaping myths and legends. We're all familiar with the local pile of rocks that's called "The Old Man of this" or "The Old Woman of that." I'm doing something similar; I'm looking back into a particular classical mythology and responding to the landscape at the same time. To coin a rather clumsy word, I'm *mythropomorphizing* the landscape instead of anthropomorphizing it. For me, it's a process of re-attunement to a hidden source of rhetoric and expression.

RW: I'm interested in your own experience at these sites. I take it these images must have a strong relationship with that.

DP: Very much. Yes. They are records of my own excitement, astonishment and general feeling of being given some sort of secret knowledge, in a curious way. A lot of the places I go to these days are often not marked on maps.

When you get a boat out and sail around the coast, you get a totally different view of the world. It's almost as if it's not the same place at all. You could walk along cliff-tops and get one view, but out in a boat, it's like you're seeing the real underbelly of the world in an odd way. Revelations just come thick and fast.

I've been out with friends, who have been similarly "gobsmacked." [laughs] I've even been with local fishermen who know the area well and have taken me out and landed me on a rock with my tripod and camera and have just spent time slowly drifting whilst I made my picture. They've told me it's been an extraordinary experience for them also, because they don't normally spend time like that just idling amongst the rocks.

Some of these places are like sculpture gardens, and they just fill me with wonder and evoke all sorts of associations. That's so exciting, because I never know what's just around the corner or what ideas will suddenly be generated as a result of seeing a particular shape of coastline or freestanding rocks. It's intoxicating, really, and quite addictive.

RW: So is that part of the siren-call?

DP: Absolutely, it is! Very definitely, and I was not unaware that I was being lured, siren-like, out to these places. I like to characterize my fishermen friends as my little local Charons, guiding me safely across the dangerous waters of the unconscious.

RW: To different worlds, maybe even like an underworld!

DP: Sometimes it is! Recently I was in a place that was completely extraordinary, a large island of rock with subterranean tunnels that you could sail through. At the westerly-most end, there was a headland, which was like the fingers of a hand coming down into the water [makes a shape with hand, fingers spread and touching down on the table top]. There were so many arches! I spent time sailing around in and out of these arches, desperately looking for a place to plant the tripod but couldn't find a place. So that's one photograph that probably will remain in my head. It was like a voyage to the underworld, literally.

RW: Well, that's amazing. When I look at the prints, I take it that you look for soft light?

DP: Generally yes, but it can also be strong sunshine. My enemy is a partly cloudy sky, that is, a mixture of blue sky and white clouds. The white clouds then become difficult to print out, and also the clouds pass in front of the sun and momentarily shroud the subject in shadow. So I like either flat lighting or cloudless skies.

RW: So what results in the prints is a very soft, sort of vague space, which is very quiet. It almost evokes something of the eternal.

DP: Yes. The photographs take about eight minutes. The principle camera I use is a 360-degree panoramic camera that only sees the world as a vertical slit behind the lens, which travels across the film as the camera rotates. This gives what I think of as a sort of a time dilation. The whole image is never gathered instantaneously, and this often allows for some serendipity. For instance, if I have to photograph in partly cloudy conditions there could be a brief break where the sun comes through the clouds and a streak of light appears which then will slowly fade, placing a little highlight in an unexpected place. And also with the peopled landscape photographs in my last book *The Phenomenal World*, the placement of figures in the scene can't be foreseen.

RW: I don't know those photos.

DP: I'll just get the book. [leaves and returns] Okay, here's a case in point. We see a scene with quite a few people in it. When I start the exposure, the

position of the people is unknown; they come and go, come and go. The serendipity here [pointing at a small figure] is that this guy stood transfixed, motionless, in two different parts of the picture in exactly the same posture! I didn't choreograph that at all. It just happened in this one, out of about a half-dozen exposures.

Similarly, here there are people scattered around. Now this guy [pointing]—when I knew the camera was just about to take him, I asked him to just stay put for a while until the camera had time to pass over him. When I'd started this exposure about seven minutes earlier, he wasn't there.

It's exciting when things like this suddenly happen, because it puts a completely different view on my intentions. When I visualize the photograph in the first place, I'm looking at the shape and composition of the image. I'm allowing for the fact that people are going to come and go, but I'm never sure what will happen exactly.

RW: Things happen which you couldn't have planned, and you're also referencing myth and archetype in your photographs. In both cases, you're dealing with realities that extend beyond the ordinary realm.

DP: Right. It's the universal. If a myth is to work properly, it's got to be accessible by pretty well everyone. And so what I'm looking to do is to cram as much into the picture in as simple a way as possible, to evoke this feeling of communion, you might say, with some mythical idea.

RW: Now that's strikes me as wonderful, and it also strikes me as difficult. Sometimes there's a resistance to things pointing that way, so to speak.

DP: I think there's less willingness to engage with what I call the larger ideas, the larger forms and complex ideas. It requires an audience that is willing to put effort into engaging with the unfamiliar. Maybe that's a result of the fast-moving pace of life and the much talked about attenuation of the attention span. But I think also it's perhaps to do with forgetting something of the cultural heritage.

A lot of my reading has to do with what's been written hundreds of years ago, or maybe even thousands of years ago. Generally speaking these works have survived because they speak of something universal about the human condition. That's a wellspring of inspiration, which is either disregarded or just overlooked. And yet, it's entirely relevant today, which is why we still read this stuff.

I think it's possible to put a modern perspective on many of these ideas. For instance, here [opens book] I'm looking at a picture of an arch here.

Arches are very interesting metaphors for transition. They can be seen as gateways and thresholds, but also as bridges between worlds, between the temporal and the eternal. In this particular image [pointing] my own shadow appears, without my body, literally disembodied, an effect achieved by the slow scanning of the image slit of the camera over the 8-minute exposure.

This evoked for me a quotation from Dante "before you ask me, I will tell you: this form you see breaking the sunlight here upon the ground is a man's body." Now this has to do with Dante's passage through Purgatory where he's just come out of the Inferno with his guide, Virgil, who is a shade, so-called, and therefore is ethereal and doesn't cast a shadow on the ground. Coming out of the Inferno into sunlight before climbing the Purgatorial Mountain, they are greeted by another group of shades running down the mountain to greet Virgil. They suddenly halt in terror, though, at the sight of Dante's shadow, much as we would if confronted by a phantom.

I was not there with the idea of illustrating Dante when I made the photograph. It's a construction I added later, but the thing is, I'd read Dante before, and had been interested in this graphic idea showing the difference between mortality and immortality. Dante's image here is absolutely startling!

Because of the way this camera moves, it describes a period of time during which anything can happen. Those are my feet [points] here in this picture, again disembodied; so I'm there, and I'm not there. [turning page] There's my hand on the rock, which kind of references the handprints you see on Aurignacian caves in Europe and around the world. In the past the hand has been placed on the rock, the mouth filled with red ochre, and the outline of the hand literally spray-painted. The rock is seen as the repository of the life force, so the placement of the hand on the rock is a way communicating in some way with that life force.

RW: I find it wonderful to hear how you're relating this work to some of the great wisdom tradition of literature. It seems we have less and less of a connection with history nowadays.

DP: Joseph Campbell, the mythologist, using a geological metaphor says something like, "We live today in a terminal moraine of myths and mythic symbols which formerly inspired and gave rise to civilizations." There's a bit more to it than that, but we've kind of lost that substrate.

RW: Indeed. And can we really survive this way? What are the statistics for the use of Prozac, drugs in general, the reliance on entertainment etc. to get us through the night, or the week?

DP: What we require is a focus and trajectory through our lives that enables us to negotiate this complex journey, and it's always an individual, very personal route we all have to take. The map for each person has not yet been drawn.

RW: It's always a personal route, isn't it? The heroic journey, it's been called sometimes. That can't really be discarded.

DP: We're crying out for heroes and I think, in some respects, we're not being supplied with the right kind of contemporary heroes. Sporting heroes are all very well and good, but they're not carrying us forward in the way that helps us to develop an inner life.

RW: If your work speaks to anything, it speaks to the inner life, I think. Not wanting to name places has to do with that. The way we name things tends to foreclose our inner relationship with them.

DP: It's the Rumplestiltskin factor. [laughs] Name it, and it's gone.

RW: We're moving so fast that we don't really meet anything and, in a way, these photographs are like places where the world is being met somehow—the world as a mystery.

DP: That's right—the world as a paradox, all of those things.

RW: When you go out there, it takes time. Do you carry a radio or plug into an iPod, or anything?

DP: No.

RW: Excuse me for asking. [laughs] I didn't really think you did!

DP: [laughs] Absolutely not! No! My camera is very heavy and needs a heavy tripod to support it. That gives me just enough space in the backpack for some water and a sandwich, maybe, so I'm never tempted to carry non-essentials. Because of its weight and bulk, this camera is a very jealous mistress so that even carrying a small digi-snapper along as well is an extra burden, not to mention a distraction!
  The idea of reaching a place after a long hike and getting the Walkman out—well, it's not what I'm there for! [laughs]. I would be reading the landscape in terms of what I was bringing to it, rather than in terms of what it can give to me.

One goes naked into this, in a sense. One should be ready to respond to whatever presents itself without any distractions.

RW: And that's not a given, is it? To become open, in other words.

DP: Well, I find that I can snap into it, that is, if I find something that throws me out of the thought patterns that I'm in. If I have an encounter with just a bunch of rocks that says something to me, then I'm instantly focused on what its photographic possibilities are.

RW: Something speaks to you.

DP: That's right, but I'm a strong believer that you need to go at least halfway toward something for it to open itself to you. I spend a lot of time just chasing after these places; going out hiking, or going out in a boat. It's usually directed to some specific objective, but normally what I find en route is something unanticipated which is even more interesting!

RW: I have the impression there's a sort of British tradition of explorers going to far-off lands. Have you ever felt yourself part of something like this?

DP: I've never thought about that. I'm aware of it, and I've been interested in the history of exploration, but I've not seen it as an exclusively British pre-occupation. I'm not nationalistic in that way. For me, art is, and should remain *terra incognita*, and it's a territory that continually opens itself up to personal exploration.

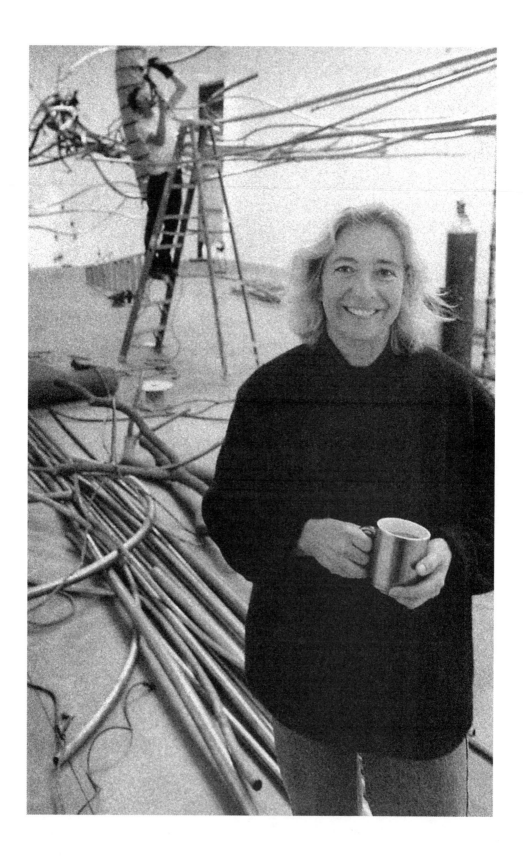

# JUDY PFAFF

## PASADENA, CALIFORNIA, OCTOBER 1995

*I met Judy Pfaff at the Art Center in Pasadena where she was busy creating a new installation: Ear To Ear. Pfaff is one of the best-known artists in the country. She put her welding equipment down and walked over to say she couldn't interrupt her work just then, but could we meet for lunch somewhere in downtown Pasadena? We did, but after finishing our sandwiches we felt that the conversation should continue, so we met again at the end of the day. To say that talking with Pfaff was refreshing is a poor description of it. Having never met Pfaff before, I found the whole experience astonishing.*

Judy Pfaff: Up until about five or six years ago, I thought all the work was about exterior things: noticing how the light falls, or a tree grows. Then suddenly, I saw it was really an interior landscape. I've just come to it. I don't think it's a surprise to anybody else, but it was a surprise to me.

With the early installations there was a lot of problem-solving, and that would get me through the show. There were also ideas coming, probably out of Modernism, about how to make the space work. I wanted to deal with transparency in this one, or temperature in that one, or some other subject. But with the last couple of shows, it would get to something interior. Before, the colors were used to do spatial things, but now they're used to do emotional things. So now there's a real shift in the way the imagery is put together and how the color is chosen. It's not about them, or it; it's really about me and mine, and probably closer to everybody because of that.

Richard Whittaker: That sounds like quite a significant change.

JP: You see, I've always seen myself as being in the art world and thinking that's the conversation I want to be a part of. But after awhile, I think, "Oh, it's a trivial conversation." It's just the one that fills up a lot of magazines and newspapers, and I never could read them anyway. So it feels like I'm on the other side now, and I'm certainly much happier. It doesn't mean much, what they think, or what you think they think. Earlier I would have thought it a horrifying discovery, to be on the outside, looking in. But it isn't. It's much calmer.

RW: That being on the outside and looking in is really, as I listen to you, actually being more inside yourself, as you were saying.

JP: Yes. I don't know how I did that. It's not something I worked on.

RW: How do you feel about that?

JP: It's good. Because the other—Marxism, let's say—is in right now. But then I'd find all my Marxists doing un-Marxist things. So I would wonder, "How could they think this, and do that?" No matter what it was, I was always in a quandary. I wanted it to be Real Truth. I guess I thought, "If you stand for something, then you stand for something." It just seems like what you thought was the truth was not the truth. Everything kept changing, so you're left trying to sort it out, or just walking away.

RW: I can appreciate what you're saying. And the mention of all the theory reminds me; you have an MFA from Yale, right? That must have meant a great deal of studying this sort of thing.

JP: [laughing] My mother used to call and ask, "Did you really do that?" You know, you don't really have to study at Yale. And if you do, you do it for yourself. I think I looked at more books on my way to school than while being there. No. The education there, for me, was through mentoring.

There was a man named Al Held there. He didn't finish high school and went into the Navy when he was seventeen. He went to Paris on the G.I. Bill. So, all the education I had at Yale was from someone who learned through life, on the street, and through other artists. He doesn't talk "that talk" at all. So we got on very well. He was a straight shooter, and could really look at paintings, could really look at stuff. He would tell you what he saw, and he would listen to what you said. If there were discrepancies, he might point them out. For me, that helped because I have never associated real thinking with making. I was just a compulsive maker. I made a lot of paintings, a lot of drawings, and everyone sort of stayed away. Plus, I didn't like to talk. They sort of treated me with kid gloves, like, "She's busy. It's good. Leave her alone."

Al Held had been married to some very strong women, very good women, and so he just thought that was normal: women with strong opinions who couldn't care less about what others were thinking, and so we got on very, very well. But he really took me to task about just making and not thinking. What does it mean? Where does it come from? If this is what you want to do, why did you use that structure? And I would say, "Then you like it?" And he would say, "What's that got to do with it?" He liked thinking.

RW: And that was pushing you.

JP: Oh, man! It still is.

RW: Yes. Here I am with an art magazine, talking with artists, holding forth, and all that. I wish I'd digested Lacan, Barthes, Derrida, Foucault—all those people. But life's too short, and, besides, these guys are just about impossible.

JP: What I've found, and what's nice about New York, is I know the woman who's the editor of Lacanian Inc. She reads Lacan, no problem, and I think

she's such an interesting woman. So I get my Lacan or my Baudrillard, from the people who get it and like it.

RW: That's a good system.

JP: The good thing about having that degree is that I could get a job. But it was very disappointing in terms of what one might imagine in going to a great university filled with the best minds. It was terribly undernourishing in that way, which was a great disappointment. I like being around very lucid people, knowledgeable people, difficult people. And so, when you go there and you can't find them, or if you do, they're not available, that's very disappointing. If you did learn things, it was in a strange way, a sort of back door way. We're talking about the graduate school now. But Yale had a great reputation in painting.

When I went to the American Academy in Rome—as a visitor, not as a fellow—every evening was full of people eating and talking about what they did, what they wanted to share, where they would take you. This is what I thought it was going to be! So I think it does exist, but don't you find it very rare?

RW: I do. And there must be a hunger for this.

JP: Yes, to be in the company of that. It would keep you on a higher level. I mean, I can listen to garbage for a long time, but if I hear something that rings true, I'm on my way. At Columbia we would have faculty meetings, and I would think, "Not one person has talked about art." Something has really gotten lost in the shuffle.

RW: Just going to an institution is no guarantee of anything. I do meet people who have a certain spark and a real passion for something, but they seem to be isolated from one another.

JP: Yes. You live in Northern California?

RW: Yes, on an island, actually: Alameda. It's in the San Francisco Bay right next to Oakland.

JP: An island? That's wonderful. Have you ever visited Jane [artist Jane Rosen] on Oak Island?

RW: I've never been there.

JP: It is so cool. It's an hour from New York City. She's told you about it, right?

RW: I called her there last night. She said, "Let me get my flashlight." I said, "You don't have lights?" She said, "No. You know, I have to row my boat out to get here!"

JP: [laughs] Well, she doesn't exactly have to row her boat. It has a motor. I tried this. I went to this boat show and bought a little rubber boat that's just so cute. Do you think I asked anybody? No! It fits me and my dog and cat and groceries. I can pick it up myself and put it in a truck, and it fits. And I buy a motor because I can pick it up. Then I call this guy and rent a little place down there on Oak Island. It looks like an embryo, this island, and there's no way to get there unless you have your own boat. It's the most wonderful environment.

So I tried to live there. I rented a place for a couple of summers. It would take fifty minutes for normal people to get there, but it would take me two hours and fifty minutes. I really wanted to do it right, but…[laughs]

RW: Well, you did it your way. There's an advantage to that, isn't there?

JP: Yes, there is. You throw yourself into the middle of the fire. I don't know how most people learn, but unless I'm really challenged, I won't go ahead. So the story of my getting to Oak Island in my little dinghy with my cat clinging to me and my dog, a Lab, jumping overboard in a storm, and the motor conking out, and someone finding me drifting out into the Great South Bay and pulling me back— I mean I live for those moments! But I also think, sometimes, "You could die, too!"

Sometimes students ask me—they want to be told—"How do you do this?" And I say, "You've got the material, so read the back of the package, then just play a little!" You really have to try it yourself. And I can't tell them so mistakes won't happen. But most people won't do that. They do all the reading, but when they get their hands in it, they find out the stuff has a mind of its own. It's like having children, I would imagine.

RW: You always hear, like it's some kind of shortcoming, "he had to learn the hard way." But you really learn that way. Maybe it's the only way.

JP: It's the only way. It's really the only way. I wish it wasn't that way. I think some people do have another way, but I have to have it actual and palpable.

RW: In that moment of decision, buying the boat without asking, trusting yourself alone, what is it like for you at that moment?

JP: I've been so lucky at it, and my batting average is so good, I trust it almost completely. I have to get the feeling. I have to see the object. Then it's instantaneous. It's when I bypass that that I go wrong.

RW: There is an intelligence, not the kind on an IQ test, but some other kind, wouldn't you say?

JP: Absolutely.

RW: How do people get where they get? To go back, how was it for you when you were a student first having to take classes?

JP: Well, I figured out a few things. If I couldn't get the object I was working on to class then they'd have to come to my place. That was clever. And if the thing wasn't simply in one place but was there, there, there, and there—then it would shift the way they would talk. Mostly, they'd say, "We'll come back when you make a painting." It solved something. I was not sick when they left.

It's interesting how people see my art. They walk around, and it's like a gestalt. They go "Ungh!" or "Oh!" But when they leave, they don't really know what it was. It's not remembered well. What is remembered is something like a sensation. Or someone might be reminded of something: "Oh, I remember…", but people don't remember the piece at all. Someone might say, "I loved the way you used paper." But there was no paper. So they remember something else, what they need to remember. They might say, "I don't like it." But that's very different from taking a loved object apart and saying, "Too short, wrong color."

RW: In art school, then, you devised certain strategies for protection.

JP: I didn't even realize that's what I was doing. And I still have it when anybody starts breaking a painting apart. It's a reflex. I just get sick, and I make it stop. I'll do something.

Students, by the way, usually like it if you tell them what's wrong with a painting or with an object. They think that when they've been told what's wrong, then they can just go fix those things. Do you know, it never makes the painting better! It just never does. You have to change, have another kind of vision.

RW: How do you teach?

JP: I have a very painful process of teaching. It's very slow. It usually is embarrassing. But I have very good instincts with people. Sometimes I think, "This feels like reading tea leaves." And then the student will ask, "How did you know my mother was a seamstress?" I do mostly one-on-one. I think I'm an okay listener, not great, but I get "takes" so fast [snaps fingers]—what they wear, their body language. I'll try to find someplace that's really theirs and which they feel confidence in. Praise or compliments do so much good! I try not to get too embarrassed if I see something that's really ugly or terrible.

Early on in teaching when we'd have some faculty meeting and someone would say, "Alice is terrific!" I would think, "Yeah, she is terrific, and everyone knows that!" So we've probably not done that for Alice. Alice probably was terrific, is terrific, and is going to keep on being terrific. We all sort of think we had something to do with that. The truth is, we probably didn't. There will always be one or two in the class. That's not the problem. You've got a class of twenty. So my first time teaching at Queen's College, I

thought, "I don't want one or two. I want this whole thing to be an organism that grows together. I'm going to get better, and they're going to get better! Something will be known, and we'll all get A's."

The good ones will always be good, of course, but I think you can get almost one hundred percent. I really do. I remember thinking, "The person over in the corner being neglected will always be neglected." And it's easy to neglect them because they've got wonderful ways of getting neglected. So I think, "This is not going to be easy." I go over there and try my damnedest to get through. I find something and figure out that it really is good. I'm not lying. Then they get to be like Alice, only they're a little behind because they haven't had the recognition for a long time. It really works! It's fantastically effective.

RW: I've never understood some teachers who can be really brutal. They have their rationalizations, but sometimes, and maybe often, not only are they complete jerks, but they're also wrong.

JP: You know what's so funny? You think, "This person's talented," and you think you know what they're going to do. You never know! It's so amazing! You never know! Experience should tell you to slow down on your judgments, those fierce judgments! The probability is that not only will you be wrong, but wrong beyond imagining!

[Our conversation continued that evening]

RW: I grew up around LA, but on my first trip to San Francisco, it was like "the shutters fell from my eyes."

JP: It's a marvelous city! There's a place in San Francisco I worked at a lot, Crown Point Press. I think that's probably the best publishing house around. In their heyday, when I would go there, I would have maybe a 4000 sq. ft. studio to myself with four printers. And occasionally they'd say, "Judy, why don't you take the Rabbit and drive around." Within an hour I'd be in these incredible places, and I just couldn't imagine the range of landscapes and the beauty.

RW: It reminds me. I'm really touched by many things I see, even certain kinds of dirt, or picking up a rock, the way it feels. I'm interested in your relationship to materials. That sort of thing must mean a lot to you, I would imagine.

JP: It does, but in a peculiar way. I was born in London and raised in Detroit and went to New York, and have done all this city stuff. I've actually been frightened about nature. I don't go hiking. If I ever do get into nature, there are these moments, and I get knocked over by it. We were just in Maine for a week, and three of the six days I was sick as a dog. It was right on the ocean, and there were all these little tide pools. I was just sitting there, and all of the sudden it

dawned on me that literally everything was moving. I just thought, "Oh my God. I am so unconscious!" I was never really sick enough to slow down to see. I was looking at these surfaces, and they were covered with things that were alive. I miss the detail unless I really slow down. But if I do, then I'm overwhelmed. I end up doing work about it, and so this moment of looking fills up a year.

RW: An impression that hits you deeply enough, even just a moment, can really be something.

JP: Yes. If I didn't know me, I'd say, "this person studies the structure of plants and animals." Or has really thought about that. But the truth is that I really don't. I don't know how I get information. Sometimes an engineer will ask me how I figured something out, and I really don't know. It just seemed apparent. I couldn't tell you how I got there. That's a problem because I'm always answering questions with "I don't know." And it sounds like I don't know, but it isn't like that. I just can't articulate it very well. But if something can't work, or doesn't work, I can get to it right away, and I know the reason why.

RW: One thing I came to in looking at your work was that most of your forms look organic, look strongly related to life, and I thought there must be something going on around that.

JP: There is. I've always had a curiosity around science and the structure of things, and I'm always looking at books. I'm not a good student in that way, but I absorb ideas. I might hear some discourse on science, and I love that. I get strength from these outside sources when they seem to support things I've come to, and I'd think, "You're not nuts on this. Lots of people are thinking about similar things." There is no real study there, but I think I'm very good with materials.

RW: What is the process for you? What is the finished piece?

JP: The finished piece always feels like evidence to me, summations of what I've been thinking about. Structurally, this piece [*Ear to Ear*] carries aspects of the piece that I did in Philadelphia [for the Convention Center.] This looks organic, but there is a hell of a lot of fitting going on. Bending small diameters is one thing, but bending tubing four inches in diameter is a different story. This one is like a big head. When you walk into this space, it will be like you're in the space of the functions of the brain.

I wanted to have all the senses and connections from right to left, and how the eye travels, and how the brain picks up information, but it's never going to be exactly like that because that would be sort of stupid anyway. I just wanted it to feel like walking inside a head—as I am alive inside.

Now this volume is starting to get its own life, and I'm able to find it now. It's becoming more alive, and there is the potential for some other kinds of

activities. That just feels great. And that would be an answer to, "So what do you want from a finished piece?"—to get somewhere, to be able to learn something.

RW: It's your own process of learning and discovery, in other words.

JP: Yes. I've always thought of it as that.

RW: Looking at photos of your other work, I did get the feeling that maybe part of it for you is getting a sense of amazement just seeing what you've actually put together.

JP: This is so exciting! I did installations for about ten years, and I got to the point where I thought, if I kept it up, I was going to disappear; it felt psychologically dangerous. I fought for about ten years to try to make objects contain something. My work has been talked about almost as being decorative and joyous. I think it has some joyful aspects, but I find myself thinking, "How could this be so misunderstood?"

I don't know anybody else who works in a space as directly—and for as extended a period of time—as I do. It is extremely rare. To do it for twenty-five years and still walk in as cold as a novice, that is, there is no game plan, and still to have this work seen in the same way makes me ask, "Am I nuts? What do they see that I don't see?"

RW: How do you see it?

JP: I just think it's more psychological. It's more fragile. It could collapse quite easily, in a certain sort of way, emotionally. You have to have the ability to keep coming back every day, and keep solving problems. There is a tenacity, and a rigor, and a discipline that I don't think is being noticed. It's as if they think I just show up and Boom! Everything fits into place! I mean, to get fluid systems, structural systems, to get things that still are visual and are able to be understood and pulled apart, you have to have a funny sort of clear mind. A lot of things have to happen, and at a certain point you have to pull something out and make it work. To use Pollock—I mean there was a kind of macho part, but if a woman tries the same thing it gets thought of as being more hysterical.

RW: Gender-based biases.

JP: A woman doing these structures, which are like webs—well, she is crocheting them! That's such a gender-based metaphor! If you just see the work, it isn't gender-based.

RW: What is seen represents only a part of what, in fact, took place. Unless someone really stops and thinks about it, that's just overlooked. So you

know people have missed a lot of what is there for you. Do you think it's a lonely thing? Even in the art world there are not many people in your position, people who do what you do.

JP: I bet you there's not an artist on the planet who doesn't feel that! What I know is that, career-wise, most artists control what appears in the media. I've never taken care of that aspect of it. The writing has been left to the observer, and, a lot of times, the writers read what has been written before; they sort of paraphrase, maybe building on a review written twenty years ago.

RW: Maybe it's always there: the fear of taking a stand, of trusting your own perceptions.

JP: Yes. In the art world right now there is very little of that. There is a lot of theory. When I was at Columbia, there was not a single art historian who ever visited the graduate school or the undergraduate school. There's no relationship. There are ideas and theories, and if you're writing something about gender or politics, then you find who fits that slot. But there is no real relationship going on. It is only the outward construct. I think there's not a lot of people who have the knowledge and the language and who do a lot of looking, because that's a hard nut to crack.

Take a great movie, with great actors, great director, and a typical scene in a high-powered office. Look at the art on the walls, the worst paintings on the planet! Schlock! It's a funny thing, don't you think?

RW: It's true! That's a great example. If you want to gain some real knowledge or reach a certain level, you find yourself moving to a smaller and smaller group.

JP: I used to say this to students all of the time. I'd say, right now, everyone—your mother, your brother—loves your work. Everyone thinks you're terrific. As soon as you get very good, they'll wonder what happened. They won't get it anymore.

RW: What interests me is about finding something inside, a real aliveness, because we don't automatically get that. Yet, art is very much driven by fashion and "the market." Fashion rules, I think.

JP: Fashion rules. Absolutely. But good thinking is good thinking. I mean, "entropy" went out of fashion and "chaos" became the new word. You can hear students saying all the time, "Oh, right. Been there, done that." It's just the most horrible feeling. People have said to me, "You're not dead?" You get located in a certain time. But I keep thinking we're all crawling toward the same goal in our own ways.

RW: One thing you were saying earlier was that a shift has been occurring for you. In the last couple of years, your focus has been shifting to a more interior place.

JP: I'm thinking, "Well, I'm still alive." That's interesting, because you know a lot of artists think they're going to die at 25, or something. And, of course, everyone is an orphan in some way. Everyone has been adopted or is from Mars or something. And you're still here! You can pay the bills, and you've done all this real stuff. You can't hold on to a lot of the fights because either they're nonexistent or you've won them!

For me, all the things that I sort of paid attention to—all that has collapsed. There's a lament about it, certainly no anger. It's just the way it is. I think when all those fights have passed, there is a lot of space, and there is more humor. Things feel like they are coming into their places now. If I get this opportunity to make some stuff here, and it keeps me alive and, well, and seems to connect to a few people, it all seems good.

There is just a lot of space in your brain to spend more time on sweeter things: more interesting things, more eternal things, more nebulous things. It feels that not much has changed, really, but my understanding of the dilemma seems better. There is a book I read a long time ago called "Black Elk Speaks." There was this sick child, ten or twelve, in a coma who had this vision. Later, he became a shaman for his tribe, and through his whole life all he had to do was to go back to this vision for answers: where to move the tribe, where medicines were needed. It was all in that vision. All he had to do was to focus differently. So, I think all the answers are there, but now I have to look in a different place. This interests me, this way of being fluid with situations. I've always had it. Now I'm just calmer with it. I can focus on different parts of what I need.

RW: I've wondered about your titles. They're intriguing. Take *Moxibustion*, for example.

JP: It's out of a Tibetan medical text. Titles are so hard for me to come up with. The "bustion" part is for heat, and "moxi" is an herb, I guess. They put it on pulse points. So, in this medical text they kept talking about "moxibustion"—and I thought it was a very cool word.

It's funny about fitting the titles. They sort of have to be funny enough, or plain enough, or curious enough. They can't be too esoteric. If a title comes to me, and I never had to think about it, that's the best way. That Brandeis show, *Elephant,* I just thought that title was so good. It was like the seven blind men walking around an elephant and each one touching a different part and describing it. They all had real information. But the thing was too big for anyone to get a handle on it. I liked that about it. I don't make that many installations a year, maybe five, seven in a good year, or maybe only two or three. I might make smaller pieces, but I live with the bigger ones a long time. One could encapsulate an entire summer. So they really have a place in my head, and, if the title doesn't fit, it will irritate me for the longest time.

RW: Do you have an interest in the relationship between art and society?

JP: I used to think I did. Now I think, "Fuck, I don't know." It's too big a responsibility. I think more like, "One day at a time."

For seven months I was in Granite Springs working on the Philadelphia project and staying in this barn, which is like the eighth wonder of the world. It was four hundred feet long and seventy-five feet wide and all made of stone. It was built by Italian masons at the turn of the century. Because of the process I was going through—buying a thousand gallons of paint, getting my car fixed, going to Blockbuster Video—I got to know lots of people. They'd seen us four or five times. Occasionally, when we'd come in at odd hours, having been working all day and looking like bums, people would just ask, "What are you doing?" And I'd say, "Come on over!" They all knew this building, all had childhood memories, but for them it had been "off limits." Sometimes they thought it was a prison; it has a tower. They thought it was a watchtower.

Anyway, sometimes local people would come over. We'd have barbecues. I still get letters from those people. They'll tell me about their grandmothers, they remodeled a car, and so on.

As artists, I think we're so close to all that stuff everyone has forgotten, that's no longer valued. Here they see this crazy woman putting everything into this project and they are so thrilled to be around it, whether they like it or not—around that kind of process. Every one of them became devoted to the crew, myself, the project—people who never thought about artists. I think it really does touch people in ways, and, what's terrible, that I forget. I get in the middle of it, struggling and wondering, "Why am I wasting my time?' and then so many people respond.

There's something about it that sets people free from their preconceptions. I see students walking in, and other people, and they all start talking about things in ways I know they don't at other times. You'll see eyes open, or people will go into the past, and they'll tell you all kinds of stories. The most intimate things! I think it really still does touch people and in ways that still surprise me.

RW: That illustrates something, I think. That people are actually very sensitive. The response must be gratifying.

JP: Yes. We all suffer, even though we've got degrees—we teach, we write, we have literary magazines. We've got all these piles of stuff, and we're still saying, "I wonder if I'm okay?" I think most artwork comes out of someplace you can just tap into and make that so obvious. And then other people can look at it and say, "I know that place too, that craving."

# IRENE PIJOAN

## BERKELEY, CALIFORNIA, AUGUST 2004

*This interview took place in August of 2004. For reasons not quite clear, I have not wanted to publish it until now. The delay is not important in terms of content, as will be apparent to readers. I met Irene Pijoan at her home for the first time on the day of our interview. It had been explained that she did not have long to live, and I'd felt anxious about doing the interview under the circumstances. But a respected friend had urged me to do an interview, and my brief conversations with Pijoan by phone quickly persuaded me to carry through. Pijoan had been a member of the art faculty at The San Francisco Art Institute for some twenty years and her work had become well known in the Bay Area.*

*Our conversation took place in two parts one afternoon, an experience I will not forget. Pijoan spoke with startling clarity. But what isn't possible to convey in text alone is the quality of her presence and her unique and often unexpected intonation, so eloquent and, at times, so fiercely ironic. I suddenly felt bereft as I left her home that afternoon. Eight days after our interview, Pijoan died.*

Richard Whittaker: With most artists, I'd think there are certain really deep connections out of which the work comes. I remember being maybe five or six years old and being transfixed by the beauty of my favorite marbles, for instance. Do you know what I mean?

Irene Pijoan: I think in my case there are several initial motivations, or roots. It's interesting that you mentioned your marbles. I was raised in houses, environments that happened to be extraordinarily beautiful, something beyond the normal beauty of a house or a garden. They were not fancy; they were not luxurious at all, but I remember that, as a small child, I spent a lot of time alone.

The first place where we lived until I was six was set off by itself in this gigantic garden. There were some very large trees in the garden; a ginkgo was outside my window that was 250 years old. In the front part of the yard there was a stone fountain, which had been there for 200 years. The house was roughly 250 years old. The fountain was covered with moss, and a trickle of water was coming out of it and oozing down onto the ground. There were little flowers overhanging and I would just spend hours, it seemed, looking at this; dipping my hands in it, putting a little bit of water over the edge, not really doing much with it, but realizing that this was strange and special.

What it really was, was a nineteenth century fervor for antiquity that had appeared at a certain point in the culture in Switzerland. There was also a Roman column in the backyard, a real one. It had just been schlepped in

from a Roman temple not very far away. About fifteen years ago, they gave it back—much to my grief, but it was probably the right thing to do.

There were other things like that, mysterious things, an *orangerie*, which was a place in the colder climates where people grew oranges in pots. That was tucked away in the hillside, which nobody had seen for years until I thrashed my way through the thickets and discovered these rooms. It was really the most beautiful, mysterious, strange, hidden, magical thing. So that just gives you an example. This was up until I was six.

Then we moved to the mountains in a little Alpine village. You see, all this was in Switzerland. We lived in a rented apartment in a large chalet in the midst of that little village of only two or three hundred people. Across the way, a huge valley, there was a view. On the other side were big mountains. These big mountains didn't really seem all that far off. They were beautiful, and yet I was unhappy being there.

I really didn't want to be in this landscape, but I just had to say, Damn! This is beautiful! I don't even like it, but it really is beautiful! I had to recognize the difference there.

RW: That's interesting, being aware of that.

IP: My father was a very prominent art historian, a major figure of his time—Spanish. So maybe now I will enter the Freudian part of it; I was born when he was seventy-five years old. My mother was forty-four. They met, they conceived this child out of some sort of passionate love, and my father then went on to continue with his work. Men like that never cease working.

He had no propensity toward fathering. He was old and he was sick; he had diabetes and he needed constant tending. So mother tended to him, and there was a woman who came by when we lived in the first house who would cook and clean and take care of me. She was sort of the real mother in a way, but she did not move to the mountains with us. So I was bereft and very isolated, very lonely.

Loneliness is a part of my fundamental, what?—temperament, trauma, or whatever you want to call it, because my father didn't know how to take care of me; he had no interest really. My mother was busy with him. She was loving, but she was putting out all that she could already. My father was broadly considered to be, quote, a genius. Out in the living room, as you can see, the extent of his oeuvre is staggering.

So here was this guy who was supposed to be a genius, and when it came time for me to develop, I was skipped over. I dropped out of school at sixteen and spent four years on the street, mainlining drugs—that's a whole story in itself—feeling completely overwhelmed, like I could never, ever compete, and naturally wanting to equal his achievement somehow. That weighed on me

tremendously in my development as an artist. In anything I wanted to do, that would have been held up as a point of comparison; and that was unmatchable.

So under all of this abandonment, sorrow, heavy-duty rebellious teen-age response, when it came to patching myself back together, I realized this fucking weight is there, and how am I going to proceed?

I think that, as a result, I started making art—a lot out of fear, out of pain and sorrow, out of anguish. It dovetailed very much with the abstract expressionist kind of *stürm und drang* of the time. You know, "go within and dig out this stuff."

RW: Let me recap a little. Were you still living in the house looking across at the mountains when you were going to high school?

IP: We moved out from the mountains after my dad died. You see, we were supposed to have been there for his health. So we moved down briefly to an apartment in Lausanne, and it was just a horrible scene being there alone with my mom. I was just starting what you're calling "high school." In Switzerland, you start when you're ten. When you're ten, they examine you and they track you. There is a sense that it's for life. If you screw up this examination, that's it! You're going to push a broom somewhere.

The constrictions and conformism of that society was overwhelming to me. I just could not deal with feeling like I was on tracks. I was a girl from—on my mother's side—a high bourgeois family. There were expectations; I was considered "bright." I was supposed to be a doctor or something, you know.

RW: Right. So it was a very difficult time. You dropped out and were on the street. Somewhere you got involved in drugs.

IP: I started when I was twelve. I was just out there. My mom and I fought every day; and that's all we did. I fought against the school. I wanted to demarcate myself from that society. It was the sixties. It was the time, anyway, to do that. It felt like I was in a cark, in a prison of expectations. School was very rigorous: French, Latin, a little English, a lot of German, math. I mean this was not messing around. When you graduated, you were at the level of two years of college here in the U.S.

I fought it every day, and I looked for the baddest people in town. They could be found in bars, and I just hung with them, much to my mother's despair. Then one thing led to another. But this is more the story of my life, than of my art...

RW: Yes. You said that you turned to art out of fear, and as a way to help yourself, but had you had any experience with drawing or painting or looking at art that might have been an antecedent? Of course, your father was an art historian.

IP: Yes. So images were around the house all the time. We had an El Greco for a while that hung around. In the living room, you may have seen it, there's a little portrait that's basically two thousand years old. It's beautiful, very moving; and I think that thing influenced me a lot. It's why I absolutely insisted to have it later on.

RW: You looked at that a lot as a child?

IP: I looked at it. It fell into my eyes and into my heart. It was so mysterious; the big eyes looking back at me. I didn't really have the conception of time, that the thing had come from Greco-Roman Egypt. The *Faiyum* portrait somehow stayed in the family.

RW: So that portrait, it was from Egypt?

IP: Yes. Greco-Roman Egypt. It came from that period when the Romans invaded Egypt. The Romans came and brought along this whole multi-cultural crowd of workmen they had helping them. There were Greek painters among them who had been trained in the Greek style of encaustic painting with wax.

At that time in Egypt there were also some Jews, some Copts, people from all over the place. So it was a very interesting time there. The Egyptian art had always been extremely stylized, but what the Romans brought was the naturalistic style. They would paint these people from life, just their faces on little wooden tablets like that. They would bury them in Egyptian sarcophagi, these very hieratic boxes, and, on them, they placed the portrait. It's very recognizable; I mean, they're real people. It's just staggering.

RW: That reminds me of some Etruscan art.

IP: Yes. The Etruscan is a little more stylized, but the Etruscan has some similar feeling of that. It's intense.

I don't know if I ever thought about it when I was a little kid. I met this little portrait going up the stairs everyday. It was hanging in the outside hallway, if you can imagine. It just looked back at me, and it was just mysterious—again, mysterious and powerful.

I saw a man one time when I was coming back from school; I was five or six. He was stepping out of a bakery, with the bread under his arm, and he turned back to look at the baker. He had the loveliest look, and it was just like the Roman portrait! I went, holy shit! I was so excited by this! I ran home, but there was nothing to say. What could I say? I felt like I had seen an apparition.

166

RW: Six years old, seeing a person's face as he turned in your direction, and this is with you today! There's something really kind of extraordinary about that, isn't there? Art, what is it? There's another world that art history can't address.

IP: Yes, that's very nice the way you couched that. Of course, with my father an art historian and my mother trying to get us some holidays as she was able—because she had to do everything—she would load us into this old Peugeot, and we would go. We went a couple of times to southern France, to the land of Matisse and Picasso—Picasso who, by the way, was a friend of my father's. They were the same vintage in Barcelona. There was also Dali and all manner of poets that made a gigantic difference in establishing Catalonia as a real culture—re-establishing it—the language, institutions, all that.

Anyway we went down to southern France; that was one thing, and one time we went down to Brittany. Crossing on the way to Brittany and Switzerland you can go fairly easily to these fields of menhirs…

RW: …I don't know what that is.

IP: Menhir. That's one of those great big stones dug into the ground.

RW: Like dolmans?

IP: Dolmans are their cousins, the ones with the tabletops on them, kind of. Menhirs are just stones sticking up, eight to ten feet high. There are rows of them planted in lines, and nobody really knows why they are there. My father was endlessly fascinated by these Druidic things and why are they there? They are so powerful and, again, so mysterious.

We would stop at those. We would stop at every cathedral, every castle, every chateau that had some crazy-ass architecture, and at every museum. I would just go, "Oh no. Not another one!" But in point of fact, all this dragging around to all these places really did form, if not a sensibility, at least a love for these things. And now, if I'm in Europe and I see a cathedral or a museum, I have to go in. Museums are actually places of solace to me; they're like home, in a way, as are cathedrals, which are places of spiritual experience.

I don't consider myself a Christian. I have had a Buddhist practice for twenty some years, and that's been much more fruitful for me. But just the utter sense of spirituality that's in these cathedrals! Or even in the little churches, little country churches, Romanesque, with a ceiling painted with stars; those things are amazing!

So that was one more art experience that was forced on me, but ended up being very good. Another one was when I was fifteen. I was so out-of-hand, and so loaded with LSD and so forth, that my mom didn't know what to do. Out of desperation, she said, "we're going away this week-end." She lugged a friend with her into the car lest I try to jump out of the car, I suppose. We drove to Venice. It was winter.

I had never seen Venice, and somehow I didn't really know what Venice was. I didn't know what to expect. So we get there. We take the *vaporetto*. There's a fog over the city because there are all these fumaroles that come off the water there. Buildings are just kind of emerging out of the air. You can't even see the end of the canal, and God! This can't be real! I've dropped acid again! This is just too amazing, too extraordinary.

I don't really remember the museums there, just walking in these empty side streets with the canals, hearing the steps reverberate and being lost. That was unforgettable. It was a vision. And then on the way back we stopped in Padova. Have you ever been there?

RW: No. I've been to Venice, but not Padova.

IP: Padova is in the Veneto. It's close to Venice. We went there. It's a modest town, although it has, as virtually all northern Italian towns have, just treasures in there. But the only thing that my mother knew about was this Travertine Chapel painted by Giotto. This is a smallish chapel, which is. gosh, it's probably about fifty feet long or so. It's in a little park. Outside, it doesn't look like anything fancy, but you walk in and it's painted from floor to ceiling—including the entire nave and everything!—with these frescoes by Giotto.

I mean to tell you, the extent of the loving endeavor, the color, the fullness of it, the fact that it was painted directly on a wall; the fact that the paint is the material surface—by the process of lime fresco, the paint has become part of the wall itself. There was something about it that really hit me. That was like paint at that level of Venice's fog. It was just *whoooo*! Man! Here's somebody who went all out! And look at that!

RW: This was important for your mother that you see that.

IP: It must have been. I think that she, well, she carried art. She didn't write about it like my father did, but she was an artist at heart. She painted and drew, but was really trained as a musician and a bit of a dancer, and she taught. But she was completely enthralled by beauty. She would sit around and she would go, "but why is the sky green? Look now—it's turned lemon yellow!"

She loved places with views. She had to live on Lake Geneva. She had to see her bloody lake!—to look at the color changing on it, minute by minute;

to go swimming in it like an otter as far into fall as November, when it was practically freezing out! She just had to go into this silken water and look at the reflections. She would walk around and say, "Why beauty? Why are things beautiful? I just don't understand." It's one of these questions that can't be answered, but she just kept asking.

RW: Fascinating. You must feel that you carry that from your mother— certainly, you would. We carry our fathers, our mothers, regardless.

IP: Right. I feel like I have a stellar set of parents. They did not take good care of me. They did love me madly, but they didn't love me well. So I got the love, but I didn't get the proper caring. As a result, I tried to patch myself together for the next twenty years. I feel like I carry this incredible heritage. That's why it pisses me so much off that I'm going to die here at fifty. I have so much more to give. But, you know, we're beyond that now. Now I can barely get up. I don't have a choice anymore. [silence]

The other thing is that it was also extremely nineteenth-century. When I came to this country, I mean, it was a shock!

RW: Where did you come to? California? New York?

IP: I came to Sacramento. Yes. Because I was still timorous.

RW: Were you on your own? Alone?

IP: Yes. I was out of school for four years. I dropped out at sixteen. I hung out, traveled, had bad boyfriends, did and dealt drugs, drank a lot, ruined my body. Gave myself hepatitis, which is probably a major contributor in this cancer right now.

I kind of ran aground over there, and I ran into this American woman who was originally from Sacramento. She was a bit of a nut. She was on SSI. I ran into her on the road in Spain. I hardly spoke English. She didn't really speak any French, but we took after each other and we traveled together.

She taught me a lot, like she turned me on to books and feminism—major enlightening experiences! Bulbs going on in my head! I hadn't thought of myself as a woman; then I could really try to cut through that. There were other books on humanistic psychology that also set a framework for my issues and really helped. And all this came from America, for the most part, or from an Anglo-form culture.

I had always felt a great kinship for the Anglo-form culture because I'd been sent to England when I was young to camp. I just loved the English scene and especially the swear words! Ninety percent of what I knew—since

I was a bad girl, you know—ninety percent of what I knew in English was swear words.

Anyway, she kind of brought me to the point that I might want to go back to school, but I couldn't go back to school in Switzerland because, like I said, once you dropped out of your track, you were just in free-fall.

RW: That path was foreclosed.

IP: Foreclosed. So she said, well, there are Junior Colleges over there. It might possibly be that you could get admitted to one of those on the basis of what you know at sixteen. Well, I knew a shit-load for a sixteen year old!—compared to an American who's eighteen, you know?

So I got in. It was American River College in Sacramento. I was too afraid to go to LA or San Francisco. I was a country bumpkin, really. I mean, is all this relevant?

RW: Does talkking about these things bother you?

IP: No, but I'm not talking about art.

RW: Well talking with artists about their lives and experience seems important too.

IP: Okay. Well, that's good. When you say the word "experience," that certainly ignites a very, very important approach in my art.

RW: But please stop, or interrupt if things are not going... I'm not here to put you through anything you're not happy with.

IP: No. I should sit up more. [Adjusts her position]

RW: Now I was wondering about the first time you picked up a brush or a pen or pencil and said to yourself, so to speak, "I'm going to do a painting or a drawing." Was there a moment you remember of doing that?

IP: No, not really. I was given those things as a child and I used them; and, in retrospect, I think rather well. Art education at school was very minimal and nobody was trying to make me be an artist. The whole of this preamble is trying to lead up to the point where something went "click."

RW: And that moment came?

IP: Yes. It went "click" after I went to junior college for a year. I took all sorts

of other fun and wonderful classes, and had a passionate, delightful, ravenous time availing myself of what was available, mostly the liberal things. Anthropology, I remember, fascinated me. Poly Sci was very interesting. Psychology—I mentioned earlier that psychology had been the first turn out of the dark.

RW: You mentioned humanistic psychology.

IP: Yes. Quite a lot of it: Perls, Frankl, Rogers, you know. People of that era that were happening out here. Esalen, and so forth. And people had tried to send me to shrinks. I did have a relationship with a shrink for a couple of years after I spent six weeks in the loony bin. The shrink was great because he held my hand and prevented me from killing myself.

He was a support system; it wasn't really a standard psychotherapeutic relationship because they were all trained as Freudians. These Freudians are useless, man. Anyway, they're useless to teenagers.

RW: Did you happen to cross paths with any Jungians?

IP: No. It was Freudians. They sat there on one side of the desk and you sat on the other. They wouldn't utter a word, and you would say, "What am I doing here? What am I supposed to do?" Well, nobody bothered to explain.

So anyway two days after my twentieth birthday, I got to Sacramento with my little suitcases and no idea of what was going to happen next. I stayed at the youth hostel for a while, because that's what they have in Europe. Then I got myself a bad boyfriend in short order, very bad, maybe the worst one I'd ever had. He was a paranoid schizophrenic.

Eventually I found a little room with two very straight and nifty girls who were engaged to be married. They were having their preparations. I was thinking, "Jesus man, this is the moon! I don't understand where I am."

These people were living different lives from me. Everything was different, but I persisted. I took all these classes. They had a rather lively little art department. In particular, there was a ceramics teacher named Temako, a Japanese-American who had been interned and carried wounds from that. He and I just hit it off. The connection with him was so nice, even though ceramics wasn't my cup of...

Then after a year, I went to Sacramento State. At Sac State there was also a good art department at that time in the seventies. There was Bill Allen, Carlos Villa, Oliver Jackson, Joan Moment—the lone woman in the joint.

RW: Was Robert Brady there?

IP: Brady was just barely starting, and he's still my buddy. I took classes

from Brady, Annenberg, who I adored, but didn't take classes from—there was a good thing going on. There was also a sculpture lab located to the side of campus in an old hanger. That place was vast and underutilized. Once I realized that psychology wasn't going to be it for me—because I started ascertaining that psychologists were either just as crazy as I was, or they were scientists doing experimental psych—I thought, this is *so* boring. They're trying to make points that really are common sense. I just don't have the temperament.

So that's when the "click" went on. I just thought, "Well, that's it! There's nothing else!" I'd had the idea that I was going to make a difference for the world; that psych was good for that, and I was going to do it one person at a time. I really believed that, if you changed one part of the kaleidoscope, then all of the pieces shift a little.

Anyway, I just said, "I can't deal with this." Then I went to the art department and made art all of the time. I needed to make sculpture more than painting. I needed the physical thing. I needed that corporeal confrontation between the body and the thing that comes to represent, in a sense, the body.

I was influenced by Eva Hesse, so there were these large abstract structures, or semi-abstract, and very much about materials. I was using plaster, because by then I realized, oooh, Manual Neri! I saw a show of his at the Oakland Museum and it was, phew! All of his plasters, these figures, I could completely relate to it.

I might add, there is something very classical in his work in which I may have recognized Europe, because, quite frankly, I just could not get the smallest grip on what was happening with Funk Art—or, for that matter, Pop Art or any kind of irony. I seemed to lack that thoroughly, and it grieved me that I could not enter that dialogue, because that was the cool dialogue.

RW: It sounds like something saved you from wasting your time just going down an empty path for the sake of fashion. That's not so easy for a lot of people.

IP: No, I tried. I actually went down these paths many times.

RW: What happened?

IP: What happened is that it sort of dead-ended, but it taught me stuff. I believe in learning by osmosis. I believe in people making, as I've sometimes seen students do, of making Francis Bacons—sometimes for years—yet you know that they have more than that in them. You just have to hold their hands and wait it out.

Anyway, there was something that was just so highly satisfying in making

these big sculptures, and some little ones too that were very private, very intimate. The place was open twenty-four hours, and I would just go there in the evening and stay until three a.m.

RW: Now you were working in plaster and ceramics too…?

IP: I wasn't working in ceramics anymore because I wasn't in a ceramic lab. My pieces were mixed media. I principally used plaster on top of something. There's something regurgitative about me. It's something that's almost scatological. I almost eat and shit, and play with my shit.

RW: I've never heard an artist say that to me, but, you know, that's a classic Freudian analysis of what artmaking is, isn't it?

IP: Yes.

RW: Do you think that's why you're putting it that way?

IP: No. I think I just tend to want to handle things and handle things until I own them. So mixing plaster; getting all covered with plaster; making these lath structures. Some cheesecloth would be applied to that and then the plaster applied to that. And then, on top of that, making a painting. A piece that might be about eight feet high by eight feet long and very flimsy and funky and leaning on sticks and not made to last. Then on top of this structure, that has a very physical presence, then painting a space like a room that has perspective that would then engage us back into the space of painting and the space of illusion. So trying to have both the illusionary space, where a narrative can evolve, and the physical thing that's in the room with the viewer, confronting the viewer.

RW: Would you be willing to say that touching the material, having your hands in it, feeds something…?

IP: Yes.

RW: This direct contact, it feeds something…

IP: Yes. Yes. It does. And I really think that at the foundation of art is this need to make, to be physical, to have that connection between the mind and the body. That's what it is, really.

So there was a flurry of work that happened in this very short period of time. My friend David Stone from the Acme Gallery—a wacky, artist-run

gallery which was a complete blast where we would just have fun and think we were the coolest kids in town—David said, "I'm only going to keep the gallery for another month. Do you want the last month?" And I said, okay.

So in one month, I did a slew of work like you wouldn't believe! It made a beautiful show and damn if it wasn't even reviewed in the paper! I was a junior.

So right there, all of the sudden, there was a teeny bit of E-G-O poking in; all of the sudden I realized, "Oh shit, *I can do this!*" I could compete with you know who.

RW: I'm not sure.

IP: My dad, I guess. Actually it was very, very empowering. At the same time, it was very disempowering because, as you know—and as I've gradually come to absolutely believe and reckon with the fact—for the artist, the needs of the work, the needs of the self, the needs of the lived growth involved, these are perpetually in conflict with the needs of the marketplace, the expectations of success, the building of a career, the strictures of money and basically the world in general, the worldly world.

That conflict is the central paradox of the position of the artist, and just destroys most artists and most art. There are a few who, I would say, are able to just blithely shine us on and continue their imaginative journey without too much interruption. These people are either heroically strong somehow, or gifted with such a good sense of security that it doesn't matter, or they are so insane that it doesn't matter to them. But I am not one of those three kinds.

What I am is one who has struggled. Part of the struggle comes from the price inside, of the family that wants to crush the ego before it does anything.

You're supposed to be good, be perfect and blah, blah, blah...and just hide basically. "Be a good girl and don't expect anything; never toot your own horn." I've done this to a large degree, and it's cost me; it's cost good a bit; it's cost me a lot. Because, America! If you don't toot your own horn, you're submarined.

I think it took me to about the age of forty-five to realize that it wasn't such a big deal; to where my relationship with my ego became conscious enough that I could negotiate in and around it, and to have some lucidity around it.

It still didn't get me out of the woods, because we internalize a voice in our heads that is never ceasing, I will say "we"—maybe I should say "I"—but I suspect strongly that many, many other artists have that: that fucking voice, the voice of your dealer, the voice of your greater ambitions. I mean every artist has a wild dream to have a big retrospective at New York MOMA. So you always try to see if you can point your boat in that direction and second-guess what it is that could be the winning ticket. You sit there in

front of your work and you're making micro-decisions every moment.

These micro-decisions add up to a work, and this work is either quote, authentic, or not. The word "authentic" has a big, bad rep because of post-modernism, and I'm quickly understanding why. At the same time, the artist, facing the work, has to recognize and decide and see whether this work really tells the truth about him or herself; not the truth with a big T; the truth with a little t; the truth of today; the truth of now; the truth that makes a real account of a situation—or some other, larger truth in which the painting starts to glow in the way that happens beyond intentions, and which is really what we would be looking for.

What makes the painting really happen is when we can say, "I planned this and this has happened." You just go someplace, following something, and you get someplace like that.

The place where you go is not the place you had anticipated. The place where you go is the place where you may have had the courage to let yourself go to. In other words, it's not a person doing the creating. What it is, is a person who is scanning experience and positing experience on the artwork, such as it is. This experience comes to us from who knows where? Because, as you know, life is ungraspable. The privilege of being able to manifest is ungraspability; it's an amazing privilege. To have the courage to go there is another thing again. So I don't know how I got here. Ask me something.

RW: I believe a lot of artists will recognize what you're talking about. Have you ever read any of Agnes Martin's writings?

IP: I love her writing and her work, and what she stands for. However, she's really such a purist and a modernist, and in that sense, it's a bit too much for me, really. I don't consider my work, as it stands right now, to be modernist work, or to want to espouse a line of purity like that. For instance, I've changed styles, I don't know how many times. It has cost me a lot, but I am very happy for it, because it was fun, man! And it was agonizing, because I knew I was going to take a hit, career-wise.

RW: I wonder about those moments in your career where you changed something. How that was for you?

IP: Well, my work kind of happened in reaction to the previous body of work. I started out with these big sculptures. I got into grad school at UC Davis which, at that time, was Arneson, De Forest, Thiebaud, Neri, and Cornelia Schultz—once again, the lone woman. All these people had big reputations. They were the leading shock troops of Bay Area Funk, and I didn't understand a thing about their work—Arneson's work, Roy's work, even Thiebaud's work,

in a way. The only one I really understood was Manual [Neri], and we hit it off. It didn't matter that I didn't understand these people, I took them anyway. I earned their respect somehow, in an oblique way. I had virtually no training in 2D. I precipitated myself on what I wanted to do. I had virtually no training in Art History. I found myself in high company, tons of stress: graduate school. You don't piss or shit for the first two years. Then this emotional event happened. I lost a close relative in Switzerland and I responded to that; I just really looked inside.

When you have a highly emotional and painful experience like this it's easy to pinpoint what's going on because it's just right there in your face. So that was good. I could tell what I did not want to do.

I started to make a structure in wood that was whittled and papier-mâché. It was a long, elaborately made boat, but it didn't quite fit the bill. So I started making drawings. That was the only thing that did. These drawings were in 6B pencils on BFK Reeves. They all used the same compositional format: two rings, concentric, in a circus, some figures in the ring, things flying off in space, off of trapezes, or doing unexplainable rituals down on the floor, and using the basic geometric elements, the square, the circle, the triangle, to create various things.

The upshot was that these drawings were not drawn very well since I didn't know how to draw. But we talked about looking into the unknown; they each contained a silence. They were narrative, but I could not tell you what the narrative was about. Yet, it was precise. I would spend days working out where things were going to be. It was a pretty amazing experience of spending days using your intuition and not much else; working these relationships out and not out of any received ideas; then drawing them in, shittily. There were about a dozen of those.

At the same time I did this huge sculptural installation with my friend Liz Jennings, these kinds of monster things. Actually, they were kind of like me. There was plaster, burlap; there were chairs piled up underneath to make a structure. It was nutty. We worked all night long for weeks. So I was on these two different tracks at the same time, really different. Okay, so I did that, and somehow I was sure I was going to get flunked. But I didn't get flunked; I got a scholarship to Skowhegan, and I got a full scholarship for the rest of grad school.

RW: That's something!

IP: Yes. So all of the sudden I became sort of the little, you know, *somebody* over there. It pissed everybody else off, of course.

RW: Do you think the response to that body of work, the fact that it was

received so well, was because it was authentic?

IP: They saw that! And what I'll always be grateful to them for is that they didn't penalize me for marching across media, for going into a media [drawing] I had not been admitted in and had never done before. And they respected me as a woman, which is another thing, you know. So I have an everlasting gratitude to these people.

RW: The art faculty at UC Davis...

IP: Yes. So then I went to Skowhegan. I started making little self-portraits. They were so intimate. I didn't really need to talk to anyone, even though I had a great time at Skowhegan. Great summer sex, and all of that. And again, they saw the work; they saw its strength, even though it was so modest, the double portraits.

One style was realistic and the other one was a metaphor. They functioned as equivalents. This side, water oozing down a wall, it could be tears or not: and the other side, a little lady holding a towel in a Renaissance kind of setting. The lady's face was painted in oil, which I had never touched before.

It was a great liberatory experience, just to throw in all these styles. It was just a little before the "New Image" thing. Remember the new-image painters, Lois Lane and all these people?

RW: I can't say I do.

IP: What they did was called "bad painting" also. They brought image back into the language. It had been thrown away by abstraction. Then it had been pulled in a different direction by Pop. Theirs was much more personal. So it was opening up that possibility. Because "personal" was a fucking dirty word, I mean.

RW: Right.

IP: So it was really quite a gesture of liberation moving from the idea of "a style," the idea of a person adhering to their hard-earned signature. Anyway, I was still going through grad school. Then I started making these little pieces in encaustic. There's one on the door. Go ahead and take a look at that.

RW: [I get up and walk over to look] I've never seen encaustic done like this, with this three dimensional surface.

IP: It's a technique I invented. I studied about encaustic through all the books in the seventeenth century. There was not much written about it. The

little Faiyum portrait was in my mind all along, all the Faiyum portraits.
RW: That was the 2000-year-old one?

IP: Yes. It's the one in my living room. It's a home place that I went to: the idea of self-portraiture that entered in at Skowhegan and continued with these things. It combined two styles, the hyper-real style of the raised figure, and then the backgrounds that could be painted loosely. I wanted the looseness confronted with the tightness.

Actually it's always been a strategy that I've used to some degree. So I made these things! And they were, oh, they were nice! People started buying them. This was in grad school, my last year, 1979-80. People liked them. People came to the studio and wanted to show them. I was kind of like this little island out there in Davis.

[a little material was lost here. Pijoan began talking about envy, others for her, and her own feelings of envy for other artists.]

IP: …I was getting sick of that: the envy, jealously, wanting more success. "I think my paintings are just as good as hers, but hers sell for $30,000.00 blah, blah, blah…" Okay, let's not go there—maybe some other time.

RW: Enough said. [laughs]

IP: So I made those. I showed them with Inez Storer at Stinson Beach, or wherever it was that she had that gallery. Do you know who she is?

RW: I know the name, but that's all.

IP: As if it matters. Then I got a scholarship to be an artist in residence at the University of Georgia on a Ford Foundation fellowship. The stipend was just enough to live on in flea-ridden Georgia.

RW: Gosh! Georgia?

IP: Georgia was a revelation, man! Georgia was just—*oohhhh, goshhh*. Now I understand what they mean by "The South." I still know, I'm sure, only the quarter of it, but that was really something! Especially from the point of view of being a woman. It was very interesting because the faculty paid a lot of lip service to how much they respected my work and so forth, but then when it came to actually being buddies—hanging out—they were gone.

But the University of Georgia had a summer program in Cortona in Italy. They sent me there to teach, so I had three months of teaching in Cortona—the hill towns. It was really cool because I taught in this little chapel that had

disappearing frescos in it; it was old. There is no development there, so this was a gym; they had put the gym in a chapel with frescos. It was empty during the summer, so it was my classroom!—with a bunch of girls from the south with their hair-curlers and god knows what else.

I got a lot out of the teaching there and, of course, tons out of Italy which I had already traveled to two or three times. But just taking advantage of tours—it was loathsome to be carted around in a bus, but once you were there, phew! There was always some unbelievable marvel to see, and you were filled with it! The beauty of Tuscan light! The utter dream of Tuscany! It's like a dream, floating, floating... okay, I'm digressing.

So when I was in Georgia, I made more of these encaustic things and I became more interested. I went from self-portraiture to portraiture. I worked in that series and had another show, this time at Paule Anglim in San Francisco.

Then I went to another fellowship, an artist-in-residency in Roswell, New Mexico. It was quite well known because they support you for a year. They give you a house, a studio, a stipend and, at the time, it paid for your materials—six other artists in the middle of nowhere!

RW: I've been through there a couple of times, the flying saucer capitol.

IP: [laughs] Okay. Yes. The isolation is almost complete. Which would help one concentrate, but would also drive one slightly out of their gourd, a single woman, blah, blah.

So I continued making my relief things, but I changed them. I made them on more 3-D surfaces. They were round or concave or convex forms. I would put the figure on there. They were very beautiful. They were good. Then I realized, shit, I'm going to get pigeonholed into this thing! Are they going to expect me to make encaustic relief things for the rest of my life? Because it wasn't like now, where you can freely change and so forth. It's been a long time coming, this moment—a great moment! Back then changing was like jettisoning everything!

RW: Would care to say more about that?

IP: Yes—for people like me who have needed to change their imagery in order to grow. My commitment was really *to growth*; it was to following wherever it was that the art was telling me to go...

I wanted desperately the other stuff, the success, but not so desperately that I was willing to give that up. So there was a great deal of conflict. And that's also partly why, in time, I chose to teach. I didn't want to be dependent on these gallery checks and their fickleness and the fickleness of the marketplace. And I knew that I was a born teacher. I knew because my mind

is so didactic that it's horrifying.

RW: What do you mean it's so didactic that it's horrifying? Can you say a little about that?

IP: Oh yes. I can tell you all about it! My mind picks up experience and thinks about it, cogitates, analyzes, puts it in categories and prepares to explain it all to the next person! To shed the light! Both my parents were teachers. My father was a university professor; my mom was a little kid teacher. So that's one thing. The other thing is that I'm a control freak! So doing this enables me to try to control the world around me and make it in my image somehow.

RW: This didactic part wants to control, but help too, I suppose—show people the right way.

IP: Umhunh. But it's also fuckin' Calvinistic! But yes. The didacticism of my mind applies to not just my students, but to my friends, my family and everything around—to the point that now I'm planning my own funeral.

RW: And as with probably so many things, there's the good and the bad, right?

IP: Yes. There are both in me. I have learned to hold back a little bit, but if I look at my stream of thought, through meditation, I see every attempt. It's funny, because my teacher here was actually talking me out, through a meditation—allowing me to let go of that so I could see and receive the world and its perceptions without trying to tweak them until one thought turns into another and another, and pretty soon you're out in Katmandu, you know? I realize that for me it's a very special task, especially, especially at this late date.

    See that's the problem with these questions; they are absolutely great, but then I feel like I need to start about two miles behind and explain the whole circumstance I've lived through. It's such a roundabout way of doing things, and I don't see how, in an interview, you would include some of this, but really, it's more of a document.

RW: That's right. I think it's good to think of this as a document, rather than to worry about the rest of it. You have some important things to say, and if they're put in context, so much the better—as long as you're up to it.

IP: Okay. Let me close my eyes…[pauses] *Didacticism*. I do think it's an endlessly difficult question, not just for artists but for human beings in general. We need to be able to instruct each other, to guide each other. In

182

order to do that, we base ourselves in our own experience and reframe it; articulate it. Yet at the same time, you can't get caught in that process. I was saying how I get caught in that process. The only thing that has given me a teeny bit of distance from it is through meditation.

So now I'm going to get on the subject of meditation, okay? But making my way as clearly as I can towards the question you had, which was why did you think that this opening up of all styles for all artists any time now was important? That's what you had asked.

RW: That's right.

IP: Maybe I'll start by answering the question in as simple a way as I can. People's worlds in this era are bombarded by so many different levels and sorts of experience—inner experience, clashing with art, conflating with outer experience—and having constantly to try to bring the two into some sort of harmony.

You know, analytical experience has taken a very strong lead in art in the last ten years, maybe fifteen, and that's only a reflection of what's actually happening to us: mobility, different media, different approaches, and so forth. So you have to really commit to an artist and go there with him or her and just try to follow the train of thought through it all. I mostly don't have the patience to do that, but with younger artists and how they work, that's just how it is. To stick to one thing is okay, too.

RW: Is there a connection to be made between the overwhelming amount of information, the overload of stimulation, and not being able to find a quiet mind, if you will? I mean I have my thoughts on that, but…

IP: Yes. And that transitions us perfectly to the subject of meditation. I came to meditation about 1983 out of an inner need that was just very strong, the kind of need for someone to have a garden, or to live in New York. Or the need for somebody to get married and have a big wedding with a dress…

RW: It is something you felt.

IP: Yes. Because I had already practiced without really knowing that this is what it was called. In my hours in Roswell, in my loneliness, I was already practicing.

When I was only a teenager, I read books about Zen in French; they were turning points for me. So twenty years later, I call up a friend, Cornelia Schultz. I asked, "What do you do if you want to meditate around here?" She gave me two sources, the Tibetans and the Vipassana folks. I went to the Tibetans a little while, but that went nowhere. So I went to the Vipassana

folks, and I hit the jackpot.

RW: Is Jack Kornfeld [who was working with Pijoan] connected with Vipassana?

IP: Yes. He's one of the lead teachers of a strong and growing array of primarily Western teachers who have studied in depth. There is a center based in Spirit Rock in West Marin and also one, which is led by Joseph Goldstein, based in the woods of Vermont or somewhere in the northeast. There's also one in Hawaii. There's a Sangha that's kind of all over the U.S. now. It's remarkable that this has expanded so beautifully because it's based on very definite principles. It's kind of tweaked for Westerners, but it's not a watered-down practice, not a lot.

Okay. Let's go to the practice itself. I could go on about the practice itself for hours, and I would give a dharma talk. I don't think this is the purview of our time here together. But I'll try to go as shortly as possible into it.

The practice is of holding up a mirror to the mind and the body. So you sit down, close your eyes. Silence. You pay attention to the breath, sensations in the body, and the emotions, or feelings, which we feel at all times. The breath changes all the time; the sensations change all the time; the emotions or feelings change all of the time; and then the thoughts come and go and change all of the time. So these four levels of experience—there's another one that's too rarefied and I won't talk about it—these really represent all that comes into us.

It's like automatic function, like the breath. It's mental function; it's emotion response; it's physical response—and you start to see, interestingly, that these functions are kind of articulated with one another, at least at one point in the meditative process, if you go to a certain depth.

Where you go is so interesting and so complex and so rich, that it makes you understand that this process has no end, that this process is a process of discovery, pure research. You don't get to some place where you've conquered it at all. There's more discovery; there's more adventure. It's like an adventure; you're cast out in the wilderness by yourself in the jungles of Papua New Guinea, you know. Everything takes a different color. Everything changes all the time.

You start noticing these changes because...well, you think, "the breath; I breath in; I breath out; leave me alone." But then you really pay attention to it for a period of days and nothing but it, and you notice all kinds of stuff. One of the things you notice is how the breath, for instance, is connected with emotion, or feeling—a feeling sensed sometimes, things that you can't really put into words. You may feel a certain way that is just odd; and then thoughts, a thought may come through the mind, trigger an emotion, that will trigger a sensation in the body.

How these things are articulated fascinates me. There is the Cartesian

level; the emotive level; the physical level. So that is just fascinating to me—and watching at which point the mind just becomes distracted, constantly, from the task, which is the task of concentration—the mind just focuses on the breath for a minute, maybe thirty seconds, maybe ten, then a thought interjects. And thought, as we know, leads to another thought, leads to another thought, leads to another thought. Pretty soon, you're in Timbuktu. You've completely forgotten where you are and what you're doing.

RW: The didactic process in relation to this inner landscape could be a matter of providing some guidance, some knowledge, right?

IP: What it is, is that all of the sudden you have a little experience; you start noticing, "Wow, this is what happens, the breath was here and then these thoughts interjected." So your mind goes around just trying to frame this, articulate it, and take that home.

RW: The mind wants to possess it and have control.

IP: Exactly. So for me there's been a monkey on my back in my own practice. Craig [Pijoan's husband, Craig Nagasawa] doesn't have that. It's amazing! Totally amazing.

RW: Yes. I have some experience along these lines.

IP: Maybe that's why you make this magazine. It's not a bad thing because it propels you in the world. It makes you do stuff.

RW: Right. And it has the good and the bad, too.

IP: I think it's a way of co-opting experience in order to gain control over it. It's very unfortunate when you're just trying to be and let things come in and out—because it is a flow. Something comes in; it leaves. The process goes on and on.

I guess that was a discovery; and I was able to struggle with that, agonize over that until a point when I just went, "God! This is so idiotic! This is so prevalent! This is so goofy!" and I could laugh about it.

That, and other things from practice, is what gives me a certain distancing and, at the same time, a closeness to experience which made it possible to take what was happening to me with a grain of salt. If it wasn't for that practice, I don't think I would be with Craig. I don't think I would have had a child. I don't know whether I'd have a career. I mean I'd just be getting peeled off the ceiling somewhere.

Anyway, I'm just describing to you a tiny example of things that

happened. The things that didn't happen—as I talk to you now about the chatter of the mind—things that didn't happen, are silence, and a certain emptying out. Those moments are blissful in the extreme! Healing in the extreme, mysterious and deep! Those are some of the goodies in meditation. They're amazing goodies. You can't take those home because they come, and then they go. Then another wave of something else happens: agitation perhaps, or sleepiness.

So the purpose of meditation is not to attain those states; it is to continue the discovery, the layers, the levels, the strange and beautiful things that appear.

There is a teacher in Thailand, Achann Chah. He said something like "Just be quiet. The mind is like a still forest pond. If you sit there quietly, all manners of strange and beautiful animals will come and show themselves." It's such a true thing. Yes...

I hate to have to use this word "mystery"—it's really boring... *numinousness*, to use a Jungian term, the glowing of experience; experience starts to glow. You look at a leaf on a tree and you just see it for the first time; you see light, and color starts to come back into your vision. You had forgotten that it was even there—*all kinds of things.*

So, how does that relate to my work?

The way that it relates is that it forced, at some point, the radical change from figuration and narrative to a different kind of figuration and narrative that was much more loosely organized. I started to see myself not as a container or as one who had to present this statement, but more like something with two ends; experience enters and then leaves.

Actually we don't have much of a choice of what it is or even what our response will be. We may have the choice, a little bit, of coming back to attention, having given ourselves this instruction, and trying to hold this; of coming back and letting go of things, and then coming back to the place of beginning. Beginning again, each time, you know?

But for the rest, we think we're containers and that experience amasses, that we grow into this big important thing. Mind you, on the brink of death, I'm very sad about the big important thing that I've become to myself and to others. I have to leave that behind. It really bums me out, because I feel like I was in a really good place in my life. I was just almost, you know, really getting going, because it took me so long to really get going.

Seeing yourself, though, also as this vessel, as a sieve: there are lots of little holes; water enters the sieve, and it spends but a moment there; then it drips out. It's a lovely image, this sieve. It doesn't hold on to anything. You get to see what happens a little bit. It doesn't just fall straight through; and it's pretty. A sieve is pretty. It has all these holes and these dots and stuff, and it's cute.

From seeing all that, I saw that experience was non-hierarchical. That is

the big thing that I learned: there wasn't any place in my experience, my close inner experience, that really superseded something else. That means that a thought is just as good as a weird shape that just came from God knows where. The thought may have a narrative for describing itself. A shape that comes from anywhere—we don't know—say a structural shape that appears that things can fit into, and so on. Daily things of daily life. Sensations, feelings. They get worked through, and you get to describe these with precision and patience.

I use dots a lot in my recent and not so recent years. Making a dot is a way of just facing oneself in the center of a moment. You just [gesturing as with a brush] *Bing!* You make a dot. Then the moment changes, and [gestures] *Poing!* You make another dot.

So it's just all of these little markings, or trackings. I did a lot of works on paper that worked with that. Anyway, this was tremendously liberating. It was also, once again, tremendously befuddling to my public, whatever tiny amount of it there is.

That's when I realized I could put everything but the kitchen-sink in there as long as it's real and it's coming out of me right now. Then, gradually, sort of more concerted things re-appeared.

When I start cutting through the paper, I have to plan; I have to know where it's going in advance. But I'm always able to avail myself of this method of receiving into a work by just abandoning, putting down my weapons, abandoning the kind of control, and yet being very clearly and precisely answerable to what is happening right now.

So that's what led me to an understanding of—*postmodernism* is a word that is already out of fashion now—but the whole opening up of the vocabulary and of the field for artmaking today.

I think this idea of being non-hierarchical was picked up by others, too, probably in a completely different way. It has been fairly prevalent. I think it's been a major break. So that's why I said I love Agnes Martin. I love her purism and her, what's the word...?

RW: One thing she talks about is *humility*, which is an idea that is probably incomprehensible to most people.

IP: And I think my seeing really is humility—in the sense that I really have to be brought to my knees to make movement in my work, and I am being brought to my knees now. I have to roll with the punches, and it's really quite a job, but it's a good job. I'm getting so much wonderful help, and I'm so full of gratitude for that. People who are true friends and have true love.

[Pijoan is overcome with emotion. I turn the tape off. After a while she

wishes continue.]

I've had a very big battle with humility because, in my background, you weren't supposed to show any ego. My mother had virtually no jewelry. She never wore a spot of make-up. The money that was in the family, on my brother's side; there was a real feeling that you had to make a contribution.

All this is to say that humility was given to me as an "ought to" which is a total drag. You don't get to come by it. Ego was given to me as something I had to win, up against my father. It took me until I was about forty-five years old—I kid you not—to come to the realization that "Fuck it, man!" If I want to go around wearing something on my chest, *I shall*!

But, at the same time, I deeply believe that building a life on ego is, it's a losing proposition, man. You will never end up where I am now; surrounded by the loving friends I have, if you did that.

RW: Are there particular pieces you'd want to say anything about? Maybe some really stand out.

IP: Well, out of every body of work there's always one or two where you feel you've really nailed it. I can tell you which ones they are, but I don't think it's very important.

RW: Another question would be, and this is a bit redundant, but first of all, would you describe your life of artmaking as a search, a journey?

IP: Oh, completely! And it was there from the beginning, a commitment to process. My first commitment was to process, which really is a meditative pursuit, as opposed to product.

Of course, I got tangled because I wanted a product, and artists need a product, not just to sell, but they need it because it reflects their quest. It reflects what they are trying to do. A whole bunch of processes all stuck together is not going to be enough, which is sometimes what students don't understand. But my life, and my work, yes.

RW: And, if one were to describe it as a search, then what is the search?

IP: Well, as I said, there's no end. The search is for discovery. The search is for understanding, or seeing life, the universe, the planet, ourselves, our interactions, our social constructs, and so forth; to see them in a new way; to see them more clearly. In my case it really had to be centered on the inner life, and I know that I'd probably be crucified for that by most of the art world, which, by the way, has haughtily shat on my face for the last twenty years.

I've had some very faithful and wonderful people in my trajectory too,

but there just have been some things that really rile me. So, like every artist, I'm subject to bitterness, but I do my very best to maintain perspective about it and not let it lead me around, because that's the kiss of death. Artists motivated by bitterness—there's just a bad scene. That's going to eat them alive.

RW: So much of what you've said is so valuable. There seems to be a lack, in the fashionable thinking, a lack of articulation of the potential value of the kind of search you have spoken about so well. This realm of inner experience, that world is a huge world. There are no maps, really. And the artist is the person who has the privilege, the difficulty, without support or guidance, of finding his or her way in that world.

Theory is all over on the side of the object. It may be very sophisticated, and so obtain authority, but what about this other world?

IP: Yes. It's I think true. The writer is the writer and their job is to try to contextualize it in a philosophical context. It's very Cartesian. There are artists out there, for instance, Amy Sillman in New York. She plays when she paints. She plays. Her playing is full of style that comes from the sixties, but it's also just invention. Really it comes from a very similar place as myself. I don't know what they're writing about her, but that's where her work is.

So much work you look at and you just go, "duh." That's kind of a drag, but I've gotten much more tolerant in the sense that I've become aware of all that I don't know. Maybe these people are doing something that I don't know about and I'll cut them some slack, rather than just to crash in on them and say, "Well, this is fucked."

I think it's too easy for us artists to kind of write off the rest of the art world and just try to make ourselves a corner and solidify our corner and get our friends to join in. I mean it's great to have that, but it's also great to stay open. You need both, basically.

189

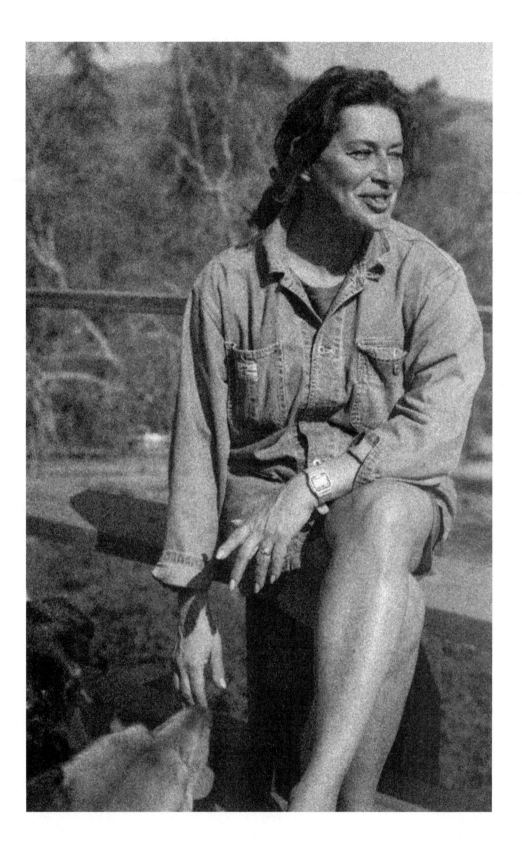

# JANE ROSEN

## SAN GREGORIO, CALIFORNIA, 1994

*Jane Rosen lived, worked, and exhibited in NY for twenty years. Rosen has taught art at several colleges and universities including The School of Visual Arts in Manhattan, Stanford, the University of California at Davis and the University of California at Berkeley, where she recently [2006] tendered her resignation to pursue her own artwork and a book she's working on with Richard Rhodes.*

*My friendship with Jane has been an ongoing source of inspiration and support. Rosen is an unusually gifted and charismatic teacher. She recently has begun giving drawing workshops at her forty-acre ranch and studio along the California Coast south of San Francisco. In 1994 I sat down to talk with her about her art. My wife, Rue Harrison, joined us.*

Richard Whittaker: Who and what does your art address?

Jane Rosen: I want to make work that you don't have to have a Master's degree in Art History to understand. When I lived in St. Martin there was something about the quiet and the water. I became interested in fishing and met an elegant old black man, Mr. Anstley Yarde, who was very tall and thin and had a great presence. He taught me how to fish. You use a can and string. He'd get me at six o'clock in the morning and we'd get these snails. We'd sit on a rock and drop soda-can lines, and just sit there. I never caught a fish, but he'd catch them. He'd *hear* them and I thought: this man has *knowledge*. One day, we're sitting on the rock and he asked me what kind of art I made. I knew Mr. Anstley Yarde would not understand the art I was making at that time, and I realized I wanted him to understand it. It raised that question: who and what does my art address? Who did I want to talk to? And what did I want to talk about?

RW: There's the hard-nosed challenge to that simple idea that, as a writer, or artist, I understand enough *to know* what I'm saying, or trying to say—that postmodern, skeptical view. What do you make of that?

JR: If you say there is no possibility of communication, you still have to wake up the next morning, make your coffee, and function. Now what can guide you through that? A critical theorist who is very involved in deconstruction was at a dinner party along with a friend of mine—a sculptor—and, as they were leaving the dinner, the theorist left in my sculptor friend's coat. She did not know until she got home and looked in the mirror and noticed that her dress no longer hung out under her coat that she was in someone else's coat!

191

Whereas the sculptor immediately knew that the remaining coat wasn't hers. She didn't even have to put it on to know it.

I don't know if this story is useful, but I know that people now—more than they have in many, many years—desperately need something that is a direction *toward*, rather than nihilism. My interest in art is not about telling us what the bad news is; we know what the bad news is. My question, and the question that my art addresses, is "What is the possibility of the good news?" Not that the art has to be uplifting, but that it address questions about other possible states of awareness that could lead us toward that which could be a help.

Theorists will start talking and I'll start thinking, "O God—I'm illiterate!" But in actual fact, I'm literate about another range of experience, a range they are not connected to. It's simply not an issue for them! So I have no problem with what they're doing. What I'm saying is, "You still have to get up in the morning and live life." The moment you realize you're mortal, that you are only here for a certain amount of time, that your body is a machine, and it's parts— just like my Volvo— are going one by one, the question becomes, "What is it?"

This is why I say art is the language of the body and feeling trying to make a relationship between what the disconnected part of my mind is desperately trying to understand. That, as a possibility, is what art does. It's informing and transforming another part of myself, and showing me what's really going on. I think of this as my "underwater life." It has to do with the difference between sitting in a boat on the surface of the water versus diving under the water and snorkeling, which is a much more three-dimensional experience. My mind is sort of above the water. This underwater life constantly registers all of these impressions that aren't being heard or received.

RW: By your mind?

JR: By a certain part of my mind. Right now there is so much talk about the mind-body connection. Although I'm interested in esoteric things and always interested in the question of philosophy or spirituality, I feel like I'm some construction worker who's seen God and didn't want to! I had the experience and then had to understand what the hell it was!

This underwater life is going on all the time. When I see a shell or I see a horse; when I see two weather systems meeting, I don't understand it with words: I *feel* something, I experience something. I am aware of it, but I can't say what it is. When I try to understand it with my hands, something in the alchemy—the process of working—engages a kind of listening; the underwater life connects. It registers something and begins to lead me. So rather than impose, I follow. For me, that is the art process.

To make art about the bad news or the negative aspects of our existence, of which there are many—and God knows, after living in New York for twenty

years I think I've hit most of them!—is not my interest. The question is, "What is my possibility?" How can art direct us toward our possibilities? Toward a finer quality of existence so that the relationship between nature and the culture I find myself in can be reconciled; so a balance can be brought; so I can understand. That is what interests me.

The art world, in a way, is both a help and an obstacle because it exposes my ego and my inadequacy. It asks for newness, a kind of brilliance, and fast food. It's got to be quick. However, I'm slow and have a range of experience from the extraordinary to the mundane. How to reconcile those things is not something that can be easily digested by the art world. It's a slow hit. My original dealer, Ed Thorpe, is someone who took on people who were slow like that.

RW: What you call the underwater life, the experiences and processes that go on in the body, and being in touch with that experience—I like the way you express that.

JR: The Egyptians spoke about the intelligence of the heart and the intelligence of the body. What I mean by that is—let's talk about animals again. For me, animal nature is a very important key to understanding our own nature. Watch a cat waiting for a mouse. There is an attention in his body that is extraordinary. There are no distractions, no thoughts about what he is going to do later or whether maybe there's another mouse that might be bigger. The cat is completely there. There are times when I am working where there's a state like that. When I'm working there are times when I can hear my blood and my heartbeat in tune with the movement of the material. It's about being in your body. I think athletes experience this and people who are alone in nature for long periods of time, like farmers. They have a kind of intelligence. You can see them looking at you. They don't say much. But there is an intelligence, an instinct just like the cat. I think it's the knowledge that American Indians have—that more ancient cultures have. The Eskimos understand. For the Egyptians, art was a byproduct. It wasn't the point. It wasn't the point! It was the byproduct of an investigation.

When I am working in the studio, I come up against all these difficulties. I start. Something comes. It's given. I look at it. My ego says, "What a good girl am I!" Then this ego goes in and takes over. The beauty is that this mistake becomes visible, like the registration of a sewing line. You see where you were not paying attention. Your marks are a registration of the state you're in. You see when you've just destroyed something that was given in a moment after really struggling through an obstacle. That's what I mean by an accumulation of different experiences that get registered on this wood, on this canvas, this paper, this stone.

There you are outside of yourself being informed as to how you are. You become humble and go back and try to listen. I think that my having

synesthesia—that is, actually hearing forms—if I look at a wing, I don't see the shape of a wing, I hear the sound. So, if I am hearing this sound as a form or movement and am following that sound, the wing appears. I don't make the wing. If I try to make a picture of that wing, I draw very badly.

It occurs to me that, in this act, this effort, that I openly engage in the possibility of becoming more alive. You have to be more alive. You become more aware of what is going on. That awareness can be felt by the viewer, and they can experience that in themselves. It is rare that this fortunate event occurs. Most of the time it doesn't. That, for me, is a language that can be communicated.

RW: The possibility of becoming more alive. Could you say anything more about that?

JR: Most of the time we are not able to be in that state. For instance, I'm usually more interested in watching videos or talking, and I am not really feeling fully alive. What I become very interested in—and this is why I speak about the relation between nature and culture—is how there could be a finer quality of awareness, which is given to me in nature. When I'm in the face of "human nature," how to be able to be in a room with people? To be in the face of difficulties? To be in the world and to be more alive? Other questions this brings are: How am I with students? What does it mean to be on the forward roll of the wave in a more aggressive state, or in the backward roll in a more passive state? What does it mean to be in a better or worse position in the art world, or in society, or in my own work? How is it possible to bring this intelligence to that?

When we were small children, my brother and I were told by my father over and over again, "This above all, to thine own self be true." I would ask him, "Should I go to the prom with Jimmy?" and he would say, "This above all, to thine own self be true." It wasn't a big help at the time. [laughs]

When I look at students' work and they are covering things with bees' wax and brassieres, these images of fear about gender, fear about race, fear about inequalities, fear about the environment—well, I'm afraid of those things too, in a certain state, but, in another state, those things are simply not issues. This kind of fear and questioning of these things like, let's say, feminism—I've lived the life of a feminist! Yet my art doesn't address that directly. It doesn't mean I'm not interested in that. It doesn't mean I don't fight for every woman student and every other woman artist. I do. The contribution would be to struggle with relating the finer to the coarser, or the coarser to the finer, to make a relationship to these two things.

RW: I remember a quote in something about Rothko to the effect that the Abstract Expressionists were the last generation of American painters who could believe

that art was a noble calling. But talking with you, and I find this with many other artists too, there's still a feeling that could be described on that level somehow.

JR: You know—and I don't mean to put anybody down—but for something to be really art, not social commentary, it has to engage more of the viewer. It has to activate what can be felt, what can be sensed, and what can be thought. It has to activate that. Rothko: when you look at a Rothko, here's a man who prayed on canvas. He prayed with his mind to understand the nature of light. He prayed with his heart to feel the space within and he prayed with his body to be in relation to the material. This prayer is perhaps a question that takes many forms, but speaks of what our better nature might be. For me, this is art.

Rue Harrison: Does your passion for teaching relate to the importance art making has for you?

JR: They're feeding each other. Here's an example: I was trying to understand how to talk about painting issues with an advanced drawing class at Stanford. My friend sent me this little quote from Leonardo Da Vinci, "Painting is concerned with the ten things you can see: these are brightness and darkness, substance and color, form and place, remoteness and nearness, movement and rest." There was something so extraordinary about thinking about painting in that way. Around students or around questions like this, something else comes up in me that's just not there normally.

I have a sensitivity to the students. I've noticed that, if they like you and they see that you're lying, they put their heads down like this. [Rosen demonstrates] They get embarrassed for you. They show you that you're not telling the truth. They're embarrassed for you because they like you. If they don't like you [she demonstrates a look of disdain], I can read that. I can sometimes feel them like a moving mass of energy. But the point of the Leonardo quote is that it started to feed me. I mean, why "form and place"? Why "substance and color"? So it's like the laws of polarity. You don't know hot unless you know cold, soft unless you know hard.

What happens is I'll be in my studio and I'll start thinking, what does that really mean? I'll be researching it for all of us. Then the students come with what they've found. I come with what I've found, and there's an exchange. Now, to me, that's sacred. Also, to watch them the first time they make a connection between the sensation of touching something and what their eyes see—a relationship—it's an extraordinary experience for them, and it's one they've had in nature. It's one they've never had a name for, and which has never been educated. Drawing can educate that. So I work a lot with students on these and other relationships that they have.

RH: What relationships are you referring to?

JR: The difference between walking in nature and reading a book about it. Yesterday, I took sixty of my students from U.C. Berkeley on a field trip. First we met at the beach. It was just extraordinary because the fog came in, but there was a line of light along the horizon that was very beautiful. The cliffs there have a scale that does this to you. [makes a vertical axis with a movement of her hand] You immediately [straighten up] I think it's almost a law. It doesn't matter what state you're in. I mean, just visualizing the cliffs, it happens to me. So I just watched them walk down the beach, each one of them, like bells being struck the moment they had these perceptions.

As you stand there looking at one cliff—it's just a sand cliff, a drop off from the erosion of the water—in the middle, you see a boat. There's a boat that obviously many years ago got blown in and covered by sand, and the erosion has exposed it. The front of this boat is sticking out from the sand cliff, and above it is a half circle of these monk-like shapes: six men in robes—my favorite image, probably in the world. The image of these two things is so strong that I just knew if they could see that...

Anyway, after that, we drove to the Rodin sculpture garden at Stanford. Rodin was amazing, and the students could sense the relation between the movement of the mass of the cliffs and the feeling for the movement of the mass of the human form that Rodin had. Finally we went to hear Kiki Smith speak, and the Berkeley students, who are very bright, could see the contradictions brought by these three very different events.

RW: So you see a possible role in the process of drawing that might reconnect us to the natural world?

JR: Without a doubt. Let me show you something. [leaves and returns with a beautiful bivalve shell]

RW: It's beautiful.

JR: Does that have a way of connecting us? I mean, the experience of trying to understand it with your hands. If you sit down and try to draw that, it brings up, without a shadow of doubt, the connections of everything. Open and close. Breathe in, breathe out.

RW: Nature is very important to you. I mean, here in your house, all around, you have pieces of nature you've collected.

JR: They make me remember. Re-member. It doesn't matter what state I'm in. I just think there is this extraordinary miracle, and I've felt it since I was

a little kid. One of the reasons for making art is to express that for which there are no words.

We got this house on Long Island, an hour out of Manhattan, where I was living. It was on a bird preserve, and the only way to get there was by small boat. There were cranes and herons and ibises and hawks and harriers and osprey and kingfishers and ducks and sparrows and cardinals: a world of birds. I could understand their language. What I found is that animal nature is a key for us to understand our own nature. The relationship of their nature to the forces of nature all comes down to a kind of sacred map. The kinds of laws that govern nature begin to become visible in the interactions between these various species. You can see that in the shape of an oystercatcher's bill. It opens laterally, so that it can eat clams and oysters. Not only that, but a law appears in its relationship to others—there's a pecking order.

There are these elemental laws. There are only a few of them. I keep coming upon them each time I draw these forms. As you reduce it to the essential form, the essence of the form, there are very few movements. So that the forward roll of the wave, the forward roll of the spiral, gives you the hawk. The returning, or the receiving, gives you the sparrow. The wolf. The lamb. [Rosen makes gestures for all these] Depending on where it is on that spiral movement. And then, not only that, but you start to see the pinecone, which is a double spiral moving in two directions at once: five rotations one way, eight the other. That's the Fibonacci curve.

There is some way I feel that I'm never going to get at this relatedness by the actual math in that way. But the feeling tells me what the laws are. I can show you the relationships, but I can't tell you their names. I think they don't have names like that. I feel like Richard Dryfuss in "Close Encounters of the Third Kind"—you know, with the mud in the kitchen [gesticulates wildly, laughs]: "oh-oh, it's getting closerrr!" It's just so much like that. It's a really big thing, and it's a taste that I can taste sometimes with everything in me.

I moved from this loft in Manhattan to come look at this stuff. From experiences at Oak Island and from reading *The Conference of the Birds*, I'd sit and watch a blue jay and I'd notice that the guy in the Price Club would have the exact same expression as that blue jay fighting with that woodpecker. I'm thinking to myself, "What's that?" It's absolutely a key when I look at students' faces. They're each a different bird, each a different animal.

There are big questions that the kids have to face, for example, you're driving on 280 at night and you see a crescent moon and you feel, "I want to be that." Then you look and you see an endless stream of red taillights, which, if you didn't know what they were, would be equally beautiful and mystifying. And, in fact, I am part of the endless stream of red taillights. So what is my relationship to the moon and to this line of cars ahead of me, and how do I contend with and reconcile both? What are the laws governing these things that can help me—and those around me—to understand my proper place?

197

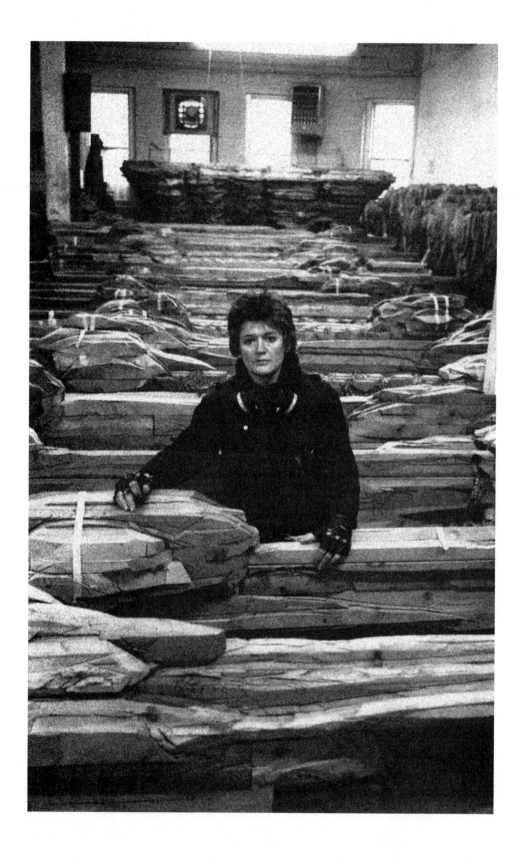

# URSULA VON RYDINGSVARD

## SAN FRANCISCO, CALIFORNIA, FEBRUARY 2003

*I got a call from Jane Rosen alerting me that her friend Ursula von Rydingsvard would be in San Francisco to give a talk at the San Francisco Art Institute. It would be a good chance to meet her and perhaps conduct an interview with this renowned sculptor. The artist would be staying with Ann Hatch and would only be in town for a day and a half. Fortunately, the pieces all came together.*

*Von Rydingsvard's work is powerful. Just looking at photographs of this New York artist's large cedar sculptures produced an effect in my body, which I found intriguing—and difficult to put into words. One often hears something like this said about art, but looking at von Rydingsvard's work seemed to produce a concentrated version of this experience.*

*We settled down in Ann Hatch's living room overlooking San Francisco Bay to talk…*

Richard Whittaker: Is there anything you're thinking about currently which you might want to reflect on?

Ursula von Rydingsvard: The thing I'm thinking about now is something I've thought about for the past number of years; that is, trying harder to break up the givens that I know, but to break them up in a way so that they have meaning. The process of breaking up is a kind of groping to figure out where I want to go—I guess to try to have a platform that I'm working through that does not have as many answers.

RW: You've been making art for many years.

UvR: Yes. I've been making art since the late sixties.

RW: So you've found certain directions are beginning to become fixed? Or habits are forming?

UvR: Yes. I think it's as in living life, that there are things one leans on. One gets a degree of comfort by leaning on them. I want to be very wary of that in my work. You lean on something because there is a connection between that which you lean on and yourself. I want to make sure that there is indeed a connection that still feels exciting, and that it's a connection I made a decision about. I guess my instinct is to throw things out of whack a little to see where they land and then to start gathering them again to see if there's another way that they might assemble themselves, which might be worthwhile for me at that moment. Just the process of throwing it off means that I have to reassess it.

RW: There's the search for some life, to use a big, general word.

UvR: I think that's really one of the most important things in any work, the life that one imbues it with. I'm not even saying that there's too much life or there's too little life—I don't think I'm saying that. I guess I want to ask the questions that feel like they're the most exciting questions to be asked; they're not questions I can ask verbally.

RW: I regret that I've seen only photographs of your work, but I've looked carefully. Even the photos affected me strongly, and it was clear they were reaching me in non-verbal places. You're saying that your questions can't be asked verbally, but have you ever tried to articulate it any more than that?

UvR: It sounds so corny when I say it, but the process is basically a kind of reaction to whatever is happening when I'm building a piece. You need a starting point, something you're going after. Maybe you were working on something in another piece that started a tangent you couldn't follow out with that piece. So now you're working out that tangent in this new structure with some sort of image in your head that you want to go for. But often, because of the reality of what's happening, that image is impossible to realize—or impossible to realize the way you had intended for it to be realized or, often, that image is not clear. But there are images that are insistent images, which are more specific and more clear. If the image is insistent enough, then you try to reach as close as you can to that, unless, in the process of building it, it's really not looking the way you want it to look. Then you let that go.

What I always want to do is to be able, objectively, to look at what's being built and intuitively react, "Oh, this looks so dumb!"—And maybe that's what I want, kind of a dumb orientation for that moment. Or, "it feels kind of good."

So the words that are associated with what I am looking at are really words that are like some sort of traffic light that tells me something like, "be a little cautious about this one" or "go for this one." I'm really simplifying it here.

RW: While working with materials, there's something inside that's looking and responding, sometimes saying "no," sometimes "yes," etc. When you say, "I have an image in mind," there's a tendency to see "image" only as a visual thing. But is there something more than just the visual in this guiding image?

UvR: That's a lot.

RW: The reason I ask is because of how your work gets to me viscerally, and, when people write about your work, this aspect always seems to be mentioned prominently. It's rare when large works, welded steel, etc., touch me this way. How do you respond when you hear people saying your work affects them this way?

UvR: I like it.

RW: You must find something like that true in your own experience, or do you?

UvR: Yes. It's just that, with my own experience, there is the drive to go into an emotional arena. But I never describe that arena because I can't. As I hear myself right now, I say, "What are you talking about? What arena?" I have never said that to myself. It's very intuitive.

RW: Yes. I think one doesn't want to dishonor the experience by using language that doesn't work somehow.

UvR: Except that I love language. But what you're saying is that language is hard to tailor to it, and I must say that there are people who can really do it. I'm not sure that I'm one of them. I find that no sooner do I say something that just the opposite is equally true. I feel like I'm a constant liar, you know? But it's usually after I hear myself. My intentions are to say something that's somewhat true.

Jazz players, for example, could care less about verbally describing what it is they're doing or why it is that they're doing it. I almost feel like I'm playing the position of a dumb one, but maybe I like that position.

Often I have horrible dyslexia about geographical locations, and I can't help but think I facilitate that not knowing; I sort of prepare the bed for not knowing where I am. When this world is not such a known, it becomes new, and you're so much more alive and open-eyed to it.

RW: I know that experience and love it—like being on a familiar stretch of road, when suddenly, for some reason, you don't recognize it, and it's new.

UvR: Or going to another country and not getting a map. Doing it another way.

RW: Yes. Well, I wanted to ask you about scale. Obviously scale plays a very significant part in your work. Not a simple issue.

UvR: There's part of me that loves being angered and heavy and really present, but...I try not to associate with things that have to do with

machismo, things that have to do with an "aggressive stand" or egocentricity. Sometimes those things are associated with scale.

RW: There's a part of you where there's anger that sometimes comes into play?

UvR: Yes. I've got plenty of anger and, yes, it does come into play.

RW: It comes into play as a force, perhaps, that affects your choices?

UvR: There are also some things in the work that feel agitated enough that they can be talked about as "anger" as well.

RW: Sometimes do you feel you can come up with thoughts or actions or choices that you couldn't have without this force of anger?

UvR: It's a great mobilizer. It prevents you from the maintenance mode.

RW: You can make radical decisions, and one doesn't even feel there was anger there. It could come out as a visual choice. Does that make any sense?

UvR: Yes it does. And I have never, ever in my life said in words, "okay, I'm going to put 'anger' in here."

RW: No. It's not like that. Now scale—people are going to respond to sculptural objects in relation to their own stature. Do you play with that?

UvR: A lot. The whole basis of scale is in relationship to the human size. Even when it's outdoors, it's in relation to the human size but also in relationship to what surrounds it. In scale, it's incredibly important in the outdoors to have a presence underneath the sky, underneath the sun, and I never, ever think of competing with what nature does, in any way. But I do try to hold my own with the surroundings, to have a presence in the context of the surroundings.

RW: If I'm standing in front of an object, which is eight, nine, ten feet high—one thing that might do is put me back into an earlier part of myself.

UvR: Sure.

RW: With the *Bowl with Side Steps*, for instance, which is seven and a half or eight feet high, or with *River Bowl*, which is huge, do these put you in a certain space like that when you're in front of them?

UvR: I think it can, but it doesn't necessarily have to. It depends on what piece, and how I do it. I think being larger in itself doesn't have to make you go back to one's younger years. I think, in fact, there is a way of making huge pieces that can do the opposite of that, support one's strength and the size that one is—depending on how one does it.

RW: Can you say anything more about that?

UvR: I think that going larger or changing scale is critical, but there are so many more undercurrents and implications to that, depending on how one does it. There's a huge piece that was done by Tinguely in which a machine was installed at the Museum of Modern Art a long time ago. I think it was in the late sixties or early seventies. A machine—huge!—threw a ball to presumably the viewer. So playful! There was almost a tenderness that he gave to this huge machine. And we all know that there are some sorts of huge animals that are on the side of being tender.

I remember a guy who worked for a circus and was their freak. He was some enormous height. I don't remember how high. He used to eat four-dozen eggs for breakfast with two loaves of bread. And everybody would pick on him—not the circus people—they knew better. But when he got into the outside world, they would pick on him, as though he had to be a bully, and he had to be aggressive because he was that big, but he didn't come with the qualities associated with bigness.

RW: He was vulnerable.

UvR: Yes.

RW: I wanted to ask about another aspect of a lot of your large pieces, they seem to have a geological quality also. There is the evocation of strata, for instance. Do you think about this geological aspect?

UvR: I do. I don't think about it as a scientist obviously would think about it. I love the transitions of age, the evidence of those transitions.

RW: There may be a very massive object like *River Bowl*, but the surface is intimate, in that the evidence of the hand is everywhere. There's the massive scale and then the intimate quality of the surface, which is also very much present; both things present at once. It's almost contradictory. Someone wrote, "dialectical." Do you have any thoughts about that?

UvR: I think you're saying it well.

RW: What's it like for you when you're touching and cutting, and your hands are on the work?

UvR: It's not what people would think. I'm constantly pulling a dozen slivers a day out of my hands. I can wear gloves, but I have to leave at least the tips of my fingers exposed. Otherwise, I can't really feel what it is that I want to feel. When I do the cutting, I can't wear gloves at all. I'm constantly getting smashed by the cedar. There's a way that the cedar becomes something that I need to protect myself from. Sometimes I manipulate it in a way that is so aggressive and so heavy. I wear respirators, not just the paper masks. And I hate the respirators. There's a tremendous weight. I'm getting dents in my face, but I have to do it. I'm allergic to cedar because it's been with me for so long. My hands are always like sandpaper, the tips of my hands. But I'm not complaining. I'm getting a truckload in right now, a huge flatbed being delivered upstate. It's not as though I don't need it and don't want it, but I do not idealize it. It's too much around me to idealize. I know its strengths and its shortcomings.

RW: You've been working with the cedar beams, the 4 x 4s since...

UvR: ...1974.

RW: It's been a very rich medium for you. You haven't exhausted it.

UvR: I don't think so. I keep thinking I will, and, if I do, I'll go to another material.

RW: I wanted to describe an experience I thought you would relate to. I was in Death Valley not long ago. Magnificent place. In some parts there are hills of black rocks, basalt. I was walking out into this place and stopped and picked up a chunk of that dense rock. I was holding it in my hand and said to my wife, "This is a piece of basalt." I guess I was in sort of an altered state, actually, because just as I heard myself saying, "This is a piece of basalt" I was immediately aware of a huge gap between the reality of this object in my hand and these empty words. No connection. You're smiling and nodding...
   One's relationship with the world as object. Does this relate in any way to your work as a sculptor? With your materials?

UvR: It does. I just don't know exactly how to amplify on that. But I understood what you said.

RW: Do you read much?

UvR: Yes.

RW: One reads a lot about "The Other." Do you have any thoughts about that?

UvR: I don't know how to respond, because I don't know in what context you're talking about "the other." "The other" can mean anything.

RW: In this case, with the basalt, I saw it wasn't me. It wasn't the words. The chunk of rock was what it was—something utterly other than me.

UvR: That's right.

RW: But, in fact, the basalt is just a little piece of a larger otherness. All of nature is other. I guess one is just mute in front of that.

UvR: That's right... And do you think that there's a way in which we experiment with being "other"? Like you are "other", and I am "other"? You know what I mean? That there are times when that's what we need to do, too—just even with ourselves?

RW: I think there's something deep in what you're pointing towards. I don't know that I have very good articulation around it, either.

UvR: I have a great love for many objects. These are objects that don't even have to have a reason for existing. And often these things are man-made, but they're man-made in the most hokey way. Often they're made out of some kind of necessity, and "hokey" meaning that they might be squeezed and pressed together almost out of nothing. It's not as though there was some kind of expert tool-smith that made this chalice with inlaid gold and rubies.

I think of something as simple as—in China I saw a guy about a year ago with a bottle that was made from a bamboo tree. All the bamboo trees get their strength because they have not only the stem itself, but also the stem is cut transversely by a diaphragm, a diaphragm which gives it its strength. They use the bamboo for scaffolding, going up fifty stories with it! Not an ounce of steel—all bamboo.

So he takes a piece of this bamboo—it's maybe this wide [holding hands apart]—and cuts it off where the diaphragms are. Then he turns it sideways and cuts a hole in the stem so it can be like a bottle. He puts some plastic circular thing in it so it won't spill and now he can put a straw in it. You can tell it was some peasant's thing that he took with him every day to the fields. It was very functional, very light, and the straw added a recreational quality. It held water and was actually very beautiful to look at.

205

RW: I remember a talk Wayne Thiebaud gave. He felt it was important to surround himself with objects that sort of fed him somehow. Is that something that relates here?

UvR: Absolutely! Yes they do feed something, but I don't do it for that reason. I do it because it's my pleasure to surround myself with things that are visually fun to look at.

RW: When you make a work that goes in a public space, do you have any hopes for what that work might do?

UvR: I do. I have hopes for all of my sculptures. To verbalize what these hopes are would be very difficult.

RW: I guess I'm thinking about how a work in a public space has an inner action. We hear a lot about the environment. Take the phrase, "habitat restoration." A good thing, but do you think we can think about this phrase as it applies to us in an interior way?

UvR: Absolutely.

RW: Let's say that *wilderness*, for instance, could have to do with a kind of original experience, a place that hasn't been spoiled by "education," so to speak. There's something necessary about preserving certain parts of ourselves, let's say.

UvR: I feel strongly that yes, one can drink in all of this stuff, but I think—well, there are times when one rides in the subway when all of the subway cars line up. You look to your left, you look to your right and you see almost infinite numbers—especially if the car doors are open [extending out]. You see infinite cars, with many, many people in each car. There's a way in which you feel you have to reconfirm that you really exist. There's a way in which you can almost lose the fact that you actually exist. I've felt that way on the main streets in Tokyo. Everything there was built in the 50's, and you look down one street and you look down others, and you can't see the end. In that part of Tokyo, everything was done in a grid, built so quickly that there is a frightening sameness in streets that are so long you couldn't see their ends. You try to figure out how it is that you can deviate from all of that, and for that deviation to have meaning for you.

In *Last Tango in Paris*, there was a woman who was married to Marlon Brando. She committed suicide, and Marlon Brando was talking over her grave. He said, "You got your lover a pair of cuff links exactly like mine. You

bought him the same bathrobe you bought me, but I see…"—and the lover actually lived in the apartment next door—"but I see that somewhere…" (I'm making this up probably, but I'm making it up only partially)—"but I see that you have, with your bare hands, that you have scratched the surface over and over again, of a corner of our room"—I think it was their bedroom—"and it is only now that I understand that you were trying to make that different somehow from your lover's bedroom next door."— trying how to better figure out who you were through that difference.

Perhaps that's what I think I'm trying to do, to see if I can excavate some sort of meaning for myself through these objects that I make. And I think that we all have our own way of doing it.

# KATHERINE SHERWOOD
## HERCULES, CALIFORNIA, MARCH 2002

*In 1997 painter Katherine Sherwood suffered a severe cerebral hemorrhage that left her right side paralyzed. It seemed that her career was over. By the time I met to talk with her, however, events had followed another trajectory. Not only had returning to the studio and starting to paint again proved powerfully therapeutic, hastening her recovery, but her painting, now accomplished left-handed, took on a new character; it reached another level, as if coming from somewhere else. Since her stroke, her work has been exhibited more widely; it was included in a Whitney Biennial, and she's received a number of significant grants and awards. Sherwood was also able to continue as a faculty member of the art department at UC Berkeley.*

*I met with the artist in her studio…*

Richard Whittaker: It's such a different experience to look at an artist's work in her studio.

Katherine Sherwood: The paintings develop as a family and they're so close together in this space. They animate the space in a much different way than when they're taken out of this context and put into a gallery setting.

RW: In a gallery, of course, artworks become commodities. I think that's the reason I'm less receptive to the art in galleries. I imagine you've thought about this: the commodity aspect.

KS: For twenty years. But, you know, in respect to the studio, it is an extremely private space, and I wouldn't want people to view the art in the studio. I'm feeling strongly about both situations. When you mentioned the part about commodity, I thought about more public spaces, like a museum—and that's about commodities, too.

RW: What is the idea of an art museum anyway?

KS: In the modern era, I think it's been almost going to some sort of religious place to see art.

RW: I know it's implicit that going to a museum is supposed to be good for you. But from the point of view of the curators, critics and theorists and so forth, all this seems very abstract. I like your mention of it being like "a

religious" place, but I don't see any of that aspect being put forward by curators or critics or theorists.

KS: That's probably my projection of it because it's been that way for me for a long time, I'd say. I found that especially when I lived in New York and was constantly going to museums there—the Met and the Frick—I was going to a very quiet place just to look. The religious aspect is probably just my associating this with the art viewing experience.

RW: It seems there's something very right about that, a possibility where art and religion approach each other. What I don't see is where the "art world" supports that.

KS: I would agree with you on that.

RW: What interests you right now?

KS: What's really interesting to me now is that I'm preparing to teach a class in the fall: "Art, Medicine and Disability." I'm trying to locate that specific territory where those three concepts are best described by visual art. I'm trying to look at how visual artists have responded to illness and disability.

There's a whole range of things I'm trying to work out in looking at art from different cultures that specifically have to do with healing. For instance I'm looking at the 16th century Blue Beryl Treatise in the Tibetan art tradition. This explains every bit of their system: all the herbs; the different kinds of states that each part of the body can be in—it's just fascinating. I'm also trying to look through the lens of disability at a few modern art historical subjects. For instance, Toulouse-Lautrec as a disabled artist; also at how Monet, Manet and Matisse grew old. And, for instance, looking at the work Monet did at the end of his life when he was almost blind. I love those paintings. I think they're the best of the whole body of his work.

RW: Can you describe that work for me just briefly?

KS: They were at Giverny, of the lily pads, but were so abstract because he could hardly see anymore. To me, they were the true predecessors of artists like Pollock. Even though Monet wasn't proclaiming abstraction the way Kandinsky did, I feel he really led the way with those paintings.

About half of the class will be looking at contemporary artists like Hannah Wilke, who had cancer and made art about it. I'm going to look at developmentally disabled artists and mental health patients who were artists. I'm also going to look at Art Brut in that context.

RW: What is it in this area that intrigues you?

KS: Well, it's from my own experiences of this and from making art out of those experiences.

RW: You've had a stroke.

KS: A cerebral hemorrhage. A friend of mine in the English department at Cal [UC Berkeley] is the presidential chair of Disability Studies. She approached me about a year after I had returned to teaching and asked if I would be on the Disabilities Studies Board of Advisors. It's a new program. I agreed and went to a few meetings. It became clear that, because of my art historical background and because I had been interested in a lot of these artists before I had the stroke, that it was a good fit.

RW: The word "disability"—I'm guessing there is another side, maybe the opening of some ability. Right along with this disability, there may be something that becomes accessible. Would you say so?

KS: I definitely believe that when, for whatever reason, you're denied access to a certain part, then you will have that equal part show up in another place. I also strongly agree with Oliver Sachs that having a disability—a severe illness—reveals creative parts that you hadn't known before. But I will also say that I just believe it's part of a big continuum. What do you think of when you think of the word "disability"?

RW: I hardly think about it, first of all. I think I take it just on the surface, a person in a wheel chair, some physical problem that makes it apparent their physical capacities are not like mine—or a mental condition, a brain function problem. But, to be honest, I haven't thought about it.

KS: I don't think it's the greatest word to describe what's going on. "Disability" has a "dis-" in it. You're thinking of the negative aspect right away. There should be a one-syllable word like "race" or "sex" to describe that.

RW: I guess what I'm asking about has to do with your art making. What moved you to become an artist in the first place?

KS: At around twenty-five years of age, I started realizing that making art made me exceedingly happy. That's been the case ever since, for almost twenty-five years. I was so happy to merely change hands after I had the stroke instead of giving up my avocation.

RW: How did it happen that you took up art at the age of twenty-five?

KS: It actually started a few years before, but that's when I decided I would pursue being an artist. It happened because I was an art historian in college and I had to take some art classes for that major. I found myself enjoying making the art much more than studying art history.

RW: You mentioned earlier that you wouldn't want people to see your art here in your studio; that it's such a private space, and there's something about the privacy of art making, that's...

KS: ...that's very essential for me. I long for that solitude that I can get in the studio.

RW: Can you say more about that?

KS: For me, that's where art is made. I love the fact that I get to go into my studio and work by myself.

RW: You discovered that making art made you happy. Is that still true?

KS: Yes.

RW: That is a very big thing, somehow.

KS: I will say that before I had the stroke, my studio practice was fraught with struggle. I never thought, "I'm having so much difficulty," but it was a constant thing. I would have ups and downs. Since the stroke, I don't quite have the ups and downs. I know what I want to do and I don't have long intellectual quibbles about it.

RW: Those intellectual quibbles. Where do you think they may have come from?

KS: I think they came from being an artist in New York and growing up through the 80's and seeing what happened in the early 80's, seeing the over-intellectualization of theory and how, in a way, that became the subject of art. Then coming to the university, which highly valued that intellectual display and undervalued the artistic display.

RW: Has the atmosphere changed at all in the university in terms of the place the intellectual theory holds?

KS: Our department and the art history department split up twenty years ago. That split is more evident in my institution than it would be in others.

RW: Somewhere, maybe in the 60's, there was a shift in the art world so that the gatekeepers of the meaning of art started moving over to non-artists.

KS: My sense is that that happened much more in the 80's, although it may have begun in the 60's.

RW: Do you have a sense of where that might be today?

KS: I don't. To be truthful, all that stuff doesn't really matter to me anymore. I had such cognitive damage from the cerebral hemorrhage that I had to learn how to read again, how to reclaim all the art historical facts I had before the stroke. Now I don't have the patience and I don't have the time. It takes me a long time to read now, and I really treasure reading what I choose and it's not that. That's very funny for me to say because before the stroke I was a voracious reader of all art theory.

RW: I never had much patience for it myself. Getting back to how art making was for you before the stroke and, now, it's not so fraught; can you say more about that?

KS: I don't know what it is exactly. My experience is just much more direct than it was before. For instance, I believe that my left hand is a more natural painting hand than my right hand, but my left hand couldn't do these paintings unless it had all the years of the right-handed making.

RW: This sidedness that people talk about—right and left brain—from this very real event that happened, you now inhabit your body…

KS: …very differently. Some people say that because I had a left-handed cerebral hemorrhage that it shut down what is called "the interpreter," which is a part of the brain that transmits knowledge into the left hemisphere. That's one theory for what's happened.

RW: When you are working—painting—how do you pick a color?

KS: I used to paint with oil and, of course, I mixed them. To mix colors one-handed is a very hard proposition. Now I've tried to detoxify my process as much as possible, and so I started buying latex paints. I order my colors so I won't have to mix them. So I decide on colors in the very early stages.

RW: Do you have feelings about colors?

KS: Yes.

RW: Is it possible to say anything about that?

KS: No, because it's really an instinctual feeling. It's not, "I picked blue because of this," or "I picked yellow because of that."

RW: There is an instinctual feeling then.

KS: Yes. But I'll also say that sometimes I pick colors purely for their ugliness, and then sometimes I pick colors as a symbol of the person that I'm making the painting about, or the seal that I'm making the painting about.

RW: The seal?

KS: All these are based on King Solomon Seals. They're from a medieval text called "The Lemegeton." All the seals represent the spirits that he harnessed to bring him his fame and fortune. So all these paintings may look like purely abstract paintings, but the lines are from me following the seals.

There are 32 white magic seals and 32 black magic seals. I only work with the white magic seals. I began incorporating them into my art in 1994. Over the next three or four years I pretty much utilized all 32 of them. Then, when I had the stroke, I returned to the ones that had to do with healing. I started working on one or two seals at a time. In this room I've been working on "Gremory" [shows me a book with diagrams of the seals]. This is Gremory. In that painting, it's on its side. In that big painting, it's standing upright and in this painting too. The rest of these are Balam [another seal]. Can you see Balam in that one? [pointing]—in all three of those.

RW: I can see that now.

KS: In this one, it's squished all together.

RW: Working on these seals this way, is it a form of research?

KS: In 1993 or '94 I was invited to be in a show in Thailand, and I wanted to do work that was somehow related and relevant to the Thai audience. I had experimented with the theme "luck," and so I decided I'd do all these works on paper about luck. At the time I lived in a loft above "The State of the Art Bingo Hall" in Alameda County. It was a huge hall that had video

monitors every nine feet showing the ball with the number that popped up. I used to go into it because it had an ATM machine, and I also walked around it because I had dogs. I started collecting all these "records of ill luck" as I called them. I did drawings on top of the bingo cards, and also did a series of small 9 by 9 inch ink-on-paper drawings of these Solomon Seals. That was the first time I had ever researched it or used it. Ever since 1994 the seals have been a dominant force in my work.

RW: What attracted your attention to these Solomon Seals?

KS: I had a very slim pamphlet that my husband had gotten in New York in the East Village, a compendium of seals. Those Solomon Seals had always been the only ones that interested me. At first, my usage of them, from '93 to '97, was just purely aesthetic.

RW: It had nothing to do with the mythos of Solomon, the mystery of the ancients, that sort of thing?

KS: I knew about that, but I wasn't about to stake a claim of efficacy about any of that. I wasn't interested in that aspect of it.

RW: Did you become interested at some point?

KS: About seven months after I'd had the stroke, I came back into the studio. All my art friends had wanted me to get back into the studio. They had recommended that I start by just doing drawings, but, instead, I wanted to go back and finish the three paintings I had begun before the stroke. So that's what I did. My results were quite minimal. Then when I started to make paintings from scratch, at that time I thought I would concentrate on one seal at a time and just on the seals that assured you of good health.

I discovered then that this was really the highest form of occupational therapy I could engage in. I'd had seven months of occupational therapy before. Working in my studio this way is what made it possible for me to get well.

RW: What do you attribute the difference to, if I can ask that?

KS: When you have a near-death experience, that is always life changing. I think that sums it up better than anything else I could say.

RW: I'm intrigued by your not claiming any other relationship to these seals except as lines that held an aesthetic appeal.

KS: That's the way it was before the stroke, but not after the stroke.

RW: What's changed in your relationship?

KS: It's almost like before, I would scientifically survey them and practice them, and they were together as a group. Now that I am really grappling with one seal at a time, one seal that I make artwork about for a whole year, my experience is much richer with them.

RW: Someone might speculate that these seals represent something intentional. One might even speculate that these lines contain something special.

KS: Yes. But it's fascinating to me that I was first attracted to those seals because they didn't carry any symbolic content that I could read, or anybody else that I knew about versus these other kinds of seals that were clearly Christian, clearly Islamic. I chose them because they were very eccentric and the symbolic content was not known—or not easily identified. It interested me that King Solomon was someone equally revered by Christians, Muslims and Jews.

RW: So you knew something about their background.

KS: I did all the research, but I wasn't emotively connected to them.

RW: Looking back on it, is there a question about what attracted you aesthetically?

KS: Yes. But at the same time I started using images of brains in 1990.

RW: So after you began painting again, your relationship to the seals changed. Would you say something about that?

KS: There are private elements I don't choose to talk about. In terms of having a moment of epiphany, that was not the case. I'll simply say that I now have a very rich relationship with them.

RW: What I think of as a King Solomon's Seal is this [drawing a six-pointed star]. It can be seen as two triangles, one pointed up and one pointed down. Let's say this is an old symbol. Or I could just say, "oh, a six-pointed star." Maybe if I spend a year with it, I would start to have some ideas about different ways to understand the meaning of this.

KS: But I think these are more than symbolic representations than something like that [the star]. So if you're dealing with a symbol that is like this [showing by drawing lines on paper], you don't have a simple symbolic thing like the six-pointed star.

RW: So maybe it's something else, as you say.

KS: That's why I did not choose the ones like that [the more schematic symbols].

RW: These remind me of Chinese ideograms, stylized representations of things, like drawings in a way.

KS: I did work from 1992 to 1993 based on *The Secret of the Golden Flower*, a text from 18th century China, which summed up the ideas of Taoist philosophy. That was the work I had done immediately before and with brains and perception.

RW: There's something about these seals that continues to be alive for you in order for you to work for a year on these.

KS: I think that's just the pace I want to go now. It seems to recommend itself for that amount of time.

RW: That recommendation, is that received in the feelings?

KS: Yes, I think it is all instinctual.

RW: In something I read about your work, it was suggested that a key interest in your work was the point of meeting between the visible and the invisible. Does that interest you?

KS: Yes. But I didn't suggest it.

RW: Not something you would be moved to talk about?

KS: No.

RW: In reading about your work, I thought there might be something in your process of working about calling something up. Does that strike you?

KS: In the sense that I'm using the seal or imploring the seal could be read as calling up. I'm not opposed to that notion.

RW: From your own experience does it correspond in any way?

KS: Yes.

RW: It would be calling up what the seal would be reputed to represent?

KS: Yes. To try to match my intention to be approximately close to that intention that that seal brings.

RW: I gather that you have a personal interest in the religious dimension of art.

KS: Yes.

RW: Is that something you came to from your parents?

KS: From a very early age I was just innately concerned with spiritual problems and spiritual existence. I can remember being six or seven and always enacting play that was based on that. I studied it in college with art history. They were always connected; there was some kind of connection for a long time.

RW: Enacting in play? What was that like?

KS: The structure of my play was based on religious things. For instance, Palm Sunday would just be endlessly fascinating in our fire pit in the back yard.

RW: Burning the palms?

KS: Yes. Trying to re-enact the ritual in my imaginary space.

RW: Did you go to church?

KS: Yes. My father died when I was nine, and my mother remarried three years later. She married a Catholic man. We lived in New Orleans, and then we moved to Santa Barbara. Because I was at such a young age, I was just absolutely taken with Catholicism. I was introduced to it when I was in seventh grade. So that was another chapter.

RW: The ritual, vestments. Some of the churches are incredibly ornate. Did you go to one of those?

KS: No, but I always appreciated the Spanish Catholic taste, the more baroque expressions of Catholicism. Then I started taking religious studies

courses in college. When I finished school, I continued to do art that was reflective of those experiences, but I didn't belong to any church or group. It provided me an opportunity to learn about all different kinds of religion. That was very valuable, at the time. It was a revitalization of some topics I had closed myself off to at the time; for instance, looking at the *Bible* in a historical context—that kind of thing.

RW: You take a pleasure in making these paintings. Then there is the action of calling forth, which is also associated with the making of these paintings. Is that an open question?

KS: Yes. But I think that is part of the process. That's what I love, the process of making them.

RW: Have you given thought to the relationship of art making to the unconscious? Is the unconscious a useful idea?

KS: Yes.

RW: Do you see art making as having a living connection with the unconscious, shall we say?

KS: Yes. But I would be the last person to be able to define it.

RW: As Jung said: "Remember, the unconscious is unconscious."

KS: I think that's great.

RW: I don't suppose it's all that uncommon, but I've seen in a painting or drawing that, later on, it became obvious what it was about. It's a shock to have evidence of forces moving me of which I am unconscious.

KS: But it's a very big relief for me. I think when you experience something so absolutely life-altering as a cerebral hemorrhage, you see that, "okay, I wasn't in control." What's happening is not just the conscious person inside of me. Once you give up any notion of control, then I think life goes a lot easier. That's what I've experienced.

I think the nature of what happened divided me in two. On this side [the left], I have perfect control, but I'm always aware of how on the other side I don't have any control. That both sides are part of the same body makes me think differently than I did, differently than I could think before.

RW: You've come to terms with that?

KS: Yes. It's been almost five years, and that has afforded me enough time to really grapple with it and with who I am now.

RW: Earlier you'd said that the three things, medicine, art...

KS: ...Disability. I put art first though. Art, Medicine and Disability. So it's the visual art about medicine and disability that I'm investigating.

RW: What do you see in these relationships that is valuable?

KS: I see the vast continuum of what a person can be. Each one of the artists I'm looking at is so complex and has different factors influencing them in making their art. I think that, for instance, the two most notable 20th century artists most often associated with disability are Frida Kahlo and Chuck Close. You couldn't find two more different artists in every important way than these two. Partially, that is what I want to show; that some people are deaf, and they make fantastic art. Some people have learning disabilities, some people have problems of intellectual development, and they make beautiful art. They don't even have a concept of who they are or what art is, but they make beautiful art. By showing the broad panorama of it, I think people will understand it better and not be scared of it. That is a real thing with disability, the notion of disability. It just scares able-bodied people.

I know it's a tough subject. Also I know that one word I haven't mentioned, but that I've been making art about, is death. I want to look at artists like Wendy Sussman, and how she almost saw her death and made paintings about it, and artists like Rothko and Goya. He's an interesting person because he was deaf first; then he made those black paintings to portend his death. Those kinds of subjects I'm really interested in.

RW: I saw Wendy's paintings a few months before she died. I was unnerved by them, and couldn't find words to talk about them. I felt tremendous respect for her.

KS: I consider it my great good fortune that I came to Berkeley and we became friends. She was the greatest painter that I knew, and I'm just shocked that she's not here. I think that she was always concerned with death, at least from the early 90s on. There was that beautiful series that she did about her mother's and father's death.

RW: It struck me so strongly about Wendy's work that she painted about these very big realities that we can only face with a question, I suppose. I don't find the art world much able to deal with such things today. It makes me think of the claim that painting is dead today. I hesitate to bring this up before a painter. Does this concern you at all?

KS: No. Because the notions of painting being dead have arisen many times during my lifetime. John Yau once related to me during a dinner party—at the time it was an issue in the international art world—some Spanish woman had said, "What's all this rubbish about painting being dead. It's died a hundred times, and it will die a hundred times more." That about sums it up. There's another thing I always remember from a lecture by Robert Irwin I heard as a college student. He said that for 20,000 years men and women have been painting, and they will go on painting for that long. Now I don't think painting is the popular art form that it was maybe two or three hundred years ago, and I definitely think that the art form of this past century is film, and I'm glad to give them that credit.

RW: Just last night I was in the Mission district in San Francisco. I walked by an open door; there was an art exhibit inside. It was a community center. There was a feeling in that place. The paintings, though unsophisticated, were alive. There was a feeling of hope, of possibility, the feeling that life was worth living. To me, that's the living spirit of art, something I don't think the art world knows what to do with.

KS: That seems very familiar to me. I know I have often looked beyond the art world for examples of folk art, children's art, and it's because I think I'm trying to see where that spirit is alive.

RW: Art, medicine, and disability. You've mentioned that there is a vast continuum. I don't know where I'm going with this.

KS: Yesterday I was reading a book about Karl Prinzehorn who was the first psychiatrist and art historian who collected the art of the insane. He did this between 1918 and 1921 in Heidelberg. About half of those artists he collected were part of the Nazi extermination trials. This was before the Nazis started attacking the Jewish people. He was trying to make a connection between Expressionism—as it had flowered in Germany at that very same time—and the art of the unconscious, which we've been talking about with the art of the insane.

RW: You teach art. What is the role of teaching art in the university?

KS: There are three or four levels of what I do. I teach non-artists and, hopefully, open up the world of art to them in a much more personable way. With the art majors, one out of ten may go on to graduate school, or, if I'm feeling generous, I'd say maybe two out of ten. So, in a way, I'm educating stockbrokers as well as art historians. For the graduate students, that's a different role. They've already made their choices, and it's about maybe guiding them through an intense part of their creative life. I couldn't go to sleep at night thinking I was educating every student to be an artist.

RW: Lately, I've had some impressions about language in relation to the visual. Have you thought about that?

KS: I have to think about that a lot, being a teacher, but I'm a person who has no faith in language as something that can explicate what's really at the core of art. I'm not a great expositor.

RW: Do you think images can have a medical function?

KS: It's from the medical world and the military world that I've gotten my source of images for many of my paintings. In that way, the visual relics of the processes were what interested me.

RW: What is it about the visual relics?

KS: For instance, all the satellite photos that the CIA has taken. It's just fascinating to me that they can record all this data in such a thing as a satellite photo and use it to determine military policy. Also the amount of over-information that we have that we just cannot process. Now, because of microscopic photography, we have entry into the inside of our bodies, and that has fascinated me since I started using the brain imagery in my work.

RW: Have you given thought to all this over-information in which we live in relation to painting?

KS: The parallels of over-information in both are very interesting.

RW: We have a culture of the intense surfaces. The contention that "painting is dead" may be a sense that it can no longer compete in this atmosphere of charged surfaces. But maybe that's not what painting is really about.

KS: For me, most paintings are about a certain kind of ambiguity that ads cannot be about. I would hope that the intention of the painter would be wholly different from the intention of a designer.

RW: The relationship a painting has to time is very different from these other surfaces. These charged surfaces are meant to impart their content very quickly. Whereas a great deal of what is important about a painting has to do with the period of time involved with its creation. And perhaps the surface is meant to yield something over a longer period of time.

KS: Yes. I agree with you.

RW: When I look at your work, it is ambiguous. When I begin to understand more about it, it becomes more and more interesting.

KS: I think that there is a huge gap between what motivates me—my experience—and how well any of that is communicated to the outside viewer. They are two things. That's inherent in the process of making a painting, an abstract painting. I don't get upset about that. I feel good about what I communicated, and if that is not communicated at all and another set of ideas are communicated, that's fine with me. I don't expect people to walk up to these paintings and understand that the photographic images are from my brain and that the abstract lines are part of a Solomon Seal. I am not that naïve. But the drive inside of me to make the paintings is so strong, and I know that I'm going to have to relinquish the paintings; they're going to have to go live their lives in the outside world. Whatever happens to them there, then so be it.

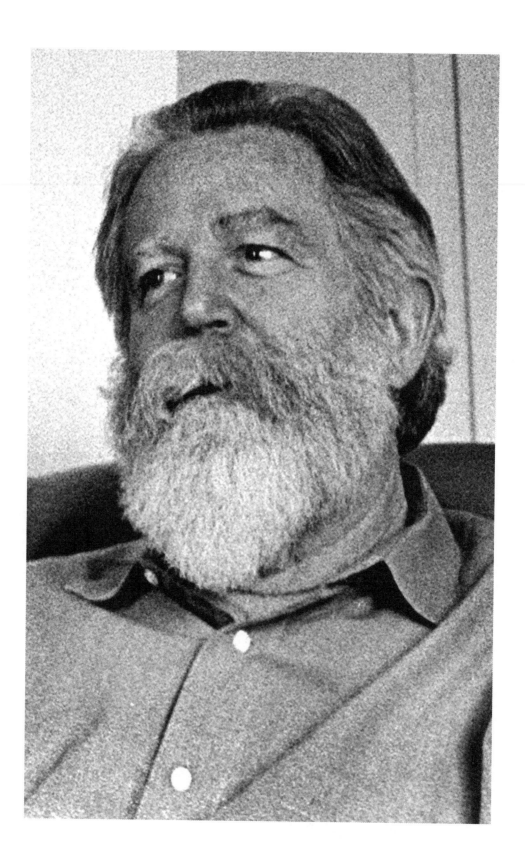

# JAMES TURRELL
## NEAR FLAGSTAFF, ARIZONA, FEBRUARY 1999

*It was thanks to artist Walter Gabrielson that I was able to get in touch with James Turrell. Gabrielson is an old friend of Turrell's from Pasadena and, like Turrell, also a pilot. The prospect of meeting the artist was quite exciting, and arranging it took some time. Michael Bond, who managed Turrell's projects around the world, was encouraging. He sent me to Los Angeles to look at one of the artist's pieces,* The Second Meeting, *in a private collection there. [Eventually I found myself on my way to Flagstaff, Arizona. The time I spent studying Turrell's work only increased my sense of his unique place in the art world.] I met the artist at his studio on his ranch some thirty miles outside of Flagstaff.*

Richard Whittaker: When I was talking with Michael Bond, I learned you were a Quaker.

James Turrell: I was a Quaker, and then, for a while, I wasn't. Now I am again.

RW: I understand you did service as a conscientious objector in the war in Vietnam.

JT: I did that before Vietnam.

RW: And you learned to fly a long time ago.

JT: I learned when I was sixteen.

RT: I also heard that you'd flown Tibetan monks out of Tibet early on. It must have been quite an experience.

JT: Yes. It's not hard to believe in reincarnation. I feel like I've had several lifetimes in this life. Those are somewhere in memory.

RW: Well, I'd like to learn something about what first attracted your attention and interest to light.

JT: I was fascinated with light right from the very beginning. I did several things in my room when I was very young. We had these blackout curtains in Pasadena, as a response to the threat of attack in WWII. I pulled them down and put the constellations along the ecliptic so that during the day I could see the stars. I was interested in light phenomena.

My grandmother used to tell me that, as you sat in Quaker silence, you were to go inside to greet the light. That expression stuck with me.

One thing about Quakers, and I think many Friends might laugh about this, is that often people wonder what you're supposed to do, when you go in there. It's kind of hard to say. Telling a child to go inside "to greet the light" is about as much as was ever told to me.

But there is an idea, first of all, of vision fully formed with the eyes closed. Of course the vision we have in a lucid dream often has greater lucidity and clarity than vision with the eyes open. The fact that we have this vision with the eyes closed is very interesting. The idea that it's possible to actually work in a way, on the outside, to remind one of how we see on the inside, is something that became more interesting to me as an artist.

RW: At what age would say this started?

JT: It was when I was very young. My brothers and sisters are older than I am by a good bit, so I was left with my grandmother quite often. She was conservative in her beliefs. However, the Quakers were very much involved in issues of women's rights and the rights of minorities. Remember, Susan B. Anthony was a Quaker. The Quakers were very much involved in the Underground Railroad and also looked at how things were happening socially in the industrial revolution. Many Quakers were also involved with the Christian Women's Temperance Union. My grandmother was a terror to remember. [laughs] She knew Carrie Nation.

The Quakers are very liberal and tolerant people, but they are very conservative people, too; my grandmother was certainly part of it all. She had a lot to do with my formative years. Her son had raised avocados in the Escondido area and used Mexican laborers. My grandmother would make extremely hot salsa for them and read the *Bible* to them, even though they didn't speak English. They would cross themselves, right? [laughs]

I was involved with some of her views, which were a little bit startling to my mother, who was a modern person. My grandmother was not. She still wore the plain dress with the bonnet and had me wear the hat.

RW: I wonder what was your first memory? I ask, because my own first memory was of seeing sunlight on a wall. I can't help thinking of Plato here.

JT: I make spaces that apprehend light for our perception and in some way gather it, or seem to hold it. So, in that way, it's a little bit like Plato's cave. We sit in the cave with our backs to reality, looking at the reflection of reality on the cave wall. As an analogy to how we perceive, and the imperfections of perception, I think this is very interesting.

And there is the making of Plato's cave literally—at New Grange in Ireland, or Abu Sembal where you don't have a pointing sculpture like Stonehenge. Instead, you have an architectural space arranged to accept an event in light on the horizon. When that event in light occurs on the horizon, there is an event in light, inside that space.

This then became the camera obscura, which appeared in many European towns. They would have these and eventually even created panoramas and dioramas. The "camera lucida" and the "camera obscura" were what artists used to actually make this Western painting space.

We made this eye that sees for us, like the camera, and this is very much a part of how we organized our culture. Of course, it became this holder of truth. I mean, in a court of law, you take a photograph and you can use it as evidence.

But, if you think about it, there are many factors: first of all, where you point the camera, and whether you choose a lens that's a telephoto, which flattens the space and sees through the distance, or a wide angle that sees a much wider area than we see. Then there is the setting of the aperture. All may be in focus or just a part with the rest out of focus. Do you choose to put in a film that represents light from the sun as white, tungsten light as white, or fluorescent light as white? Or, do you use color or infrared? Then, of course, you get this photo that you can change in development and crop. Then you can present this photo as "proof of reality," when every step of the way you've created the reality.

This idea of how we create our reality through this, and in ways that we're not necessarily aware of, is very important. It contributes to this prejudiced perception that we have. And though learning to represent three dimensions in two has been a great help to our culture in planning and modeling and all that, there are some losses that are interesting.

There is that experiment where a window is made to appear in perspective, so it looks like a trapezoid, and then it's put on a stick against a very flat background—evenly illuminated, and a few feet away—and then it's rotated. We can't tell whether it's going back and forth or whether it's going fully around. Our guessing is less than fifty percent correct. But then, for this experiment, so-called primitive people, both in New Guinea and in Africa, were tested, and they were unable to see the illusion. They were only able to see what was actually happening. When it was spinning, they saw it as spinning, and when it was going back and forth, that's what they saw.

So certain ways of organizing information can cause some loss. Learning is one path, one way, and we have learned one way, but this also creates a prejudiced perception that we're not totally aware of.

RW: This interests you obviously, this phenomenon of cultural overlay, and then the physiological possibilities.

JT: Yes. We have the physiological limits of perception, and then we have this cultural overlay, which is a learned perception. They are not identical at all. Some of Plato's references are to that as well.

RW: You were saying there are many relative choices made, say in a photograph, which really delimit what is seen. What I'm wondering is, in the encounter with light—which can be an encounter with a different color of light, or a different quality or angle—isn't there still something fundamental about the perception of light?

JT: Yes. There is a truth in light. That is, you only get light by burning material. The light that you get is representative of what is burned. So whether you take hydrogen or helium, as in the sun, or whether you decide to burn xenon in a bulb, or neon, or tungsten wire, something must be burned to get this light. The light that comes off this material burned is characteristic of that material burned at the temperature at which it is burned. So you can then put a filter in between, or you can bounce it off paint; but there is truth in light.

There are some very interesting experiments that were done several years ago. They show that light is aware that we are looking.

RW: You're referring to Heisenberg's principles?

JT: Very much so. Which brings things around to an epistemological, scientific area where we want to disbelieve something unless it's proven. It almost gets to the point where it has a lot to do with what we want to prove. I mean, we're a part of this experiment. We enter into it in ways that can't be denied.

This can be troubling, and it troubles a lot of scientists, but I think it is also affirming of the fact that we're not apart from nature. In fact, that's one of our greatest conceits, to even think that we're somehow apart from nature.

RW: Yes. This speaks to something you've spent maybe 30 years working with and studying, and that is light. What is it that drives you in this?

JT: That's hard to say. I'm interested in participating in this culture but in a way that has meaning to me. I am interested that we treasure light as much as we treasure all these objects around us.

When somebody buys a work of mine, there is the question: what is it they own? In some way, I can honestly say that you "own the light that is passing through." [laughs] That's one way to say it.

228

The other thing is that we make statements as artists. The statement is like a completed pass. Art isn't just something that is "done." It's something that is done in relation to the culture. It has a context. And so obviously, artists have to pay attention to that as well.

RW: In an article about your work by Hartmut Bohme, he says, "we live in an age of consummate remoteness from God." A scientist wouldn't want to say about light, "it's sacred." At the same time, there's something about light, which science can't quite fully encompass, and it sort of nudges us in that direction.

JT: Well certainly, it does do that. Actually there are two astronomers in the [Quaker] meeting here in Flagstaff. One works with me on the Roden Crater project here. In some ways, they have difficulty with organized religion, but in another way, they are peering into this "face of God" every night where the real awe of it is absolutely evident to them. But to have some way to express this in the secular world is very difficult for them. On the other hand, they are some of the more devout people I know. It's an interesting thing.

Certainly, if you look at the history of religion and just take a concordance and look up "light," you'll see reference after reference to light in terms of religious experience. It is something, I think, that is very powerful in that regard. It is a primal experience. You can literally come to a different state, as you stare into the fire. This quality of physical light is particularly important and does have a history of religious connotation. You know, we're light eaters. We drink light as vitamin D.

RW: Of course sunlight is the source of life, literally.

JT: That's true. But I mean also, just in terms of mental stability, it has to do with vitamin D, which is very important in counteracting depression. So, for a lot of these people who take Prozac, just step outside for a while. It could help a great deal.

RW: There's a man in San Francisco, John Dobson; he's in his eighties now. He founded the "Sidewalk Astronomers" so people would be able to look through a telescope at the planets and the stars. He'd build refracting telescopes as big as 24 inches and take them down on the sidewalk at night. He'd stop passersby and say, "Take a look through this." He's devoted his life to this because he feels this is absolutely important to the culture. The reason I bring it up is because I think there's a relationship to what you're doing.

JT: Well, this piece out here in the desert [Roden Crater] will have similar qualities, too. Right here we're at 6900 feet. [Turrell's studio] Roden Crater is at

7000 feet. One of the things you get at a high altitude, if you get away from city light, is that the universe really opens up to you. It's a very different experience.

I even got a county ordinance passed to preserve dark skies. The dark sky is really important. There's one for the observatories on the other side of town, and now we've got one out here as well. As population comes in, they'll have to put in lights that aim down. Just aiming lights down, and not having them go up, makes a big difference.

We generate light at night in the cities to offset our fear of each other, but lighting the night sky cuts off access to the universe.

The territory we inhabit is a visual territory. There are certainly aural aspects to it, I'll grant that, but if you cut off access to the universe, you don't live in it. It's a psychological change to do that, to light the sky and cut off access to the stars.

RW: That's true. I think your Roden Crater project is going to put people in touch with a greater scale, one that's not often felt.

JT: It puts you in direct contact with it. In terms of the size of it though, I don't think the size makes that much difference. If you look inside a Cornell [Joseph Cornell's small scale dioramas] and you enter that universe, it expands to any size you'd like to think of.

It's a little bit like when you're reading a book and people pass through the place where you are reading; you don't notice them, because you're really in a space generated by the author, more than in the space where you're sitting and reading. This price of admission you've paid to enter, by giving yourself over to the story, needs to be done with art as well.

With literature, people know that and have the habit of it. With music you can be in a small apartment, and you listen to this music, which makes the space bigger than your apartment. This universe "created by the work" is also important with visual work. That's really the price of admission, and some people don't pay that price of admission with contemporary art. They "look at it," as opposed to entering it, or looking into it.

RW: Perhaps there's a lot of work which doesn't merit too much or can't take you there.

JT: That can certainly be said, and I'm not going to get into that exactly. I will say this, that in any period, the only place art comes from will be from those who set themselves up as artists in the culture. So when a culture isn't paying attention to its art, that's a certain kind of dysfunction.

You can blame artists, on the one hand, but it also takes this audience too. I think we have one right now that's hostile to the arts, to all of them. The

government isn't supporting the arts—I suppose mostly from the reaction to the Mapplethorpe photographs, which Jesse Helms objected to—but these things have a big effect.

RW: We also live in a culture that has this huge industry which baths us in imagery, particularly through television, and which co-opts anything it can use and spews it out as...

JT: ...as entertainment, and entertainment is a different function.

RW: You're very intentional about the way in which people are to experience your work. That is, you'd like them to be prepared, in a certain way, and this takes time. That's part of what makes it possible to experience the work.

JT: That's interesting because, you know, we're not totally avoiding that today. These are things of the senses, and those often do take time. So, at the same time we have this sort of rush toward "media oblivion," we're having places where we do take that time. Quality is now appearing where it didn't appear when we were younger. People have really been paying great attention to cuisine, for instance, and to things that take a great deal of time in preparation. I think that is very interesting. So it goes both ways. In the same way technology is going like this [fast gesture], the organization of society is asymptotically going the other way. Both are interesting contradictions that we actually need to think about.

RW: I find it interesting pondering some of the ideas that belong to "postmodern" thinking. There's this move toward radical relativity. That's one of the major thrusts. You used the word "epistemology," so there's the idea that epistemologies are relative, that there are no longer any objective universal standards possible. But I would suspect that the human perception of light, for instance, is basically a universally common experience, and that cultural variances would be superficial at most.

JT: It is a universal experience. It is something that even passes to other species, which is interesting too. The information contained within it may not, but that's not so much my business. I did this work—my "motel art" is at the Mondrian Hotel in Los Angeles...

RW: ..."Motel art"...did you say?

JT: Yes. [laughs] You know, artists have to do different forms. I've done etchings, and my "motel art" was lighting at the Mondrian Hotel. I did these

pieces, which use just the light that comes from different television stations. You've probably walked by an apartment and looked in and seen the space lit by the light of a television. It's sometimes very beautiful to see this light filling that space. This light is the content for me.

The thing that's interesting is that each station has different characteristics in the light that they give off. So each floor of this hotel has a piece that is tuned to a different station. With the sports station, you sometimes get this tremendous green, and there may be a uniform that's red. So you can get these high contrasts. The cartoon channel has great color. The news networks are the dullest, except for the blue of the weather channel. Also the porn channel will be very delicate in terms of the color it gives off. But all of them are very interesting to look at in terms of the light.

RW: I read you quoted as saying that the "light must have grace."

JT: Well, for me, the work has grace when it isn't overworked, or when it has a great ease. It's not too different from the manner in which you reach an elegant solution in a mathematical proof. It was done with an economy of means and without a lot of mirrors and steps.

Certainly, light does have that for me in spaces that I like. You know, many of the architectural spaces we make now have such a blank lighting. It's very difficult for people. They have that very flat fluorescent light.

RW: In trying to think a little about light, I noticed there seems to be a poverty of language for its many different qualities.

JT: We're doing much better with sound and with music than with light. One of the great difficulties is that, because we had a culture that came out of painting, ideas about light are generally ideas about subtractive light. So, they really have to do with mixing earth to make a color—off of which light is reflected.

We really need to throw away the color wheel. It is the worst educational tool. You know, we can't really go to the moon with Euclidean geometry, and you can't continue with just knowing the color wheel. The color wheel is okay for paint, but you can think of it better if you think of it in light, because light is what reaches our eyes.

We can think of what light irradiates a paint or color, and what light comes off it. We should really be talking about additive light. We need to talk in terms of the spectrum. We need to teach the spectrum, which is like teaching the scales.

So the reason we have a very poor vocabulary in light is because we're thinking of the objects that pull this color. We have an "avocado green," we

have "apricot," "persimmon," "raspberry red" and so forth. We often associate with a fruit, or different sorts of earth materials from which we've made these things. These are materials, and we have a very material world. It's a culture very much concerned with surface.

In the piece you saw at the Einsteins [*Second Meeting*], the color of the sky has changed. You can be inside the piece, and the color of the sky is different than if you step outside the piece. It's not as though I've changed the color of the sky. That ends up as the result, and it has to do with our prejudiced perception. That's because we "know" a white surface, and so, no matter what light is put on that interior surface, we're going to read it as a "white" surface.

When other colors of light are on it, the only thing that can change is what we have to contrast with it, this open sky. This is why we will change the color of sky when in fact the sky has not been changed in color.

RW: You're saying this is a culturally determined thing?

JT: Yes, I am.

RW: You mean if I were a primitive man, I wouldn't have perceived that shift of color?

JT: Well, that is not exactly clear.

RW: Isn't part of this experience due to the effects of the after-images of the blue and of the yellowish tungsten light, that these after-images amplify each other?

JT: Yes, the laws of simultaneous contrast will work within any culture. That does happen. But we will read white into this for quite a ways even though the color is not nearly so white. We do that more than most cultures. But I don't know how to look at this through other cultures, since I'm in this culture, too. This is where we get to relativity, in terms of judgment.

We don't assign color to spaces easily, as a pilot does. That's very different. You do get involved in these colors of sky, and the sky does darken as you go up in altitude. There's no doubt of that. That's a great joy to see that. You get different intensities of sky right here at 7000 feet.

RW: I'm glad you mentioned the word "joy" because, certainly for me, there can be a great deal of feeling associated with looking at light. You must have some experience of that.

JT: Maybe I didn't quite fully express it, but, as a young child, that was a

great joy. My first memory was seeing this light on the ceiling. So that's going to be from crib, I suppose. I do remember even looking at things that I imagined up there as well. In other words, things would be in this light as well. It wasn't just that it had to carry a specific image, but I imagined things out of it.

It's not too different from giving yourself over to the experience of reading a book. Seeing "the space within the space," as Antoine St. Exupery described spaces within the space of the sky in some of the early aviation literature he wrote: *Wind, Sand, and Stars, Night Flight* and *Flight to Arras*. This has great imaginative appeal.

As you fly, you do see space that is determined not so much by physical confines but by atmospheric and light phenomena within the space. I've seen sometimes a contrail that goes through the sky where you can see its shadow come down through the sky, the shadow of the contrail. This beautiful shadow actually divides the space in an amazing way. So for me, sitting up there in this cockpit, I've seen so many things that reminded me of this other way of seeing, where light is the material, and this makes the space.

Of course, it can in other ways too. When you stand on the stage, you often have so much light from the footlights that you can't see the audience. Even though you're in the same architectural space as the audience, you don't see them. So this light divides the space. Of course, if you dim these lights, that audience comes out, just like the stars come out when the sun goes down. This can happen in rather near spaces, this use of light to build space, or to end vision, as much as you can end vision with a wall.

RW: I remember reading where you described flying between two cloud layers and a jet punched through, leaving a contrail between these two layers. I thought, "that must have been such a beautiful space to be in."

JT: Well, these are spaces that we do inhabit. I think, for instance, of the Hopis and some of the Southwest Indians, who live on the mesas. They are essentially "sky people," as the Zuni call themselves—"Sky City" at Acama. The Hopis also live in that situation. They actually live in the sky. Certainly the Tibetans felt they were living in the sky. They really felt that.

Now, you begin to live in the sky when you fly. It is a different perspective. Many pilots are rather derisive of what they call "ground-pounders," [laughs] people who live in the maze, where you learn almost by memorizing the turns in the maze.

Many people, when they first fly—you can see for hundreds of miles—they get lost. You know, they can't find the airport. When you learn to fly, finding the airport is an important function. [laughs]

It's surprising how you can lose yourself when you can see so far. You are

no longer down in the maze, no longer what pilots would call "a bottom dweller." This is a new kind of perception. It's no different than say, if you become a diver and go into the sea, and experience that. You get "rapture of the deep." You get "rapture of the heights." It's something that does occur. It is a joy—this opening up of perception.

Then you find there are many ways we perceive that are not good for flying, especially when you get visibility at dusk when things are not clearly defined. You start to get a loss of horizon. This is when many of the perceptions we have cannot be trusted.

So, you actually learn not to trust how we have learned to perceive. Pilots actually have to do this, especially for instrument flight. Night flight is like flying in an inkwell. When you get away from the city and you have no horizon, the little dots of light from the farmhouses can, at times, look like the stars. You can really get confused.

One of the most interesting times I had occurred when I was training. I came down over Pyramid Lake near Tahoe, and it was an absolutely still morning. I could see the reflection of the sky in the lake. I rolled upside down, and it looked perfect upside down. I rolled right side up, and it looked just the same. Of course, you can feel gravity, but when you do a barrel roll you take that gravity into the roll. So you have to remember whether you're right side up or right side down in relation to the real world. There is this beauty of the reflection.

RW: So there are many moments in flying that are a world apart.

JT: Well, it's a world within our world, but it is something to pay attention to, just as in orienting to light. I use light by isolating it, and often not very much of it. I try to do it without a heavy hand, as in the piece you saw at the Einsteins which is seemingly a very simple situation, but it does have something to do with our perception and our relationship to this ocean of air.

RW: I found it startling, really, to experience the intensity of the two colors that developed as the light decreased.

JT: And it gets to be an extreme color that we don't normally see.

RW: It was amazing, really. I was touched in a different way by your piece in the San Jose Museum of Art. I think it's projected light. I've had very intense experiences with light myself, including the so-called "after death" experience of light. There is a golden light, as people report. It's such an extreme state, but it was a golden light and it was also, at the same time, full of feeling. I would say the feeling was love. I don't know what else to call it.

It was a very, very powerful experience.

JT: This work that I do is an emotional work. I don't think there is any doubt of that.

RW: Yes. I certainly feel that, but I think the way you talk about it doesn't always reveal the reality of the feeling part of it.

JT: Well, it's unusual to see this kind of work. We're very primitive and have very little vocabulary in terms of light. Also, in terms of the instruments of light, absolutely primitive!

If I'm a painter, I don't need to be a chemist to get thousands of colors. But I can't go down and buy a light anywhere that I can dial through infrared, red, orange, yellow, green into blue, violet, and into ultraviolet. I can't buy a light like that.

We are a primitive culture in terms of light. We are just beginning, so I have to make the instruments, as well as to make the symphony with it.

You know, when we first made the clavier and the piano, and someone sat down to play that, they didn't say, "O my God, what a machine!" It *is* a machine—quite complex, really—but it's more than that. It is something through which emotion can come, freely.

When I have a work, it doesn't have the hand, but I sacrifice only that in being fully involved in a direct emotional way. For me, it's a very powerful way. So, I have not lost a thing by taking out the hand.

RW: I was going to ask you, over the years what has evolved? It must go back all the way to your early experiences of light as a child.

JT: Well, the kind of experience you were talking about has been very important to me. I think the descriptions of near-death experience, descriptions of light phenomena in the dream, and in waking—I don't pretend to have a religious art, but I have to say it is artists who worked that territory from the very beginning. So this is not an arena that we have been out of.

I think that even when you go into gothic cathedrals, where the light and the space have such a way of engendering awe, that, in a way, what the artists have made for you in this place is almost a better connection to things beyond us than anything the preacher can say—although music, at times, can really approach that, too. I think this is a place where artists have always been involved.

It's not new territory. I really do like this sensibility of at least coming close to how we see in this other way, how this light is encountered in this dream, in the meditation. And I can say, I only had this experience once, as a child;

then later, in Ireland I had it, where the physicality of the situation I was in was like the dream. That was really powerful. I was out in a garden when I was a child, and things took on a life and a luminance that was like this near-death experience, with eyes open. Then once, in Ireland, I was in a boat, coming in from Fastnet toward Whitehall. It was absolutely still. A silver light came about that bathed everything. This was an experience I had in a conscious, awake state.

Most of these experiences that people talk about are generally in altered states that are like a dream, or at least, like a daydream.

I would like to have the physicality of my light at least remind you of this other way of seeing. That's as best as I can do. It's terrible hubris to say this is a religious art, but it is something that does reminds us of that way we are when we are thinking of things beyond us.

RW: You must find that people do resonate to your work in ways that really do remind them of these kinds of experiences.

JT: That's true. To that degree, I suppose that's a success for me, but it's not my light; it's not my remembrances to trigger. They are yours. That can only come from a direct experience, by you. So that, in some way, removes some of that distance between you and me, because we both stand before this, equally.

RW: Yes. I think it's an experience many people have had to one degree or another.

JT: I'm sure of that, actually.

RW: I don't know what one does with that, but it's an important fact. I say "important," but then, if someone says, "well, why is it important?" To say why is not so easy.

JT: It's not mine to say. It's enough for me to say, that the flower is for the plant. If bees and florists are interested in it, too, fine. I hope to make something that is important to you, but I have to make something that is important to me.

It's not my business, or even my intent to, in any way, affirm your taste. That's a difficult thing when people think of art. People are thinking of something they can take home, that in some way affirms what they believe or how they think—and boy, it's not the job description of the artist to do that. If anything, it's to challenge that and expand it.

*Works Cited (p. 7)*

Yves Michaud, "Joan Mitchell, Interview with Yves Michaud" (1986), in Kristine Stiles and Peter Selz, (eds.), Theories and Documents of Contemporary Art: a sourcebook of artists' writings, (Berkeley, Los Angeles and London: University of California Press, 1986), p. 31

First published in softcover in the United States of America by Whale and Star, Delray Beach, Florida, info@whaleandstar.com, www.whaleandstar.com

Design Concept: The people of Whale and Star
Lead Publication Coordinator: Jillian Taylor

All photographs by Richard Whittaker with exception of Rue Harrison (p. 9), Iris Even (p. 94), Craig Nagasawa (p. 162), and John Townsend (p. 198).

Distributed exclusively by University of Nebraska Press
1111 Lincoln Mall
Lincoln, Nebraska 68588-0630
www.unp.unl.edu
Tel: 800/755 1105
Fax: 402/472 6214

Library of Congress Control Number: 2007922286

ISBN: 978-0-9673608-8-1